FLASH + AFTER EFFECTS

2nd Edition

Add Broadcast Features to Your Flash Designs

Chris Jackson

ELSEVIER

Amsterdam • Boston • Heidelberg • London • New York
Oxford • Paris • San Diego • San Francisco • Singapore
Sydney • Tokyo
Focal Press is an imprint of Elsevier

Focal Press is an imprint of Elsevier
30 Corporate Drive, Suite 400, Burlington, MA 01803, USA
The Boulevard, Langford Lane, Kidlington, Oxford, OX5 1GB, UK

Notices

Knowledge and best practice in this field are constantly changing. As new research and experience
broaden our understanding, changes in research methods, professional practices, or medical
treatment may become necessary.

Practitioners and researchers must always rely on their own experience and knowledge in evaluating
and using any information, methods, compounds, or experiments described herein. In using such
information or methods they should be mindful of their own safety and the safety of others, including
parties for whom they have a professional responsibility.

To the fullest extent of the law, neither the Publisher nor the authors, contributors, or editors, assume
any liability for any injury and/or damage to persons or property as a matter of products liability,
negligence or otherwise, or from any use or operation of any methods, products, instructions, or
ideas contained in the material herein.

Library of Congress Cataloging-in-Publication Data
Application submitted

British Library Cataloguing-in-Publication Data
A catalogue record for this book is available from the British Library.

ISBN: 978-0-240-81351-6

For information on all Focal Press publications
visit our website at www.elsevierdirect.com

10 11 12 13 5 4 3 2 1

Printed in the United States of America

Working together to grow
libraries in developing countries

www.elsevier.com | www.bookaid.org | www.sabre.org

ELSEVIER BOOK AID
 International Sabre Foundation

Table of Contents

Introduction

Flash Designers: Take your projects to the next level with After Effects' robust toolset. You are about to take a journey that combines these two powerhouse applications. Enter the world of Adobe After Effects. Welcome aboard.

What Is This Book About?

This book will help Flash animators and designers understand how After Effects integrates with Flash. Both programs are becoming tightly interwoven together with every product update. Flash provides a creative web tool for animation and interactivity. After Effects provides an easy-to-use application for creating visual effects and motion graphics. With the ubiquity of video on the web, Flash animators and designers are jumping on the bandwagon using After Effects to add broadcast features to their Flash projects.

Why would someone who uses Flash care about After Effects? After Effects provides many features and effects that can not only enhance Flash projects but save on development time because of how these two applications are integrated. After Effects implements a variety of ways to create video with alpha, animate graphics in 2D or 3D space, and then export the animation with a transparent background, as well as apply a variety of effects and presets that help differentiate a Flash designer's work.

For Flash animators, After Effects takes their project to the next level in 2D animation. It provides Flash animators with an assortment of visual effects that are rather difficult or next to impossible to achieve in Flash. Within After Effects, these complex effects can be applied through a simple drag-and-drop interaction. After Effects incorporates character animation tools (parenting and puppets) that easily hinge and animate multilayered artwork. After Effects also incorporates a 3D engine, allowing animators to add depth to their backgrounds.

After Effects is an excellent tool to prepare your Flash animation for broadcast. This book covers the technical requirements you need to be aware of in video production. You will explore the world of broadcast design and learn the basics in setting proper frame size and frame rates, pixel aspect ratios, Title and Action Safe areas, and color management.

Digital video no longer has to be linear. Flash designers can use ActionScript to control video playback. Cue points can be added to the video that allow users to jump to certain frames (similar to DVD chapters). These cue points can also trigger other events or animations in the published Flash file. Flash supports alpha channels in digital video. This feature can enhance Flash games and instructional content.

A Flash user needs to know more about After Effects, its features, and what they can do with them to enhance their Flash projects. That is what this book addresses. The book's objective is to bridge the two applications and clearly demonstrate how Flash and After Effects can be integrated to produce enriched content for the web, CD/DVD, and broadcast.

Who Is This Book For?

The primary audience for this book is Flash animators and designers. These Flash users can be professionals in the workforce, students, or anyone interested in creatively enhancing their Flash projects. This book assumes that readers have prior Flash experience. They should have a working knowledge of the Flash workspace and an understanding of animation concepts and basic ActionScript.

The book provides an introduction to After Effects, its workspace, and tools. The book does not necessarily show the reader what all the tools do; rather, it shows how to use them to enrich Flash animation and interactive projects. Flash is everywhere and with the enhanced video capabilities present in the new versions of Flash Player, showcasing After Effects content using Flash is the best way to go.

Regardless of how a reader approaches this book, using After Effects to enhance Flash content is growing in popularity. This book teaches readers how to think creatively and get excited about animation and visual effects in their Flash projects. It clearly illustrates how these two applications complement each other and help raise the design bar for web, CD/DVD, and broadcast.

Book Structure and Layout Conventions

Flash + After Effects is designed to walk the reader through project-based exercises that effectively use Flash and After Effects. The exercises have been updated to include new features in CS5. Almost all of the exercise files have been saved in the CS4 format to accommodate CS4 users.

To use this book, you need to install either CS4 or CS5 versions of Flash and After Effects on either your Macintosh or Windows computer. If you do not have a licensed copy, you can download fully functional time-limited trial versions on Adobe's website *(www.adobe.com)*.

The book's structure falls into two sections. The first section discusses how the two applications can work together in unison. Chapter 1 introduces you to After Effects, its workspace and workflow. As you build a typical After Effects project, comparisons are made between Flash and After Effects. Chapters 2 and 3 illustrate how to seamlessly import and export raster and vector animation from each application. A video primer is provided as you journey into broadcast design.

The second section of the book explores visual effects and animation techniques involved in using both applications together. You will learn about using alpha channels for keying and enhancing interactivity. Chapter 6 puts vector

animation to work using text layers and animation presets. In Chapter 7 you will create 3D backgrounds with cameras and lights. Chapter 8 provides a lot of fun animating characters with bones, parenting, and the Puppet Tool.

After Effects is the industry standard when it comes to visual effects. You will see why this is true in Chapter 9. You must not forget audio. It plays an important role in your Flash animation and Chapter 10. The last chapter also discusses optimization and publishing tips and techniques.

Chapter exercises consist of practical applications as well as experimental projects. Each exercise provides step-by-step instructions and tips for the reader to use in conceptualizing and visualizing creative solutions to their own Flash and After Effects projects. Videos used have been created in the NTSC format.

To help you get the most out of this book, let's look at the layout conventions used in the chapters.

▶ **Words in bold** refer to keywords, names of files, folders, layers, or compositions.
▶ Menu selections are presented like this: **Effect > Simulation > Shatter**.
▶ Code blocks in Flash are separated from the text like this:

```
// import Flash packages
import fl.video.*;
import fl.controls.ProgressBarMode;
```

▶ Icons are used throughout the book. Here is a brief explanation of what they are and what they mean.

Download Source Files: The source files for this book are available to readers at *http://booksite.focalpress.com/companion/jackson*.

Note: Supplemental information to the text that sheds a light on a procedure or offers miscellaneous options available to you.

Caution: Warnings that you need to read.

New CS5 Feature: When possible, an alternative method is provided for CS4 users.

All of the footage, source code, and files are provided to readers at the following URL: *http://booksite.focalpress.com/companion/jackson*. Each chapter has its own compressed (zip) file. Inside each chapter folder you will find the material needed to complete each exercise. Completed versions for every exercise are provided. As you work through the chapter's exercises, you can choose to manually build the project or review the finished example.

All of the material inside this book and accompanying digital files is copyright protected. They are included only for your learning and experimentation. Please respect the copyrights. I encourage you to use your own artwork and experiment with each exercise. This is not an exact science. The specific values given in this book are suggestions. The ActionScript is used to provide a solution. If you know of a different method, by all means, use it.

About the Author

Chris Jackson is a computer graphics designer and tenured professor at Rochester Institute of Technology (RIT). He teaches a variety of graduate-level courses including 2D Computer Animation, 3D Computer Graphics, Instructional Multimedia, and Motion Graphics. Before joining the RIT faculty, Chris was a new media designer with the Eastman Kodak Company, creating and delivering online instructional training via the web and CD-ROM.

Chris' professional work has received over 25 distinguished national and international awards for online communication. His areas of research include user's experience design, 2D character animation, digital storytelling, and interactive design for children. Chris continues to publish and present his research and professional work at Adobe MAX, UCDA Education Summit, TypeCon, SIGGRAPH, and the Society for Technical Communication (STC).

Chris is author of *Flash Cinematic Techniques: Enhancing Animated Shorts and Interactive Storytelling* (Focal Press, 2010), *Flash + After Effects* (Focal Press, February, 2008) and co-author of *Flash 3D: Animation, Interactivity and Games* (Focal Press, October 2006). His books have been translated into foreign languages.

He continues to be a Flash animator, designer, developer, and consultant for worldwide corporations and nonprofit organizations. He lectures and conducts workshops relating to interactive design and Flash animation.

Acknowledgements

This book is dedicated to my wife, Justine. Thank you for all your unconditional love and the constant support. I love you with all my heart.

This book is for my parents, Roger and Glenda. Thank you for your inspiration and encouragement for me to become an artist. You made it possible for me to fulfill my dreams. I love you both.

I owe a debt of gratitude to all at Focal Press, but especially Paul Temme and Anais Wheeler. Thank you for all your support and advice in enabling me to bring this second edition to print.

Special thanks goes to my Computer Graphics Design students at the Rochester Institute of Technology, especially Darryl Marshall, Scott Bessey, and Steve Gallo. Thank you for finding the time from all of your assignments and thesis projects to help me with this book.

Some of the images and stock footage used in this book are from the following royalty-free sources: *www.istockphoto.com* and Artbeats (*www.artbeats.com*). Special thanks to Kevin Poll of iStock International Inc., and Julie Hill of Artbeats for assisting me in acquiring footage to use in this book.

For Instructors

Flash + After Effects provides hands-on exercises that demonstrate core features in Flash and After Effects. As an instructor, I know you appreciate the hard work and effort that goes into creating lessons and examples for your courses. I hope you find the information and exercises useful and can adapt it for your own classes.

All that I ask is for your help and cooperation in protecting the copyrights of this book. If an instructor or student distributes copies of the source files to anyone who has not purchased the book, that violates the copyright protection. Reproducing pages from this book or duplicating any part of the source files is also a copyright infringement. If you own the book, you can adapt the exercises using your own footage and artwork without infringing copyright.

Thank you for your cooperation!

Credits

The following stock images were provided for this book:

- ▶ **Portrait of Red Haired Girl**, photo courtesy of iStockphoto, Nadezhda Kulagina, Image #4367558
- ▶ **Window of Opportunity**, photo courtesy of iStockphoto, Paul Kline, Image #3013679
- ▶ **Big City**, illustration courtesy of iStockphoto, Boris Zaytsev, Image #2749388

The following stock footage was provided for this book:

- ▶ **ReelExplosions 2**, footage courtesy of Artbeats, #RE222
- ▶ **ReelFire 1**, footage courtesy of Artbeats, #RF107
- ▶ **ReelFire 2**, footage courtesy of Artbeats, #RF215

CHAPTER 1

Getting Started in After Effects

As your journey towards integrating Flash and After Effects begins, you first need to understand the similarities and differences between the two applications. This chapter introduces After Effects and compares its project workflow to Flash.

© 2010 Elsevier, Inc. All rights reserved.
doi: 10.1016/B978-0-240-81351-6.50001-X

Project Workflow

Flash and After Effects follow a similar project workflow (Figure 1.1). You start a project by defining what the end product will be. Once you have a clear goal in mind, storyboard and create your assets. Next, you import and arrange the media elements on layers within a timeline. Once everything is in place, you add complexity to the project through either animation or programming. After previewing and refining the project to meet its output goals, you publish the project for its intended destination.

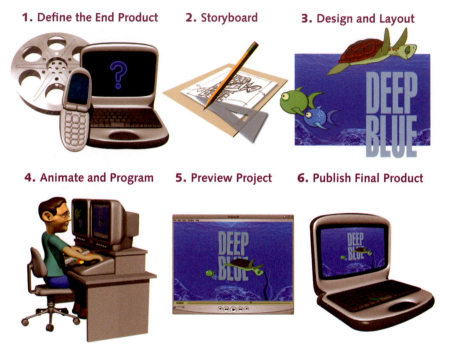

1. Define the End Product **2. Storyboard** **3. Design and Layout**

4. Animate and Program **5. Preview Project** **6. Publish Final Product**

Figure 1.1: *A project workflow that can be applied to either Flash or After Effects.*

Both Flash and After Effects allow you to import and layer raster and vector images, digital video, and sound. However, when it comes to adding complexity to a project, the two applications differ. Some of these differences are dramatic while others may not seem so obvious.

One major difference is interactivity. Flash has its own native scripting language called ActionScript. ActionScript allows you to create nonlinear interactive content for DVD, CD-ROM, and the web. After Effects provides a JavaScript-based scripting language used for automating animation, not interactivity. It can only render out linear content in the form of a Flash animation, image sequence, digital video, or sound.

Another difference between Flash and After Effects is output. Typically a Flash project is vector-based and is published for the web. Vector art uses math to

Chapter 1: Getting Started in After Effects

store and create an image. This makes the artwork resolution-independent. It can be scaled without losing any detail. As a result, vector-based artwork produces rather small file sizes that are ideal for web delivery.

After Effects focuses primarily on pixels, not vectors. These tiny units of color are grouped together to form an image (Figure 1.2). The resulting images tend to be photorealistic and larger in file size. A pixel-based, or raster, image is resolution-dependent. If scaled too large, the pixel grid becomes noticeable. A project in After Effects is usually designed to render out large video files destined for film or broadcast television.

Figure 1.2: *Vector art versus raster art.*

Over the past few years, there has been an exciting evolution in Flash and in the way it handles video content. With each new release, Flash is incorporating more enhanced video playback options and controls. After Effects has also evolved to add cross-compatibility with Flash. After Effects includes the ability to import SWF files with transparent backgrounds and export Flash Video (F4V or FLV formats), editable layered Flash XFL files, and published SWF files.

Flash and After Effects users are discovering the creative potential in combining these two powerhouse applications. It is truly exciting to explore and unlock the artistic possibilities that both applications offer each other. That is what this book is about. You are the explorer and the book provides a road map. It opens the door for you, the Flash designer, in adding broadcast features to your Flash designs. Each chapter explores how to unleash your Flash creativity by learning about After Effects.

So as Flash designers, where does one start in After Effects? You begin by exploring the structure of its user interface, referred to as the workspace. So let's dive in and get an overview of how After Effects works.

Creating a Project

In this chapter, you will build a typical After Effects project. The exercises are broken into four steps: creating a new composition using imported media, animating layer properties, applying effects, and rendering out your final composition. As you proceed through each exercise, comparisons will be made between Flash and After Effects.

 Download (http://booksite.focalpress.com/companion/jackson) the **Chapter_01.zip** *file to your hard drive. It contains all the files needed to complete the exercises.*

To see what you will build, locate and play the **DeepBlueTitle.mov** in the **Completed** folder inside **Chapter_01**. The goal of this project is to provide an overview on how to assemble a project in After Effects. It is a step-by-step tutorial that introduces you to After Effects, its workspace and workflow.

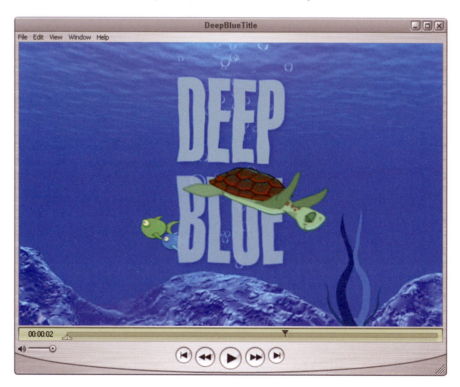

Figure 1.3: *The finished project is a title sequence in After Effects.*

Exercise 1: Creating a New Project

All your work in After Effects begins with a project file. This file references the imported files and holds the compositions created using those files. When you finish this first exercise, you should know what the Project, Composition, and Timeline panels are and how they work together. In addition to that, you'll know how to import media elements and save your project.

1. Launch **Adobe After Effects**. It opens an empty project by default.

> *Whereas Flash can open multiple movies, only one project in After Effects can be opened at a time. This is a key concept to understand. If you try to open another project or create a new project within After Effects, After Effects will close down the current project you are working on.*

2. The graphical user interface, referred to as the "workspace," can be configured in many ways. To make sure that you are using the same configuration as the book, locate the Workspace popup menu in the upper right corner. Select **Standard**. "Reset Standard" restores the workspace to its original arrangement.

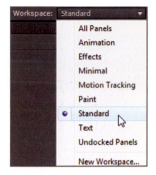

Figure 1.4: *The project's workspace should be set to* **Standard** *to be consistent with exercises in this book.*

The Workspace

The workspace is divided into several regions called frames. The frames consist of docked panels to reduce screen clutter (Figure 1.5). Most of the work done in After Effects revolves around three panels: the Project, Composition, and Timeline panel. If you were to compare these three panels to Flash's workspace, they are similar to the Library, Stage, and Timeline respectively.

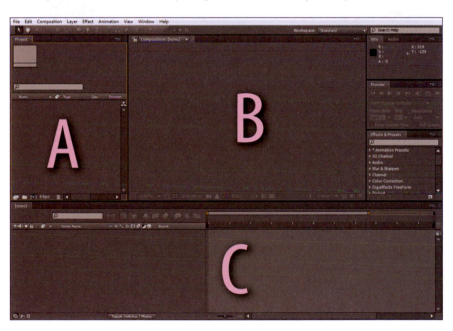

Figure 1.5: *The workspace in After Effects consists of three primary panels. They are: A = Project panel, B = Composition panel, C = Timeline panel.*

Project files in After Effects are similar to FLA files in Flash. Projects are made up of **compositions**. A composition in After Effects is like a movie clip in Flash. Each composition contains its own timeline. Even though After Effects can only open one project file at a time, there can be multiple compositions within the project. You create compositions from various imported files referred to as **footage**. Footage can be still images, Flash SWF files, digital video clips and audio.

3. This exercise has several footage files linked to it. To import the footage into After Effects, select **File > Import > Multiple Files** (Figure 1.6).

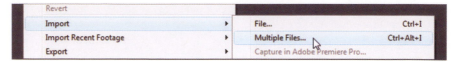

Figure 1.6: *Import footage into After Effects.*

4. Within the **Import Multiple Files** dialog box, locate and open the **01_Footage** folder inside the **Chapter_01** folder you copied to your hard drive (Figure 1.7).

 ▶ Select the Adobe Photoshop file named **DeepBlueScene.psd**.

 ▶ Choose **Composition** from the **Import As** menu options.

 ▶ Click **Open**.

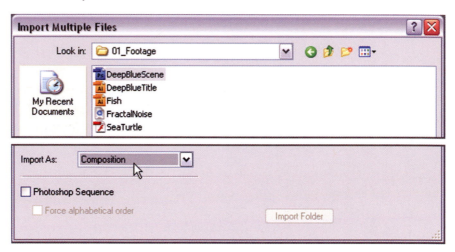

Figure 1.7: *Import the layered Photoshop file as a composition.*

Figure 1.8: *Each layer in the Photoshop document imports as a separate footage file in the Project panel.*

5. Importing the footage as a composition retains the layer structure within the Photoshop file. Each Photoshop layer is imported as a separate piece of footage (Figure 1.8). A dialog box appears requesting additional input on how you want the layered Photoshop file to be imported. Click **OK**.

6. Within the **Import Multiple Files** dialog box, select the Adobe Illustrator file named **DeepBlueTitle.ai**. Choose **Import As > Composition**. Click **Open**.

7. Select the **Fish.ai** Adobe Illustrator File. This file contains only one layer. Instead of importing as a composition, choose **Import As > Footage**. Click **Open**.

8. Select the **Fractal Noise.mov** QuickTime File. Choose **Import As > Footage**. Click **Open**.

9. Select the **SeaTurtle.swf** Adobe Flash SWF File. Choose **Import As > Footage**. Click **Open**.

10. Click **Done** to close the **Import Multiple Files** dialog box (Figure 1.9).

There are many ways to import footage into After Effects. The keyboard shortcut to import footage is Command + i (Mac) or Control + i (Windows). You can also use Adobe Bridge or drag files from the desktop into After Effects. Another import timesaver is to double-click inside the Project panel.

Figure 1.9: *When you are finished importing the multiple footage files, click on* **Done** *to close the dialog box.*

The Project Panel

The Project panel in After Effects acts a lot like the Library in Flash. It displays imported footage and stores the compositions created with these files. When you select an item, a thumbnail image appears at the top of the Project panel along with information about the selected footage. Buttons along the bottom of the panel allow you to search for footage, organize files into folders, create new compositions, and delete selected items (Figure 1.10).

Flash Library

Figure 1.10: *The Project panel (above) is similar to the Library in Flash (right).*

Unlike Flash, footage imported into After Effects is NOT embedded within the project. These files are always linked to the folder they were imported from. If you delete, rename, or change the location of your files after they were imported, After Effects will lose the link and not be able to properly display the footage.

11. Good organizational skills are essential to creating projects in After Effects. Let's organize the Project panel a little better by creating a new "Comps" folder that will only contain compositions. To do this:

 ▸ Deselect any selected item in the Project panel by clicking on the gray area under the footage.
 ▸ Click on the **New Folder** icon at the bottom of the Project panel.
 ▸ Rename the new folder **Comps**.
 ▸ You can rename any folder at any time by selecting it and pressing the Return/Enter key on the keyboard. This highlights the name and allows you to rename the item (Figure 1.11).

Figure 1.11: *Create a new folder and name it* **Comps**.

12. Click and drag the two compositions (**DeepBlueScene** and **DeepBlueTitle**) into the new **Comps** folder (Figure 1.12).

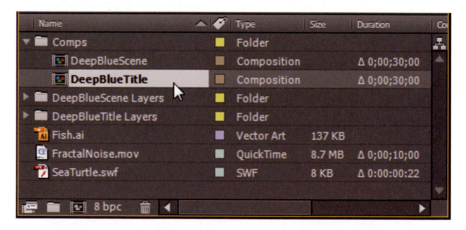

Figure 1.12: *Move the two compositions from* **01_Footage** *to the* **Comps** *folder.*

As projects become more complex, the Project panel can get quite cluttered. It is not uncommon to have hundreds of footage files. Get into the habit of organizing your footage into separate folders.

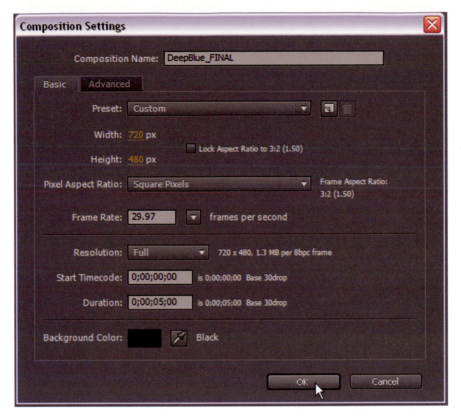

Figure 1.13: *Composition Settings specifies the size and duration of the composition.*

To animate or apply an effect to the footage, you first must create a new composition. A composition is a container that holds layers of footage. These layers are manipulated within the space and time defined by the composition.

Compositions act like movie clips in Flash. Compositions are independent timelines. You can have as many compositions as you want within a project. Each composition contains its own unique timeline just like movie clips in Flash.

13. Select the **Comps** folder in the Project panel. Select **Composition > New Composition**. Make the following settings (Figure 1.13):

 ▸ Composition Name: **DeepBlue_FINAL**
 ▸ Width: **720**
 ▸ Height: **480**
 ▸ Pixel Aspect Ratio: **Square Pixels**
 ▸ Frame Rate: **29.97**
 ▸ Resolution: **Full**
 ▸ Duration: **0:00:05:00**

Click **OK**. The new composition opens with a black screen in the Composition panel. The Timeline opens a tab. These two panels work closely together.

The Composition Panel

The Composition panel (referred to as the Comp panel) acts like the Stage in Flash. You use it to compose, preview, and edit your project. Buttons along the bottom of the Comp panel include controls for magnification, viewing color channels, displaying the current frame, and adjusting the resolution.

Figure 1.14: *The Comp panel is similar to the Stage in Flash. A popular magnification setting is* **Fit up to 100%**.

The Timeline Panel

The Timeline shows how the structure of your composition is built. The panel is divided into two sections. The right section is the actual Timeline where each layer's starting and stopping points, duration, and keyframes are displayed. The left section of the Timeline panel is broken up into a series of columns and switches. These affect how the layers are composited together (Figure 1.15).

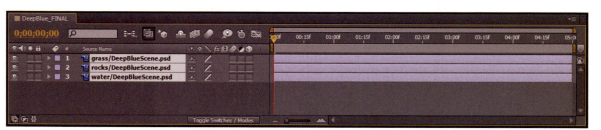

Figure 1.15: *The Timeline panel is divided into two sections. Controls and switches for layer compositing are on the left. The actual Timeline is on the right.*

As the Timeline becomes more populated and complex, you may want to zoom in or out. Use the Zoom slider at the bottom of the Timeline panel (Figure 1.16).

Figure 1.16: *The Zoom slider allows you to control the view of the time graph.*

14. Click and drag the **DeepBlueScene Layers** folder from the Project panel to the left side of the Timeline. Release the mouse. Three layers appear in the Timeline and the Comp panel displays the underwater scene (Figure 1.15).

15. Click and drag the **DeepBlueTitle Layers** folder from the Project panel to the Timeline. Position it above the **grass/DeepBlueScene** layer. Release the mouse. Two Illustrator layers are added to the Timeline (Figure 1.17).

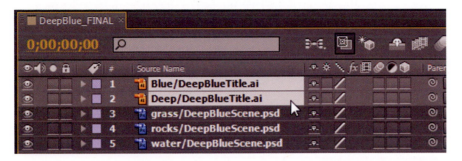

Figure 1.17: *Add the Illustrator layers to the Timeline.*

16. Click and drag the **Fish.ai** file from the Project panel to the Timeline. Position it at the top of the layers in the Timeline.

17. Click and drag the **SeaTurtle.swf** file from the Project panel to the Timeline. Position it at the top of the Timeline. Your Comp panel should look like Figure 1.18.

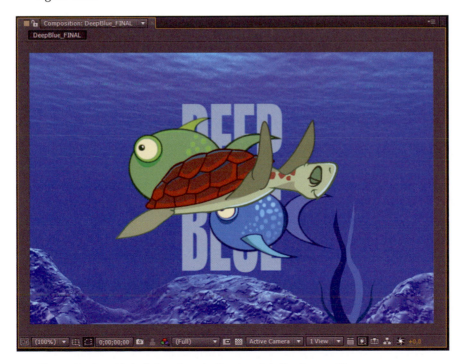

Figure 1.18: *Add the fish and sea turtle artwork to the Composition.*

18. Your first project is well on its way. Before you do anything else, save your project. Select **File > Save.** The keyboard shortcut is **Command + s** (Mac) or **Control + s** (Windows). This opens the Save As dialog box.

19. Name your file **01_DeepBlueTitle** and save it in your **Chapter_01** folder on your hard drive. Click **Save**. The file has an **.aep** file extension. This stands for After Effects Project (AEP). The saved file is not meant to be a standalone file such as a Flash projector. An AEP file is only read by After Effects.

Figure 1.19: *Save your project to the* **Chapter_01** *folder.*

Let's do a quick review. The three primary panels you used in this exercise include the Project, Composition, and Timeline. You created a new project, imported footage into the Project panel, and built a new composition using the imported items. Now it's time to learn how to bring this project to life.

After you create a composition, the remaining amount of work takes place in both the Composition and Timeline panels. The Comp panel works in conjunction with the Timeline panel. Any changes made to layers within the Timeline will be reflected visually within the Comp panel.

You will continue to build on this project using the Comp panel to position and move your artwork around. The next exercise focuses heavily on the Timeline panel, where you will set keyframes for your animation and navigate through time. The animation process in After Effects is rather different than animating in Flash. This is where the fun really begins.

Setting Keyframes

Although Flash and After Effects allow you to create keyframe animation, each application handles time rather differently. Flash is a frame-based application, whereas After Effects is time-based. This is an important difference you need to understand as you proceed through this book. To visualize this difference, take a quick comparative look at each application's Timeline.

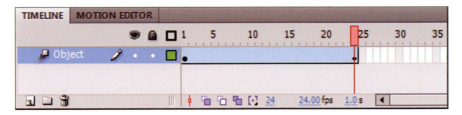

Figure 1.20: *Flash creates frame-based animation.*

Flash works with objects and frames. Figure 1.20 shows the Flash Timeline that has one layer named **Object**. The layer contains an instance of a movie clip with two keyframes and a motion tween applied. The actual Timeline is divided into cells and the unit of measurement is frames. As we see in the Timeline, the Flash movie is set to 24 frames per second. A keyframe at frame marker 24 indicates that this is a one-second animation.

Flash CS4 introduced auto-keyframing and a motion editor. These new features provide the ability to animate each property of an object separately from one another. The Motion Editor panel (Figure 1.21) allows you to fine-tune every object's property such as position, rotation, scaling, color, and filters using a motion graph or by applying preset or custom easing controls. This is similar to how After Effects creates and modifies keyframed animation.

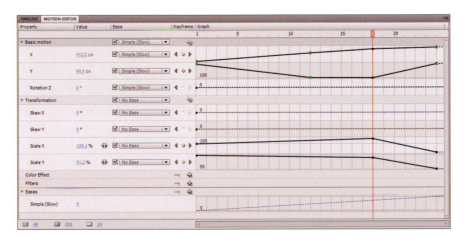

Figure 1.21: *The Motion Editor in Flash allows you to fine tune an object's properties.*

After Effects also deals with properties. Figure 1.22 shows the Timeline in After Effects. Here we have a similar object layer with only the position property keyframed. Each layer in After Effects has transform properties associated with it. These include Anchor Point, Position, Scale, Rotation, and Opacity.

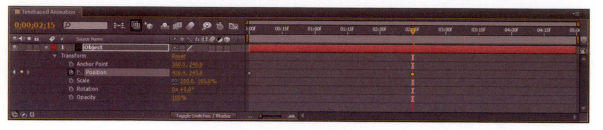

Figure 1.22: *After Effects creates time-based animation.*

The Timeline displays no individual cells and the unit of measurement indicates seconds. The output delivered is referred to as time-based media. This means that the media content changes with respect to time.

Exercise 2: Setting Keyframes

After Effects stacks layers in the same order as Flash. Layers that are higher in the Timeline panel will appear in front of lower layers in the Comp panel. Just like Flash, you can place or move a layer anywhere in the stacking order.

1. Select the **Fish.ai** layer in the Timeline panel. Drag it underneath the **grass/ DeepBlueScene** layer. Release the mouse (Figure 1.23).

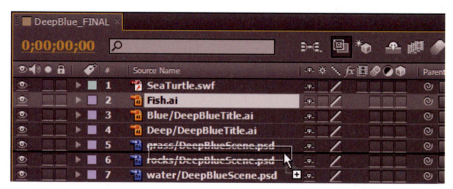

Figure 1.23: *Change the stacking order in the Timeline.*

2. Before you set keyframes, let's compose some items in the Comp panel:

 ▶ Click and drag the **Fish** artwork in the Comp panel down to the bottom right corner. Notice that the fish are behind the seaweed.

 ▶ Click and drag the **Sea Turtle** in the Comp panel to the upper left corner (Figure 1.24).

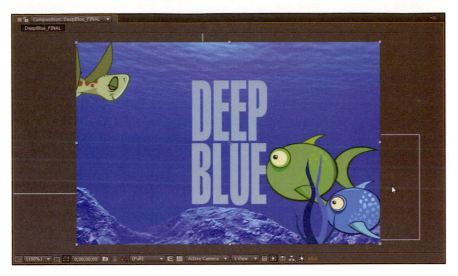

Figure 1.24: *Reposition footage items in the Comp panel.*

You can drag the footage to the Comp panel. This allows you to place it in the Comp panel where you want. You can also drag the footage to the Timeline where it automatically centers in the Comp panel.

There is one important difference between the Comp panel and the Flash Stage. After Effects will only display pixel information for footage contained within the Composition image area, referred to as the Comp panel. Any item that falls outside the Comp panel is displayed as an outlined bounding box.

3. Lock the grass, rocks, and water layers in the Timeline panel. This will prevent you from accidentally moving them when animating other layers. The first grouping of switches in the Timeline panel are the A/V Features (Figure 1.25).

 ▶ Click on the empty box in the fourth column next to each layer you need to lock.

 ▶ These switches should look familiar to Photoshop users. They are toggle switches; they are either on or off.

Video: *turns on or off visibility*

Audio: *turns on or off audio layers*

Solo: *reveals only the selected layer in the Comp panel*

Lock: *locks layer*

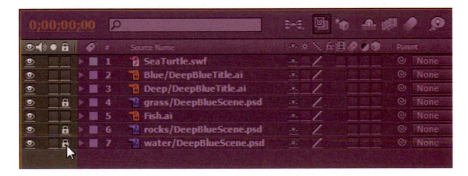

Figure 1.25: *A/V Features hide or show layers and turn any audio layers on or off.*

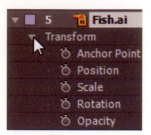

Transform properties

4. To create an animation, you keyframe transform properties inherent to a layer. In the Timeline, click the **twirler** ▶ to the left of the **Fish.ai** layer. This will reveal the word Transform. Each layer has its own transform properties.

5. Click the Transform twirler to reveal five properties, the values of which you can adjust over time. The transform properties are Anchor Point, Position, Scale, Rotation, and Opacity. Let's start with the Scale property.

There are two numeric values linked to scale—X (horizontal dimension) and Y (vertical dimension). The chain link icon 🔗 in front of the numbers constrains the vertical and horizontal proportions equally. By default, the chain is active to prevent the layer from distorting as you change the values.

ℹ️ *There are two ways to adjust the Scale. One way is to click and drag on any of the layer's four corner points in the Comp panel. If you hold down the Shift key, the scaling is constrained proportionally. The other method involves the Scale property in the Timeline.*

6. Click in the first number of the Scale field (100%) and drag the pointer to the right and left while watching the results in the Comp panel (Figure 1.26).

 ▸ Once you understand how this function works, set the value to **30%**.

 ▸ This act of clicking and dragging to change a value is known as **scrubbing**.

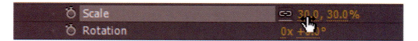

Figure 1.26: *Scrub through the Scale value and set it to 30%.*

7. Now that the fish are scaled to fit their environment, it is time to have them swim across the Comp panel. Every animation must contain at least two keyframes. If you change the position of a layer your first keyframe needs to record a starting position (Figure 1.27).

 ▸ Click and drag the **Fish** artwork off the right side of the Comp panel. This will be the starting position for the fish.

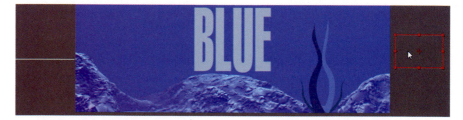

Figure 1.27: *Position the fish artwork off the right side of the Comp panel.*

If you don't set a keyframe, the current position of the fish will remain constant for the duration of the composition. You would never see them because they are outside the Comp panel. So how do you set a keyframe in After Effects?

8. In the Timeline panel, click on the **stopwatch** icon 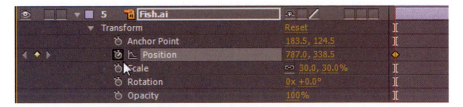 next to the Position property. This enables the Position property for keyframing. A keyframe in the form of a yellow diamond ◆ appears in the Timeline at the current time.

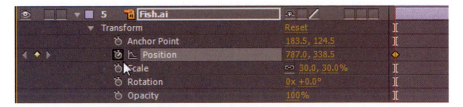

Figure 1.28: *The Stopwatch activates keyframes for animation.*

9. Change the position of the **Fish.ai** layer at a different point in time (Figure 1.29).

 ▶ Press the **End** key on the keyboard. This moves the **Current Time Indicator** (CTI) to the end of the Timeline. The CTI is the red vertical bar that shows where you are in time.

Figure 1.29: *The Current Time Indicator shows where you are in time.*

 ▶ Click and drag the fish off the left edge of the Comp panel (Figure 1.30).

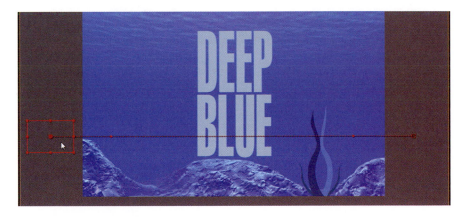

Figure 1.30: *Position the fish artwork off the left side of the Comp panel.*

A **motion path** appears in the Comp panel. This dotted line traces the path of animation from start to finish. Each dot represents the position of the fish at each frame in the Timeline.

The Preview panel is a secondary panel located to the right of the Comp panel. It contains buttons similar to VCR/DVD controls. You use this panel to perform RAM previews of your composition. Let's preview the animation you just created (Figure 1.31).

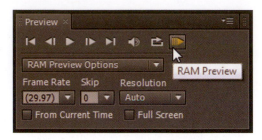

Figure 1.31: *Click on RAM Preview to play back the animation.*

10. Click on the **RAM Preview** button. There are two parts to a RAM preview. First, the Current Time Indicator moves across the Timeline loading the content at each point in time. A green bar appears under the time ruler indicating what has been loaded into RAM. After the first pass is complete, After Effects does its best to play back the animation in real time.

> **i** *The keyboard shortcut to create a RAM preview is the 0 key on the numeric keypad. Depending on the complexity of the composition and the amount of RAM installed on your computer, the RAM preview may not be able to store every frame in memory. Once full, the preview will start dropping from memory the first frames stored.*

11. Let's add more movement to the motion path. Move the Current Time Indicator (CTI) to one second (01:00) in the Timeline (Figure 1.32).

Figure 1.32: *Move the CTI to a new point in time (01:00).*

12. In the Comp panel, click on the fish and move them up slightly (Figure1.33). Since you are changing their position at a different point in time, a new keyframe is automatically generated. The path contains **Bezier** handles next to each keyframe. These allow you to fine-tune the curve of the motion path.

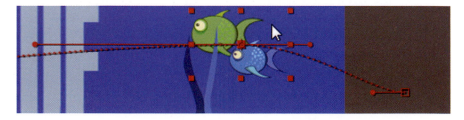

Figure 1.33: *Move the fish in the Comp panel to generate a new keyframe.*

13. Let's repeat those steps to create a wavelike motion for the fish.

- ▶ Move the Current Time Indicator (CTI) to two seconds (02:00) in the Timeline.
- ▶ In the Comp panel click on the fish and move them down slightly.
- ▶ Move the Current Time Indicator (CTI) to three seconds (03:00).
- ▶ In the Comp panel click on the fish and move them up slightly.
- ▶ Move the Current Time Indicator (CTI) to four seconds (04:00).
- ▶ In the Comp panel click on the fish and move them down slightly.
 Your Comp panel and Timeline should look similar to Figure 1.34.

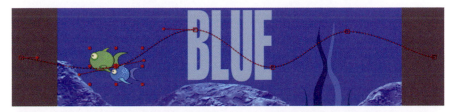

Figure 1.34: *Add more position keyframes to alter the motion path.*

14. Click on the **RAM Preview** button. Save your project.

Tweening versus Interpolation

Flash creates animation through the use of a **tween**. Flash has three types of tweens: motion, shape, and classic. A shape tween can only be applied to shapes drawn on the Stage. A motion and classic tween works only with symbol instances or grouped objects. All tweens are applied manually.

After Effects uses **interpolation** to fill in the transitional frames between two keyframes. Interpolation is the same as tweening. Once keyframes have been activated by clicking on a property's stopwatch icon, interpolation occurs automatically as changes are made at different points in time.

Flash CS4 adopted After Effects auto-keyframing capabilities in its new motion tween to easily create complex motion. Both Flash and After Effects use **spatial** keyframes visualized as a motion path with Bezier handles. Spatial refers to how a layer moves in the composition's space. In older versions of Flash, you needed to create a separate motion guide layer and link a drawn path to an object layer.

15. Let's continue to work with keyframes in After Effects. Press the **Home** key on the keyboard. This moves the Current Time Indicator to the beginning of the composition (00:00). You can also click and drag the CTI to 00:00.

16. Select the **SeaTurtle.swf** layer in the Timeline. Type **S** on the keyboard to show only the Scale property. Each transform property has a keyboard shortcut that will reveal only that property. This helps reduce clutter in the Timeline panel.

 ▸ Scrub through the numeric value and set it to **60%** (Figure 1.35).

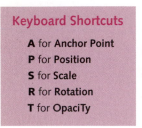

Keyboard Shortcuts

A for **Anchor Point**
P for **Position**
S for **Scale**
R for **Rotation**
T for **OpaciTy**

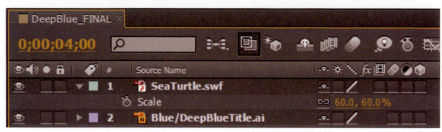

Figure 1.35: *Scrub through the Scale value and set it to 60%.*

17. You are going to animate the sea turtle; however, there is a problem. The duration of the SWF file is shorter than the duration of the composition. Luckily, the Flash animation is a complete cycle and can be looped in After Effects. To loop the animation:

 ▸ Go to the Project panel and single-click on **SeaTurtle.swf**.

 ▸ Select **File > Interpret Footage > Main**.

 ▸ In the Other Options section, enter **10** for the number of loops (Figure 1.36).

 ▸ Click **OK**.

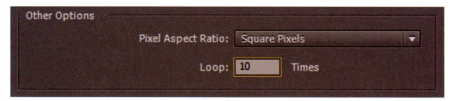

Figure 1.36: *The Interpret Footage dialog box allows you to modify how After Effects interprets specific footage in the Project panel.*

18. After you have looped the SWF animation, a ghosted bar now extends to the end of the composition in the Timeline. Retrim its Out Point by clicking and dragging it to the end of the composition (Figure 1.37).

Figure 1.37: *Retrim the Out Point to extend to the end of the composition.*

19. Press the **Home** key on the keyboard to move the Current Time Indicator to the beginning of the composition (00:00).

20. After Effects CS5 has a new **Auto-keyframe** mode that allows you to animate layers quickly by setting keyframes automatically. The Auto-keyframe button is a switch located above the layers in the Timeline panel. This mode is turned off by default. Click on the Auto-keyframe switch to activate it (Figure 1.38).

> 🛈 *This feature is not available in After Effects CS4. If you are working in CS4, you will need to manually turn on keyframes for the sea turtle layer by clicking on the stopwatch icon next to the Position property.*

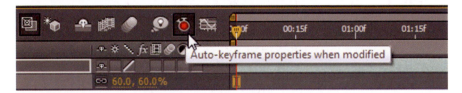

Figure 1.38: *Activate the Auto-keyframe mode to set keyframes automatically.*

21. Click and drag the **sea turtle** artwork off the left side of the Comp panel. This will be its starting position (Figure 1.39).

Figure 1.39: *Reposition the sea turtle off the upper left side of the Comp panel.*

22. When the Auto-keyframe mode is turned on, properties such as position and rotation are automatically keyframed. To see the recorded keyframe, make sure the **SeaTurtle.swf** layer is still selected.

> ▶ Press **Shift + P**. Shift keeps the Scale property visible and P reveals the Position property (Figure 1.40).

> ▶ The stopwatch icon next to Position is automatically turned on and a keyframe has been recorded at the beginning of the Timeline.

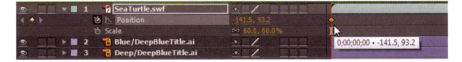

Figure 1.40: *The Position property is automatically keyframed.*

23. Press the **End** key to move the CTI to the end of the Timeline.

24. Click and drag the sea turtle off the bottom right edge of the Comp panel. This will be its ending position (Figure 1.41).

Figure 1.41: *Set the end position for the sea turtle in the Comp panel.*

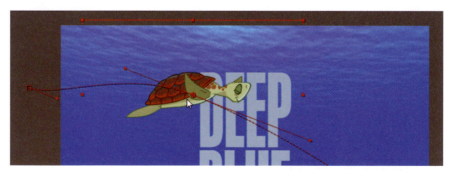

25. Now that you have established the starting and stopping positions, let's add some more keyframes to the motion path. Click and drag the Current Time Indicator to around 01:20 in the Timeline.

26. Move the sea turtle up slightly in the Comp panel. Changing the sea turtle's position at a different point in time generates a new keyframe (Figure 1.42).

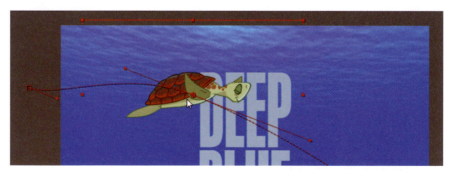

Figure 1.42: *Move the sea turtle in the Comp panel to generate a new keyframe.*

27. Click and drag the Current Time Indicator to around 03:10 in the Timeline.

28. Move the sea turtle down slightly in the Comp panel. Changing the sea turtle's position at a different point in time automatically generates a new keyframe (Figure 1.43).

29. Turn off the Auto-keyframe mode by clicking on its button ![button] again. This new feature in After Effects CS5 is a great timesaver, however, you must remember to deactivate it so that you do not automatically generate unwanted keyframes.

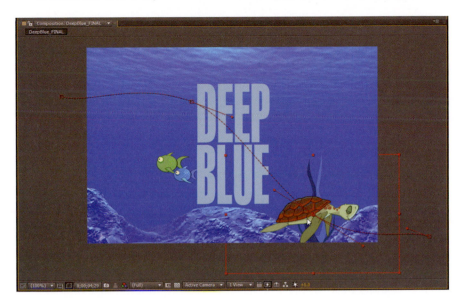

Figure 1.43: *Move the sea turtle in the Comp panel to generate a new keyframe.*

30. Just like Flash, you can easily rotate the layer to follow the path by selecting **Layer > Transform > Auto-Orient**. In the Auto-Orientation dialog box, select the option **Orient Along Path**. Click **OK**.

31. Click on the **RAM Preview** button. The sea turtle rotates to follow the motion path. Save your project.

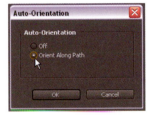

Spatial and Temporal Interpolation

After Effects interpolates both space (spatial) and time (temporal). It bases its interpolation methods on the Bezier interpolation method. Directional handles are provided for you to control the transition between keyframes.

Spatial interpolation is viewed in the Comp panel as a motion path. The default interpolation used is **Auto Bezier**. This creates a smooth rate of change from one keyframe to the next.

There is also interpolation happening between the keyframes in the Timeline. **Temporal** interpolation refers to the change in value between keyframes with regards to time. You can determine whether the value stays at a constant rate, accelerates, or decelerates. The default temporal interpolation used in the Timeline is **Linear**. That means the value changes at a constant rate.

You can view the temporal interpolation through the Graph Editor in After Effects. This visually displays the change in value between keyframes in the form of a graph. You can select keyframes and adjust their Bezier handles to affect the rate of change or speed.

32. Select the Position property for the **SeaTurtle.swf** layer. This highlights all of its keyframes in the Timeline.

33. With the layer still selected, click on the **Graph Editor** icon along the top of the Timeline (Figure 1.44). The keyframes are replaced with a graph showing the change in position over time as a linear interpolation.

Figure 1.44:
Turn on the Graph Editor.

- ▶ Linear interpolation sets a constant rate of change and is defined in the Graph Editor as a straight line (Figure 1.45).

- ▶ As you previewed your sea turtle animation, you may have noticed abrupt directional changes at each keyframe. The line shows that instant change.

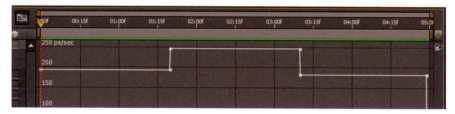

Figure 1.45: *The Graph Editor shows the current Linear interpolation.*

34. Select the Position property again for the **SeaTurtle.swf** layer. This highlights all of its keyframes in the graph. They are the yellow squares.

35. Select **Animation > Keyframe Interpolation**. In the dialog box that appears change the Temporal Interpolation from Linear to **Auto Bezier**. Click **OK**.

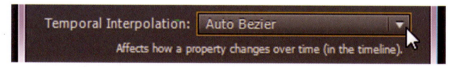

Figure 1.46: *Change the Temporal Interpolation from Linear to Auto Bezier.*

36. The graph line changes to a more smooth curved line (Figure 1.47). Preview your animation. Notice the fluid movement in the sea turtle.

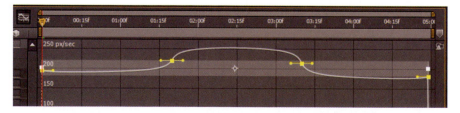

Figure 1.47: *The Graph Editor shows the Auto Bezier Interpolation.*

37. Click on the **Graph Editor** icon again to hide the graph. Notice that the keyframes have changed from diamonds to circles.

38. The last set of keyframes you need to set are for the title. Typically in title sequences, the title doesn't appear on the first frame. Move the Current Time Indicator (CTI) to one second (01:00).

39. Click and drag the **Deep/DeepBlueTitle.ai** bar's Set In Point to align with the Current Time Indicator. Changing the layer's In or Out Point is referred to as **trimming.** The word "Deep" will now appear at the one second mark.

40. Move the Current Time Indicator (CTI) to two seconds (02:00).

41. Click and drag the **Blue/DeepBlueTitle.ai** bar's Set In Point to align with the Current Time Indicator (Figure 1.48).

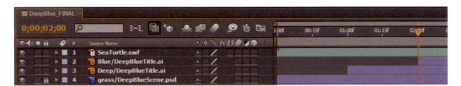

Figure 1.48: *Trim each title's Set In Point in the Timeline.*

42. Move the Current Time Indicator (CTI) back to one second (01:00).

43. Select the **Deep/DeepBlueTitle.ai** layer in the Timeline. Type **S** on the keyboard to show only the Scale property. Scrub through the numeric value and set it to **0%**. The word "Deep" disappears in the Comp panel.

44. Click on the **stopwatch** icon next to Scale to activate keyframes.

45. Move the Current Time Indicator (CTI) to two seconds (02:00).

46. Scrub through the Scale numeric value and set it back to **100%**. A keyframe is automatically generated (Figure 1.49).

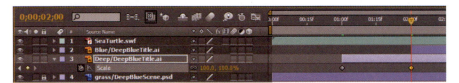

Figure 1.49: *Set keyframes to the Scale property.*

47. Now let's set keyframes for the word "Blue." Move the Current Time Indicator (CTI) to two seconds (02:00).

48. For this animation, you will keyframe the layer's Position. Select the **Blue/DeepBlueTitle.ai** layer in the Timeline. Type **P** on the keyboard to show only the Position property.

49. Click on the **stopwatch** icon next to Position to activate keyframes.

50. Currently, the word "Blue" is in its final position. Let's record that as well. Move the Current Time Indicator (CTI) to three seconds (03:00).

51. Click on the gray diamond to the left of the word Position. This adds a keyframe at the current time. The two arrows allow you to jump to either the previous or next keyframe in the Timeline (Figure 1.50).

> *Do NOT click on the stopwatch icon again. This button toggles keyframes on or off. If you turn off the keyframes, you lose all of them. If you want to delete a specific keyframe, click on it in the Timeline and press the Delete key.*

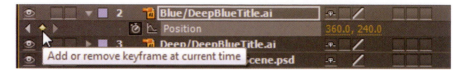

Figure 1.50: *Add a keyframe at the current time.*

52. Move the Current Time Indicator (CTI) back to the first keyframe you set at two seconds (02:00). Hold the Shift key while you drag the CTI and it will snap to that keyframe.

53. Click and drag the word "Blue" off the bottom of the Comp panel. This will be the starting position for the word. The interpolation automatically recalculates the transitional frames in-between the two keyframes.

54. Click on the **RAM Preview** button (Figure 1.51). Save your project.

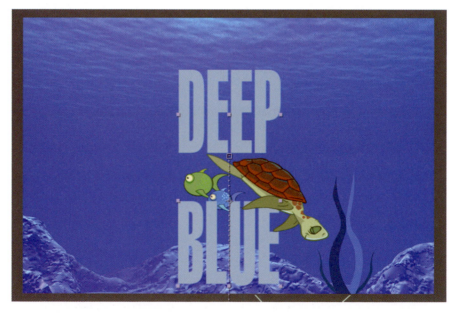

Figure 1.51: *Preview the title sequence. The word "Deep" scales from 0 to 100% and the word "Blue" moves up from the bottom of the Comp panel.*

Easing in After Effects

Before you finish this exercise, there is one more topic to cover: **keyframe assistants**. Keyframe assistants automate the task of easing the speed into and out of keyframes. Easing provides more realistic movement to objects since nothing in real life moves at a constant speed. In Flash, you apply easing through the Properties panel. A slider allows you to ease the speed in or out of a tween.

After Effects provides three types of keyframe assistants: Easy Ease, Easy Ease In, and Easy Ease Out. The last two work similar to Flash. Easy Ease smoothes both the keyframe's incoming and outgoing interpolation.

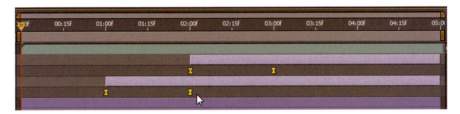

55. Let's apply a keyframe assistant to our title animation. Select the Position property in the **Blue/DeepBlueTitle.ai** layer. This selects all the keyframes.

56. Hold down the Shift key and select the Scale property in the **Deep/ DeepBlueTitle.ai** layer. This adds all of its keyframes to the previous selection.

57. Select **Animation > Keyframe Assistant > Easy Ease**. The keyframes change from diamonds to hourglass shapes in the Timeline (Figure 1.52).

Figure 1.52: *Apply the keyframe assistant, Easy Ease, to the title keyframes.*

58. Click on the **RAM Preview** button. Save your project.

Your project has now come to life. Animation in After Effects is similar to creating the new motion-tweened animation in Flash. Complex motion paths can be easily created and tweaked in After Effects. You also have control over specific layer properties such as Scale and Position.

Let's quickly review the basic process for setting keyframes. Each layer has transform properties inherent to it. These include Scale, Position, and Rotation. You set keyframes for each transform property by clicking on its stopwatch icon. This icon activates the keyframes. After Effects automatically records new keyframes for changes made at different points in time.

The next exercise focuses on applying visual effects to your project. This is what After Effects is known for. Effects allow you to enhance, transform, and distort both video and audio layers. The possibilities are endless.

Applying Effects

This is where After Effects truly shines. Once you see how easy it is to apply effects, you'll never want to stop. There are hundreds of effects that ship with the program. You can add any combination of effects and modify properties contained within each effect. It's insane! The only limitation is your creativity.

So let's start with the Effects & Presets panel. It is located to the right of the Comp panel. All effects are stored in a **Plug-Ins** folder inside the **After Effects** application folder. The Effects & Presets panel categorizes effects according to their function (Figure 1.53).

Figure 1.53: *The Effects & Presets panel organizes and categorizes effects.*

Flash provides very basic visual effects. These are called filters and can only be applied to movie clip instances. These effects include drop shadow, blur, glow, and bevel. That's it. You need to create all other effects either through tweened animation or ActionScript.

Exercise 3: Applying Effects

Effects are used to enhance a project in After Effects. These effects range from very simple drop shadows to complex 3D particle systems. In this exercise you will apply two visual effects: a 3D particle generator and a distortion effect. These effects will add the finishing touches to your project.

1. Make sure the Timeline panel is highlighted. Select **Layer > New > Solid**. The Solid Settings dialog box appears. A **solid** layer is just that, an area of color.

 ▶ Enter **Bubbles** for the solid name (Figure 1.54).

 ▶ Click on the **Make Comp Size** button.

 ▶ Click **OK**. The color of the solid layer doesn't matter.

> ℹ️ *All solid layers are stored in a **Solids** folder in the Project panel. This folder is automatically generated when you create your first solid layer. Any new layers you create will also be stored in the **Solids** folder.*

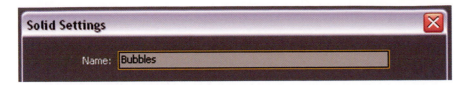

Figure 1.54: *Solid Settings dialog box.*

2. A solid layer of color appears at the top of the Timeline and in the Comp panel. Go to the Effects & Presets panel. Enter **Foam** into the Contains field. The item in the effects list that matches is displayed.

3. To apply the Foam effect to the solid layer, click and drag the effect to either the layer in the Comp panel or the Timeline panel. A red box with an X highlights the layer that will receive the effect. Release the mouse.

4. The effect is applied automatically. Notice that the solid color disappears and is replaced with a red circle in the center of the Comp panel. Click on the **RAM Preview** button to see the Foam effect (Figure 1.55).

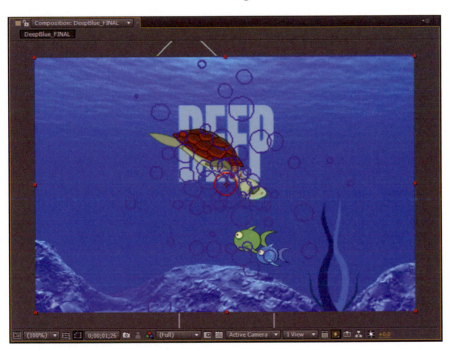

Figure 1.55: *Foam is a 3D particle generator that creates bubbles.*

Blue outlines of bubbles come out of the red circle in the center of the Comp panel. The Foam effect generates bubbles that flow, stick together, and pop. When you apply an effect, the Effect Controls panel opens as a new tab in front of the Project panel (Figure 1.56). It contains a list of properties associated with the effect. Let's experiment with the Foam properties.

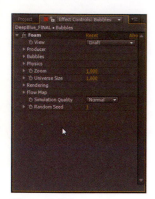

Figure 1.56:
Effect Controls panel

5. Click on the twirler to the left of **Producer**. This controls where the bubbles originate from. Make the following change:

 ▸ Producer Point: **360, 480**. This lowers the vertical position of the producer point to the bottom of the Comp panel.

6. Click on the twirler to the left of **Bubbles**. This controls the size and lifespan of the bubbles. Make the following change:

 ▸ Size: **0.200.** This makes the bubbles smaller.

7. Click on the twirler to the left of **Physics**. This controls how fast the bubbles move and how close they stick together. Make the following changes:

 ▸ Initial Speed: **5.000**

 ▸ Wind Speed: **1.000**

 ▸ Wind Direction: **0 x 0.0**

 ▸ Viscosity: **1.000**

 ▸ Stickiness: **1.000**

8. Click on the twirler to the left of **Rendering**. This controls the visual look of the bubbles. Make the following change:

 ▸ Bubble Texture: Change from **Default Bubble** to **Spit**.

9. To see the finished results, select **Rendered** from the View popup menu at the top of the Effect Controls panel (Figure 1.57). There is so much more that you can do with Foam that we will come back to this effect in a later chapter.

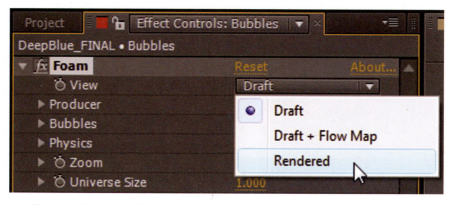

Figure 1.57: *Change the view from Draft to Rendered to see a better representation of the bubbles in the Comp panel.*

10. Click on the **RAM Preview** button to see the final Foam effect. Save your work.

The last effect you will apply is a distortion effect. It will simulate the bending of light seen underwater. The effect you will use is called a **Displacement Map**. This effect distorts a layer by displacing pixels horizontally and vertically, based on the color values of pixels in another layer. Here is how it works:

11. Go to the Project panel and double-click on the **FractalNoise.mov** footage file. This opens a preview window for the QuickTime movie. Play it. When you are done, close the preview window.

A Displacement Map can use the grayscale information to distort pixels within a layer. Areas of light grays will displace pixels up and to the right. Darker grays do just the opposite. Since this grayscale information is constantly changing in this movie, the displacement will also animate over time.

12. In order to apply a Displacement Map, you need to add the FractalNoise.mov file to the Timeline. Click and drag the footage item to the bottom of the layers. It will be hidden underneath the water layer. That is OK since the effect only needs to access the changing grayscale information (Figure 1.58).

Figure 1.58: *Add the FractalNoise.mov file to the Timeline. Position it at the bottom.*

13. With the Timeline panel still highlighted, select **Layer > New > Adjustment Layer**. An adjustment layer is added at the top of the Timeline. The footage item is also stored inside the **Solids** folder in the Projects panel.

Adjustment layers in After Effects work just like they do in Photoshop. This type of layer holds effects, not footage. Any effect applied to an adjustment layer is also applied to all the layers below it.

14. Go to the Effects & Presets panel. Enter **Displacement** into the Contains field. Two matched items appear: Displacement Map and Time Displacement. You will use the Displacement Map.

15. To apply the Displacement Map effect to the adjustment layer, click and drag the effect to **Adjustment Layer 1** in the Timeline panel. Release the mouse.

16. In the Effect Controls panel change the Displacement Map Layer property to the **FractalNoise.mov** layer. Adjust the other properties to match Figure 1.59.

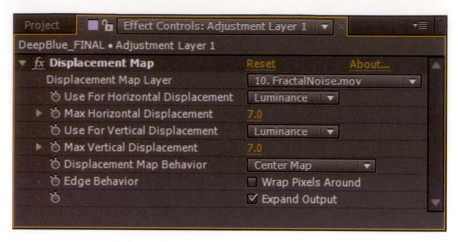

Figure 1.59: *Displacement Map settings.*

17. Click on the **RAM Preview** button to see the effect. The Displacement Map gives the illusion of being underwater. It pushes and pulls pixels based on changes in luminosity (brightness and darkness) occurring in the Fractal Noise movie.

18. There is one small problem. The edges of the water layer are also distorting. As a result, the black color underneath is being revealed. To correct this, unlock the **water/DeepBlueScene.psd** layer.

19. Select the **water/DeepBlueScene.psd** layer.

20. Type **S** on the keyboard to show only the Scale property. Scrub through the numeric value and set it to **110%**. Now the edge distortion occurs outside the Comp panel.

21. Rearrange the stacking order of the layers. Reposition the **Bubbles** and **Blue/DeepBlueTitle.ai** layers to go between the rocks and water layers (Figure 1.60).

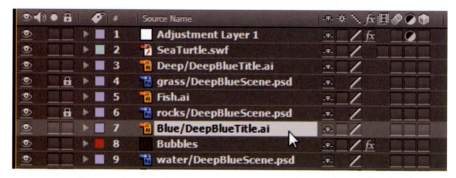

Figure 1.60: *Rearrange the stacking order so that the bubbles and blue title go behind the rocks in the Comp panel.*

22. Click on the **RAM Preview** button to see the final animation. Congratulations. You have finished your first project in After Effects. The final step in the workflow is to render the composition. Before you do that, save your work.

Rendering a Project

Your composition has been built and the layers are in place. Several of these layers animate in the Comp panel. Visual effects have been applied. Now it is time to see all of your hard work saved to a movie. This exercise focuses on rendering your composition to a movie file.

After Effects renders compositions within a project. There are many file formats that the composition can be rendered out to. These include QuickTime, SWF, or a Flash Video (F4V or FLV) file. It is a fairly simple process.

Exercise 4: Rendering a Project

1. Make sure the **DeepBlue_FINAL** comp is still open in the Timeline panel.

2. Select **Composition > Make Movie**. This opens the Render Queue. It is a new tab that sits on top of the Timeline panel.

3. In the Output To dialog box select the **Chapter_01** folder on your hard drive as the final destination for the rendered movie. If this dialog box does not appear, click on **DeepBlue_FINAL.mov** next to Output To.

4. Click on **Lossless** next to Output Module. This opens the Output Module Settings dialog box. Here you can change the file format and compression settings (Figure 1.61).

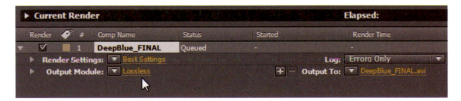

Figure 1.61: Click on "Lossless" to launch the Output Module Settings.

5. Set the format to **QuickTime** movie. Under Format Options, set the compression setting to **H.264** or **MPEG-4 Video**. H.264 is recommended for high-definition (HD) video. MPEG-4 offers a very good trade off on file size versus quality for digital television, animated graphics, and the web.

6. One of the nice features in After Effects is the ability to render out multiple formats at one time. Click on the "**+**" icon to the right of **Output Module**.

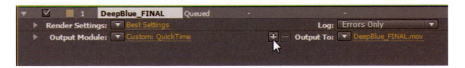

Figure 1.62: Click on "+" icon to duplicate the Output Module.

7. Since we are dealing with the integration of Flash and After Effects, let's render out another movie file in the FLV format. Click on **Custom:QuickTime** next to the duplicate Output Module.

8. In the Output Module Settings dialog box, change the format from QuickTime Movie to **FLV** (Figure 1.63). Click **OK**.

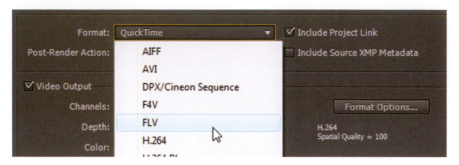

Figure 1.63: *Change the format to Adobe Flash Video.*

9. Click the **Render** button. Your composition will start to render. The Render Queue provides feedback such as which frame is currently being rendered and approximately how much time is left.

10. When the render is done, go to the **Chapter_01** folder on your hard drive. You will find the two rendered files. Launch the QuickTime movie.

DeepBlue_FINAL

DeepBlue_FINAL

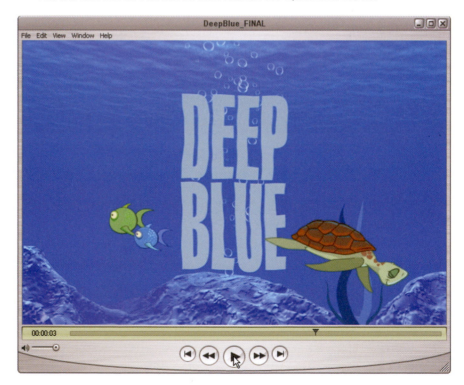

Figure 1.64: *The final QuickTime movie.*

To see an example of the FLV file, launch the **DeepBlue_FINAL.flv** in Adobe Media Player (Figure 1.65). Video for Adobe Flash Player can be encoded as a FLV or F4V file. F4V is the newer format and supported in Flash Player 9.2 and later. The FLV video format is for Flash Player 7 or higher.

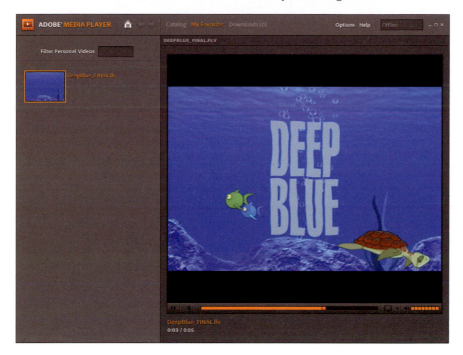

Figure 1.65: *The final FLV file can be viewed in Adobe Media Player.*

Video can be imported into Flash in a couple of ways. It can be embedded as a frame-by-frame sequence on the Timeline. You have to be careful with file size if you choose to import video this way. Video is notorious for large files sizes.

Most FLV and F4V files are external from the Flash SWF file; its dimensions are typically much smaller than the QuickTime's height and width. Common dimensions for Flash Video are 320 x 240, 240 x 180, and 120 x 90 pixels. Frame rate is also an important factor to consider. Common frame rates are 7, 15, 24, and 30 frames per second. The higher the number, the smoother the playback and the larger the file size.

Now that you are developing video for Flash, you need to know how to deal with the technical issues surrounding video formats. If you don't, you run the risk of watching all your hard work go down the drain when rendering your final project. The next chapter focuses specifically on these technical issues. These include frame size and frame rate, pixel aspect ratios, Title and Action Safe areas, and color management. They are all important video concepts to understand before you start your Flash movie.

Summary

Your journey has begun. This chapter introduced you to After Effects. Each of the four exercises discussed the steps it takes to create a typical project. Although Flash and After Effects share a common project workflow, the two applications differ when it comes to animation and visual effects. Throughout the chapter comparisons were made to Flash, its workspace and workflow. These tables summarize the key similarities and differences.

Table 1.1: *After Effects and Flash Workspace*

After Effects Workspace	Similarities to Flash	Differences from Flash
Project panel	It is similar to the Library in Flash. It displays the imported footage and stores compositions.	It provides more information about the imported footage files within the panel itself. A search feature allows you to quickly locate footage nested within folders.
Composition panel	It is similar to the Stage in Flash. It is used to compose, preview, and edit a project.	In addition to magnification, there are more controls available. The workspace outside the Comp panel's image area does not render pixels, only a bounding box.
Timeline panel	It shows the structure of your project's composition. Footage layers are stacked in a similar order. Keyframes are displayed over time.	You can access individual Transform properties for a layer. Adjustment layers can be added to effect other layers.

Table 1.2: *After Effects and Flash Project Workflow*

After Effects Workflow	Similarities to Flash	Differences from Flash
Creating a project	The project file is similar to a Flash file. It references imported files and stores the animation for publishing.	Only one project file can be open at one time. Flash can open multiple files at the same time.
Importing footage files	These imported files are used to compose the project.	The files are NOT embedded within the project.
Setting keyframes	Interpolation is the same as tweening in Flash—filling in the transitional frames between two keyframes.	After Effects interpolates both space and time. Bezier handles give you more control over a motion path.
Applying effects	Enhances items on the Stage.	After Effects provides hundreds of effects and an unlimited number of ways to combine them.
Rendering a project	This is similar to publishing a file in Flash.	You have more output options available.

CHAPTER 2

From Flash to After Effects

Video production presents technical requirements and limitations that can't be ignored. This chapter explores the world of broadcast design and offers a basic guide to exporting Flash files to After Effects.

doi: 10.1016/B978-0-240-81351-6.50002-1

Flash to Broadcast Video

Say you have just finished the world's greatest Flash animation and want to watch it on TV. What do you do? Similar to the web standards you follow when publishing your Flash file online, there are video standards you need to be aware of when creating a Flash file destined for video.

This chapter guides you through the technical issues surrounding broadcast design. These include frame and pixel aspect ratio, frame rate, Title Safe and Action Safe areas, and color management. A good place to start is at the beginning by determining the proper frame size to use.

Setting the Stage

Before you start any Flash project, you first determine the dimensions of the document's Stage. In video, this is referred to as the **frame aspect ratio**. It is the relationship between the width and height of an image. Standard definition television has a 4:3 frame aspect ratio. Where did this ratio come from?

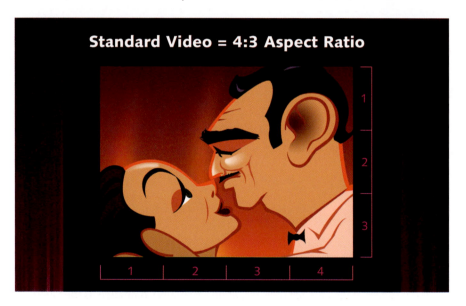

Figure 2.1: *For every four units of width there are three units of height.*

Motion pictures through the early 1950s had roughly the same aspect ratio. This became known as Academy Standard and had an aspect ratio of 1.37:1. Television adopted the Academy Standard to a 1.33:1 aspect ratio. This is the recognized video standard commonly referred to as a 4:3 frame aspect ratio.

In 1953 Hollywood introduced the widescreen format for motion pictures in an effort to pry audiences away from their television sets. Today, widescreen film has three standardized ratios: Academy Flat (1.85:1), Anamorphic Scope

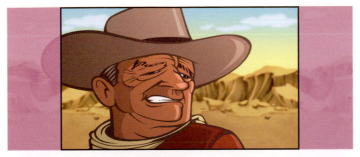

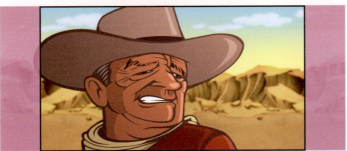

Figure 2.2: *Three common widescreen aspect ratios used for theatrical films*

(2.35:1), and European audiences watch films with a 1.66:1 aspect ratio (Figure 2.2). High-definition (HD) video adopted Academy Flat and has an aspect ratio of 1.78:1. This is referred to as a 16:9 frame aspect ratio.

There are three popular video format standards used throughout the world. NTSC, which stands for National Television Standards Committee, is the video format used in the United States, Canada, Japan, and the Philippines. Phase Alternating Line, or PAL, is the format of choice in most European countries. France uses SECAM, which stands for Séquential Couleur Avec Memoire. All three standard video formats use a 4:3 frame aspect ratio.

As previously mentioned, HD video displays a 16:9 frame aspect ratio (Figure 2.3). This means that for every sixteen units of width there are nine units of height. HDTV is a digital television broadcasting system that provides higher resolution than the standard video formats. How does all this affect Flash and its Stage size when Flash movies can be resolution independent?

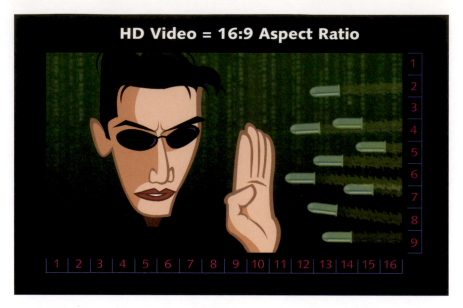

Figure 2.3: *For every sixteen units of width there are nine units of height.*

If you use only vector art, the published Flash movie can be scaled as big or small as you want without any loss in quality. Even though the movie size may not be important, designing for the correct aspect ratio is. If you don't, image distortion will occur going from Flash to video or DVD.

Square versus Non-square Pixels

Before you adjust the Stage width and height, you need to be aware of the **pixel aspect ratio (PAR)**. This refers to the width and height of each pixel that makes up an image. Computer screens display square pixels. Every pixel has an aspect ratio of 1:1. Video uses non-square rectangular pixels (Figure 2.4).

To make matters even more complicated, the pixel aspect ratio is not consistent between video formats. NTSC D1/DV video uses a non-square pixel that is taller than it is wide. PAL is just the opposite with pixels wider than they are tall.

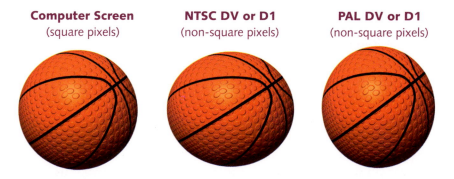

Computer Screen	**NTSC DV or D1**	**PAL DV or D1**
(square pixels)	(non-square pixels)	(non-square pixels)

Figure 2.4: *Using the wrong pixel aspect ratio can produce image distortion.*

Flash only works in square pixels on your computer screen. As the Flash file migrates to video, the pixel aspect ratio changes from square to non-square. The end result will produce a slightly stretched image on your television screen. On NTSC, round objects will appear flattened. PAL stretches objects making them appear skinny. The solution is to adjust the dimensions of the Flash Stage.

> *The pixel aspect ratio (PAR) for non-square standard video formats was modified in After Effects CS4. Prior to that, the PAR was calculated based on the Production Aperture. This included all of the pixels captured and ignored the fact that not every pixel is viewed in the actual 4:3 image, referred to as the Clean Aperture.*

A Flash Stage size to use for NTSC D1 video is 720 x 534 which is slightly taller than its video size of 720 x 486. For PAL, set the Stage size to 788 x 576. This is wider than its video size of 720 x 576. The published movie can be rescaled in After Effects to fit the correct dimensions. Even though the image may look distorted on the computer screen, it will appear correct on video. Table 2.1 shows the correct Stage size needed for each video format.

Table 2.1: *Flash Stage Size Settings for Different Video Formats*

Video Format	Frame Ratio	Pixel Ratio	Video Size	Flash Stage
NTSC DV	4:3	non-square	720 x 480	720 x 528
NTSC D1	4:3	non-square	720 x 486	720 x 534
PAL DV/D1	4:3	non-square	720 x 576	788 x 576
NTSC DV	16:9	non-square	720 x 480	872 x 480
NTSC D1	16:9	non-square	720 x 486	872 x 486
PAL	16:9	non-square	720 x 576	1050 x 576
HDTV 720p	16:9	square	1280 x 720	1280 x 720
HDTV 1080i	16:9	square	1920 x 1080	1920 x 1080

There is some good news with high-definition (HD) television. HD uses square pixels. This means that depending on the HD format you choose, either 720p or 1080i, your Flash Stage dimensions are the same as the video size. We'll discuss other methods of adapting a 720 x 534 Stage size to HDTV's wider aspect ratio later in the chapter. Let's focus on setting the proper frame rate.

Frame Rates

Video is measured in units called frames. Frame rate is the speed at which video plays back its frames. The default frame rate in Flash CS4 and higher is 24 frames-per-second (fps). This is the same frame rate as traditional film.

NTSC has a frame rate of 29.97 fps. Why not 30 fps? When black and white television became popular in the early 1950s, the broadcasts ran at 30 fps. When the color signal was added to the broadcast, the video frame rate had to be slowed to 29.97 due to technical issues. Video engineers were forced

to allocate a certain amount of time each second for the transmission of the color information. PAL and SECAM operate at 25 fps.

Flash movies cannot be set to 29.97 fps. If your Flash movie is intended for NTSC video, use a frame rate of either 15 or 30 fps. After Effects can conform the different frame rate to match 29.97 fps. Just remember that lower frame rates will not play back smoothly after being converted. If your Flash movie is migrating to PAL or SECAM video, use 25 fps.

Choosing a frame rate for HD production is more challenging. In the HD world there are frame rates of 23.98 and 24, 25, 29.97 and 30, 59.94 and 60. Flash only supports whole numbers for a frame rate. For the best results, round up to 24, 30, and 60. After Effects can interpret the imported SWF file and conform it to match the chosen HD frame rate.

Interlaced versus Progressive Video

Have you ever gotten really close to your television screen? Each frame of video is split into two sets of scan lines. Interlaced video draws each set of scan lines in an alternating fashion. The scan lines are held in two fields: the odd field consists of the odd-numbered lines and the even field consists of the even-numbered lines. Two fields equal one frame of image (Figure 2.5).

<div align="center">

Field 1 **Field 2** **Interlaced Frame**

</div>

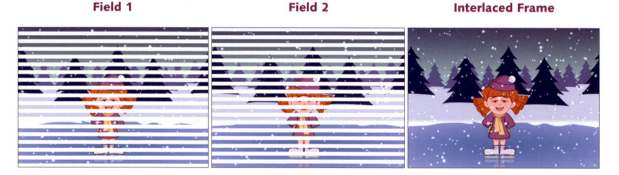

Figure 2.5: *Interlaced video is made up of two sets of scan lines, or fields.*

In the United States, interlaced video refreshes the screen 60 times per second in order to create 30 frames of images per second. First the even lines appear on the screen, then the odd lines appear. All analog televisions use an interlaced display. High-definition video can be either interlaced or progressively scanned.

Your computer screen uses progressive video. The video is scanned from side to side, top to bottom to create a frame. Every pixel on the screen is refreshed in order. The result is a higher perceived resolution and a lack of "jitters" that can make the edges in your artwork or patterns appear to move or shimmer. Figure 2.6 illustrates interlacing and its effect on an image.

Figure 2.6: *Interlacing severely impacts the smoothness of the video and makes the edges of the artwork appear to shimmer from frame to frame.*

Your artwork in Flash can be severely impacted by the alternating scan lines used in interlaced video. Avoid using thin lines or small text in your Flash file. A horizontal line 1 point thick or less will flicker on video. It is visible when the first set of scan lines appear, then disappears as the second field is displayed.

To have your Flash artwork and text display properly on video, a general rule is to set all horizontal lines to 2 points thick or greater. All screen text should be at least 18 points in size. Use bold san serif typefaces. Avoid typefaces with very thin lines or serifs. These will tend to flicker on a television screen.

Title Safe and Action Safe Areas

Standard television screens do not show the entire video picture. This problem is known as **overscan**. An average of 10% of the image around the edges of the screen is not visible to the viewer. This percentage can be smaller or larger and varies with the television's make and model.

To solve this problem, television producers defined the Title Safe and Action Safe areas. The Title Safe area is a space, roughly 20% in from the edges of the screen, where text will not be cut off when broadcast. The Action Safe area is a larger area that represents where a typical TV set cuts the image off.

What about high-definition? HDTV also overscans the image so that older programming will be framed as intended to be viewed. Some broadcasters crop, magnify, or stretch the original video based on the picture's aspect ratios.

Flash does not provide guides for Title and Action Safe areas. However, they can be easily created and saved as a Guide layer in your Flash movies. Guide layers are not exported in the published SWF file, making them a good choice.

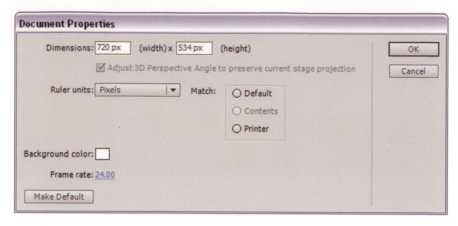

Figure 2.7: *Create a Flash movie with the proper Stage dimensions for the video format.*

To create Title and Action Safe guides in Flash you first start with a Stage size that matches your chosen video format (Figure 2.7). Refer to Table 2.1 for common Flash Stage sizes. Using the Rectangle Tool, draw a box with a stroke and no fill that matches the Stage dimensions. Align the box to the edges of the Stage (Figure 2.8).

Figure 2.8: *Use the Rectangle Tool to draw a box the same dimensions as the Stage.*

Copy the box and select **Edit > Paste In Place**. Since an average of 10% of the image around the edges of a TV screen is not visible to the viewer, scale the copied box 90% of its original size using the Transform panel. This establishes the Action Safe area in your Flash movie where all of the important animation should occur in (Figure 2.9).

Chapter 2: From Flash to After Effects

Figure 2.9: *Create the Action Safe area by scaling a copied box 90%. Create the Title Safe area by scaling a copied box 80%.*

To create the Title Safe area, select **Edit > Paste In Place** again. Scale the new box to 80% of its original size (Figure 2.9). This establishes the Title Safe area that ensures any text will not be cut off when broadcast.

With the Title and Action Safe guides in place, convert the layer containing the boxes to a Guide layer. To do this, right-click (Command-click on a Mac) on the layer name and select **Guide** from the menu (Figure 2.10). Lastly, it is a good idea to lock the layer to avoid accidentally moving it during production.

Figure 2.10: *Convert the layer to a Guide layer and lock it.*

Color Management

Computer screens display RGB colors. Video uses a YUV color space. While computers provide millions of colors to choose from, video has a limited range of colors it can display. So it is possible to use RGB colors on a computer monitor that cannot be reproduced on a television screen.

NTSC video makes life even more complicated. It uses the YIQ color space, which has an even smaller color range than YUV. NTSC is not as consistent at reproducing colors as PAL. If Flash designers are not careful with their color choices, their movie will not display properly on NTSC video.

This results in the colors bleeding, or spilling into neighboring colors. It produces a visible muddiness to the overall image. Warm, saturated colors such as red tend to bleed the most, making them a bad choice for fine detail or text. Blues translate quite well from RGB to video and make good background colors.

One solution is to apply the Broadcast Colors effect inside After Effects to the imported Flash movie. This effect forces the RGB colors to conform to the color space of NTSC or PAL (Figure 2.11). Keep in mind that if you are using the standard color palette in Flash, any reds, greens, and yellows could dramatically shift to an undesirable color.

Figure 2.11: *After Effects provides a Broadcast Colors filter to conform the RGB colors to the color space used in NTSC or PAL video.*

The best way to avoid any color shifts or bleeding is to create original art using only broadcast-safe colors. The full range of RGB color values is represented numerically from 0 to 255. Avoid using "pure" black and white. The RGB color value for black is 0-0-0. The color value for white is 255-255-255. To create safe broadcast colors, limit the R, G, and B values between 16 and 235.

The Color panel in Flash Professional CS5 has been updated to include both RGB and HSB controls. Change the R, G, and B values to 16. Add the color to the swatches. Next, select the white swatch. Change the R, G, and B values to 235 and add the swatch (Figure 2.12). A general rule to follow is that all colors should have a saturation value lower than 235, especially the color red.

NEW
IN
CS5

Figure 2.12: *Limit the RGB color values between 16 and 235 for broadcast video.*

If you are still not sure how to mix a color that is safe for broadcast, you can also replace the default color palette in Flash by importing an existing color palette or even a GIF file. Warren Fuller at *www.animonger.com* provides a NTSC color palette that you can download for free.

NTSC

To install the NTSC color palette, open the Flash Swatches panel and, from the panel pop down menu select **Replace Colors**. Within the Import Swatch Color dialog box navigate to the folder where you saved the **NTSC.clr** file. Select the file and click **Open**. To return to the default RGB swatches click the Swatch panel's pull-down menu and select **Load Default Colors** (Figure 2.13).

Figure 2.13: *Load the NTSC color palette or any other .clr file into the Swatches panel (left image). To return to the original RGB color swatches, reload the default colors (right image).*

Publishing SWF Files for After Effects

As you can see, there are a lot of technical issues surrounding video that you need to be aware of before creating your Flash movie. Let's apply what you have just learned by exploring how to migrate Flash movies to After Effects. There are several ways to do this. Let's start with an SWF file published in Flash.

Flash can export content to an SWF file, QuickTime movie, and an image sequence. All of these formats can be imported into After Effects. After Effects is one of the few applications that supports a wide variety of file types. SWF files are imported into After Effects as flattened, continuously rasterized layers. This means they can be scaled without losing detail or quality.

 *Download (http://booksite.focalpress.com/companion/jackson) the **Chapter_02.zip** file to your hard drive. It contains all the files needed to complete the exercises.*

The first exercise provides a step-by-step tutorial on importing an SWF file into After Effects. To see what you will build, locate and play the **BikeRide.mov** in the **Completed** folder inside the **01_SWF** folder (Figure 2.14). When you finish this exercise you will be able to set up a Flash animation that will import correctly into After Effects, and create a seamless scrolling background.

Figure 2.14: *The finished SWF file in After Effects.*

1. Launch **Adobe Flash**. Locate and open **Cycling.fla** in the **01_SWF** folder inside **Chapter_02**. The file contains a looping animation of the cyclist.

 ▶ The Stage dimensions are set for NTSC D1 video at 720 x 534 (square) pixels.

 ▶ The frame rate is set to 30 fps.

 ▶ The background color is not important. After Effects imports SWF files with their alpha channel preserved.

2. The root Timeline consists of one animated graphic symbol that occupies the first 15 frames. Scrub through the Timeline to see the animation. Double-click on the graphic symbol to open its Timeline (Figure 2.15).

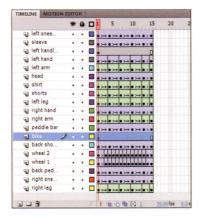

Figure 2.15: *The cyclist animation is made up of several layers.*

The looping animation consists of several layers of artwork. Classic tweens are applied to nested graphic symbols that only change in position over time. These include the head, sneakers, and bicycle wheels. The legs, arms, and shirt are vector shapes that morph over time. Shape tweens and shape hints are used to create the desired movement.

3. Return to the root Timeline by clicking on **Scene 1**. Why use a graphic symbol instead of a movie clip? Movie clips are the most popular type of symbol used in interactive projects. Unfortunately for this exercise, the movie clip is useless.

If you change the symbol type from a graphic to a movie clip and publish the SWF file it will play back correctly in the Flash Player. However, once imported into After Effects, the symbol will just sit there on its first frame and do nothing else. Avoid using movie clips when saving a web-based animation to video. Convert all existing movie clips to graphic symbols (Figure 2.16).

Figure 2.16: *Use graphic symbols instead of movie clip symbols when converting a Flash animation to video.*

Cycling

Forest

4. Test the movie to see the animation. An SWF file has already been published and saved to the **01_Footage** folder in the **01_SWF** folder inside **Chapter_02**. There is one other footage file you will use to complete this exercise. Double-click on **Forest.psd** inside the **Footage** folder to launch the file in Adobe Photoshop. This artwork will be used for the scrolling background.

 ► The image height is 534 pixels which matches the height of the Flash Stage. It is also the correct square pixel height to use for NTSC D1 video.

 ► To create a seamless scroll the image was duplicated and flipped horizontally so that the edges align (Figure 2.17).

Figure 2.17: *Duplicate and flip the image horizontally to create a seamless image.*

5. Launch **Adobe After Effects**. It opens an empty project by default.

6. Import the footage files. Double-click inside the Project panel. This opens the Import File dialog box. Locate the **01_Footage** folder inside the **01_SWF** folder you copied to your hard drive. Select the folder. Click on **Import Folder**.

Figure 2.18: *Import the* **01_Footage** *folder into the Project panel.*

7. Deselect the **01_Footage** folder in the Project panel by clicking on the gray area under the footage. Click on the **New Folder** icon at the bottom of the Project panel. Rename the new folder **Comps**.

8. Select **Composition > New Composition**. Enter **BikeRide** as the Composition Name. Select **NTSC D1** from the Preset popup menu. Set the duration to **0:00:05:00**. Click **OK** to create the new composition.

9. Selecting a video preset in After Effects automatically configures the correct frame rate and pixel aspect ratio for the composition. The new composition has a frame rate of 29.97 fps and a PAR of 0.91. The SWF footage has a different frame rate of 30 fps. To conform its frame rate to match the composition's:

- ▶ Twirl open the **01_Footage** folder to reveal its contents in the Project panel. Single-click on the **Cycling.swf** footage to select it.

- ▶ Select **File > Interpret Footage > Main**.

- ▶ In the Frame Rate section, select **Conform to frame rate** and enter **29.97**.

- ▶ In the Other Options section, enter **10** for the number of loops (Figure 2.19).

- ▶ Click **OK**. Conforming the frame rate does not affect the original file, only the linked footage in the Project panel. After Effects changes the internal duration of frames but not the frame content.

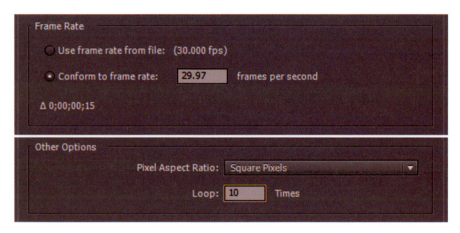

Figure 2.19: *The Interpret Footage dialog box allows you to conform frame rates.*

10. Click and drag the **01_Footage** folder from the Project panel to the left side of the Timeline. Release the mouse. Two layers appear in the Timeline and the Comp panel displays the artwork (Figure 2.20).

Figure 2.20: *Add the layers to the Timeline.*

11. The artwork is larger than the Comp panel. Remember that the footage was created using square pixels. To compensate for non-square pixels in video, you need to rescale the layers to fit the dimensions of the Comp panel. In the Timeline panel, deselect both layers by clicking on the gray area underneath.

12. Select only the **Cycling.swf** layer. Then select **Layer > Transform > Fit to Comp**. The width and height of the layer snap to the dimensions of the Comp panel. The bicycle wheels will look slightly flattened but will appear as circles on video.

Figure 2.21: *Round objects will appear stretched on the computer screen which is displaying only square pixels. On video, these shapes will appear normal.*

13. To see how the image will look on video click on the **Toggle Pixel Aspect Ratio Correction** button in the bottom right corner of the Comp panel (Figure 2.22). Click on the toggle button again to view in square pixels.

This function does not affect the final rendering, however, it does distort the layers displayed in the Comp panel. This distortion can produce unwanted jagged images. Turn this toggle button on only to preview the image. Turn it off while you are building the project to view the full antialiased images.

Figure 2.22: *The Toggle Pixel Aspect Ratio Correction button provides a preview of how the image will look in a non-square pixel aspect ratio.*

14. Click on the **RAM Preview** button. The cyclist is going nowhere. The final step is to create the scrolling background. Before you do that, save your project.

15. Let's focus on the background image. Only the height of the **Forest.psd** layer needs to conform to the height of the Comp panel. Select the **Forest.psd** layer. Then select **Layer > Transform > Fit to Comp Height**.

16. With the **Forest.psd** layer still highlighted in the Timeline, select **Effect > Distort > Offset**. The Offset filter in After Effects is similar to Offset in Photoshop. It pans the image within a layer. Visual information pushed off one side of the image appears on the opposite side.

17. Press the **Home** key on the keyboard. This moves the Current Time Indicator to the beginning of the composition (00:00).

18. Go to the Effect Controls panel. Click on the **stopwatch** icon next to **Shift Center To**. This generates a keyframe at the beginning of the composition.

19. Press the **End** key to move the CTI to the end of the Timeline (05:00).

20. Go to the Effect Controls panel. Change the first value to **6000** (Figure 2.23). The image's center point animates over time. Since the Photoshop file was designed to be seamless, the end result is a continuous scrolling background.

Figure 2.23: *Shift the horizontal center of the image to create the scrolling movement.*

21. Before you render the composition, let's make sure that the colors will display properly in NTSC video. Select **Layer > New > Adjustment Layer**.

22. Select **Effect > Color Correction > Broadcast Colors**. The effect is applied to all layers through the adjustment layer. It alters the pixel color values to keep the composition's color space within the range allowed for broadcast video.

Figure 2.24: *Apply the Broadcast Colors effect to an adjustment layer to keep the composition's color space within the color range allowed for NTSC and PAL video.*

23. Click on the **RAM Preview** button. Save your project.

24. Select **Composition > Make Movie**. This opens the Render Queue.

25. Click on **Lossless** next to Output Module. Set the Format to **QuickTime** movie. Click on **Format Options** and set the compression setting to **MPEG-4 Video**. Click on **Output To** and select the **Chapter_02** folder on your hard drive as the final destination for the rendered movie.

26. Click the **Render** button. This completes the exercise. An important concept to remember is to *use graphic symbols* instead of movie clips when publishing Flash SWF files for After Effects. Also, the Offset effect is a quick way to create scrolling background images.

Using the QuickTime Exporter for HD Content

Exporting SWF files for After Effects is quite simple as long as you remember to keep your artwork as vector shapes or stored in graphic symbols. What happens if the animation is driven by ActionScript? Welcome to the QuickTime Exporter.

The QuickTime Exporter in Flash allows you to save your movies as a QuickTime, Windows AVI, or an image sequence. There are two methods by which you can export your Flash file. The first method renders on a frame-by-frame basis all content placed directly on the Flash Timeline. The second option allows you to export dynamic content over a period of time. This includes ActionScript-driven animation that uses movie clips. Let's explore each method in detail.

This exercise provides a step-by-step tutorial on using the QuickTime Exporter to save content on the Timeline to a fixed-frame video format. Two scenes of an animation will be exported for use in HD at 1280 x 720 and 29.97 frames per second. The artwork has been prepared using graphic symbols and shapes.

scene_01

scene_02

Figure 2.25: *It is better to break scenes from a large Flash animation into separate FLA files. Use After Effects to edit the exported clips back together into one movie.*

1. Open the **02_QuickTimeExporter** folder inside the **Chapter_02** folder. When creating animation for video, save each scene as a separate Flash FLA file. Even though Flash can store multiple scenes in one large movie, having smaller individual files provides easier editing capabilities in After Effects. It also reduces the risk of file corruption that could occur using longer timelines (Figure 2.25).

2. Double-click on **scene_01.fla** to open the file in Flash. The top layer labeled **SAFE AREA** contains the Title Safe and Action Safe guides for HD video at 1280 x 720. All titles and text are framed within the Title Safe area. Notice that it is a guide layer. It is visible in the Flash FLA file but will not be included in the exported movie (Figure 2.26).

Figure 2.26: *The title is contained within the Title Safe area.*

 *Title Safe and Action Safe templates are provided in the **Chapter_02** folder for you to use in your projects. Simply copy the frame and paste it into your file.*

3. Unlike the previous exercise, the artwork in this Flash file uses only NTSC video safe colors. The default color swatches were replaced with the NTSC color palette provided by *www.animonger.com* (Figure 2.27).

4. Select **File > Export > Export Movie**. This opens the Export Movie dialog box. Select the **02_QuickTimeExporter** folder inside the **Chapter_02** folder on your hard drive as the final destination for the rendered movie. Make sure the file format is set to QuickTime. Click **Save**.

Figure 2.27: *Only NTSC video safe colors were used to create the artwork.*

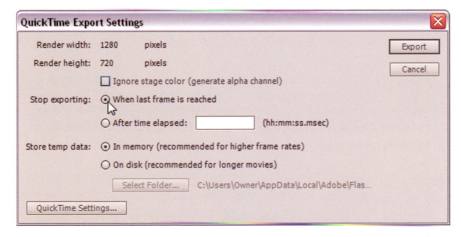

Figure 2.28: *QuickTime Export Settings provides several options to choose from.*

5. The QuickTime Export Settings dialog box appears (Figure 2.28). Make sure the width and height are set to 1280 and 720 respectively. The Stop Exporting area

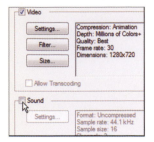

Figure 2.29: *Turn off the Sound export. Audio can be added later in After Effects.*

provides the two exporting methods mentioned at the beginning of this exercise. Since this Flash movie is a frame-by-frame animation, you want to stop exporting when the last frame is reached. Click on **QuickTime Settings**.

6. The Movie Settings dialog box allows you to adjust the video and audio settings. There is no audio in this file. Turn off the audio export by unchecking the checkbox next to Sound (Figure 2.29).

7. Click on the **Settings** button under the Video area. This opens the Standard Video Compression Settings dialog box (Figure 2.30). Here you can adjust the compression settings. Animation compression works well for Flash movies. Leave the frame rate at 30 fps. You will conform it to 29.97 in After Effects. Click **OK** to close the dialog box.

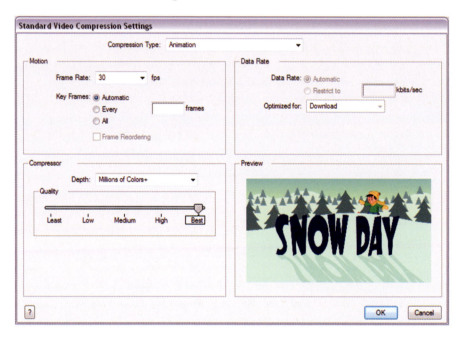

Figure 2.30: *The QuickTime Exporter allows you to control the video compression.*

8. Click on the **Size** button and change the Dimensions to **1280 x 720 HD** to guarantee the correct HD aspect ratio (Figure 2.31). Click **OK** twice to return to the QuickTime Export Settings dialog box.

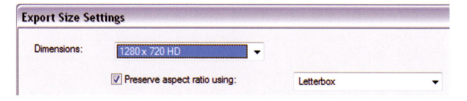

Figure 2.31: *Set the dimensions to match the correct HD aspect ratio.*

9. Quit out of all other applications so only Flash is open. Click **Export**. The QuickTime Exporter captures every frame as an SWF movie in the background to create the QuickTime movie. This can take a few minutes.

10. A dialog box will appear when the QuickTime movie is complete. Click **OK**.

11. Open **scene_02.fla**. This animation is set up similar to **scene_01**. Repeat the previous steps to export the file as a QuickTime movie. Once you've finished creating both QuickTime movies, it is time to import them into After Effects.

12. Launch **Adobe After Effects**. Import the two QuickTime movies into the Project panel. If the Interpret Footage dialog box appears, click on Ignore Alpha (Figure 2.32). Chapter 4 covers alpha channels in detail.

scene_01

scene_02

Figure 2.32: *The QuickTime movie does not need an alpha channel. Select Ignore.*

13. Conform the frame rate of both QuickTime footage files to 29.97 fps. To do this, select the footage item. Select **File > Interpret Footage > Main**. In the Frame Rate section, select **Conform to frame rate** and enter **29.97**. Click **OK**.

14. Deselect any selected footage items in the Project panel. Click on the **New Folder** icon at the bottom of the Project panel. Rename it **Comps**.

15. Select **Composition > New Composition**. Enter **SnowDay** as the Composition Name. Select **HD/HDTV 720 29.97** from the Preset popup menu. Set the duration to **0:00:11:00**. Click **OK** to create the new composition.

16. Click and drag both QuickTime footage files to the Timeline (Figure 2.33). Flash and HD video both use square pixels. The rendered QuickTime movies match the composition's dimensions perfectly so you do not need to scale them to fit.

Figure 2.33: *Add the layers to the Timeline.*

Figure 2.34: *Align the layers to play back one after the other.*

17. In the Timeline, click and drag **scene_02.mov's** colored bar. Align its starting point to the end point of **scene_01.mov's** colored bar (Figure 2.34).

18. The last step is to add some snow to the layer. Where this would require either ActionScript or a lot of layers in Flash, After Effects has an effect that automatically generates snowflakes. Make sure the **scene_02.mov** layer is selected.

19. Select **Effect > Simulation > CC Snow**. The effect adds falling snow to the animation (Figure 2.35). You can control the amount of snow, its size, and rate of descent in the Effect Controls panel.

Figure 2.35: *The CC Snow effect automatically generates falling snow on a layer.*

20. After Effects has the Title Safe and Action Safe guides built into the Comp panel. To make them visible, click on the **Grid & Guides** button at the bottom left of the Comp panel. Select **Title/Action Safe** from the popup menu. The guidelines appear in the Comp panel.

21. Select **Composition > Make Movie**.

22. Click on **Lossless** next to Output Module. Set the Format to **QuickTime** movie. Click on **Format Options** and set the compression setting to **H.264**.

Chapter 2: From Flash to After Effects

23. Click the **Render** button. Save your project. As you can see, rendering frame-based animation using the QuickTime Exporter in Flash is fairly straightforward. Let's take a look at rendering ActionScript-driven Flash movies to video.

Exporting ActionScript-driven Movies

Flash also allows you to export content over a period of time to a QuickTime file format. You define the amount of time and the QuickTime Exporter records the movement on the Stage whether it is frame-by-frame or ActionScript driven. This is ideal for Flash programmers who want to export their dynamically driven movies to video.

This final exercise provides a step-by-step tutorial on exporting an ActionScript-driven animation using the QuickTime Exporter. To see an example, locate and play the **SpaceWars.mov** in the **Completed** folder inside the **03_ActionScript** folder (Figure 2.36). When you finish this exercise you will be able to export movie clips controlled by ActionScript to a video format.

Figure 2.36: *The finished QuickTime movie file uses ActionScript-driven content.*

1. Let's first deconstruct the Flash code. Open the **03_ActionScript** folder inside the **Chapter_02** folder. Here is the breakdown of the files you will look at:

- ▶ **RocketshipCode.fla** is the Flash document that stores the retro rocketship movie clip in its Library.
- ▶ **rocketDocumentClass.as** is the Document Class that duplicates the ships and defines their initial position and speed.
- ▶ **AnimateShip.as** is an ActionScript file that positions and moves each ship.

2. Double-click on **RocketshipCode.fla** to open the file in Flash. The Stage is set to a customized size of 640 x 320 pixels. There is nothing on the Stage or in the Timeline. The Library stores the rocketship movie clip.

3. Select **Control > Test Movie** to preview the animation. Each time you test the movie, you will see six rocketships fly across the Stage at random speeds.

RocketshipCode

4. Close the SWF file and return to Flash. Go to the Properties panel. Notice that the Document Class field contains **rocketDocumentClass**. This is the link to a separate ActionScript file that will set up the animation for this Flash document.

Figure 2.37: *Link to the Document Class file in the Properties panel.*

rocketDocumentClass

5. Select **File > Open**. Choose **rocketDocumentClass.as** in the **03_ActionScript** folder. Click **Open**. The code duplicates the rocketship six times using a for loop. Each time through the loop a new movie clip object (AnimateShip) is created.

```
public function rocketDocumentClass() {
        for(var i:uint=0; i < 6; i++) {
            var ship:AnimateShip = new AnimateShip(Math.random()*640 - 700,
                            Math.random()*200 + 60, Math.random()*10 + 5);
            addChild(ship);
        }
    }
```

For each new object, a random horizontal and vertical position is created based on the dimensions of the Stage. It also generates a random speed value. These three random numbers are passed as parameters to the **AnimateShip.as** file. The last line of code (addChild) draws the movie clip instance on the Stage.

6. Select **File > Open**. Choose **AnimateShip.as** in the **03_ActionScript** folder. Click **Open**. This code is linked to the movie clip in RocketshipCode.fla through the Linkage Properties panel in the Library (Figure 2.38).

AnimateShip

Linkage

☑ Export for ActionScript
☑ Export in frame 1

Identifier:

Class: AnimateShip ✓ ✏

Base Class: ✓ ✏

Figure 2.38: *Link to the ActionScript file in the Linkage Properties panel.*

7. Each time the Document Class creates an object, this AS file is attached to the new rocketship. Remember, this code is linked to the movie clip. The Action-Script basically tells the ship where to go and how to move across the Stage based on certain parameters sent by the Document Class.

```
public class AnimateShip extends MovieClip {
    // define variable to hold positive speed
    private var speedX:uint;
    // create constructor
    public function AnimateShip(x,y,dx) {
        // set scale, location, and speed
        this.scaleX = this.scaleY = .4;
        this.x = x;
        this.y = y;
        speedX = dx;
        // move the ship to the left each frame
        this.addEventListener(Event.ENTER_FRAME, moveShip);
    }
    // move according to speed set in DocumentClass
    public function moveShip(event:Event) {
        // move the ship to the left
        this.x += speedX;
    }
}
```

The code first creates a variable called **speedX**. This will be used to move the ship horizontally across the Stage. The Class Constructor is defined and the parameters from the Document Class are stored in **x**, **y**, and **dx**. The first two parameters are used to position the ship. The rocketship's scale is set to 40%.

An Event Listener "listens" for the playback head entering the frame. It calls an Event Handler that moves the ship. Since this file is continuously entering the same frame, this function is called repeatedly, creating the movement. The rate at which the ship animates is based on the value stored in **dx**.

8. Return to the **RocketshipCode.fla** file. Select **File > Export > Export Movie**. This opens the Export Movie dialog box. Select the **03_ActionScript** folder inside the **Chapter_02** folder on your hard drive as the final destination for the rendered movie. Make sure the file format is set to QuickTime. Click **Save**.

9. The QuickTime Export Settings dialog box appears. Make sure the width and height are set to 640 and 320 respectively.

 ► Check the checkbox to **Ignore Stage Color**. An alpha channel will be generated to use in After Effects.

 ► In the Stop Exporting area select **After Time Elapsed** and enter **00:00:10**. Flash will record activity on the Stage for 10 seconds (Figure 2.39). This method includes movie clips in the captured frames.

 ► Click on **QuickTime Settings**.

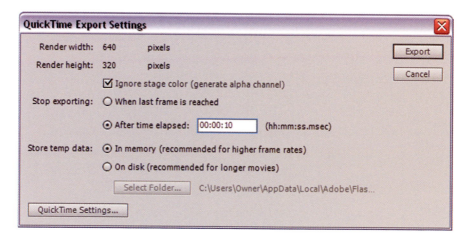

Figure 2.39: To export ActionScript-driven content, select After Time Elapsed and enter a value. Flash will record any activity on the Stage for the time entered.

10. Click on the **Size** button under the Video area. This opens the Export Size Settings dialog box (Figure 2.40).

 ► Choose **Custom** from the Dimensions drop-down menu.

 ► Set the width and height to **640** and **320** respectively.

 ► Click **OK** twice to return to the QuickTime Export Settings dialog box.

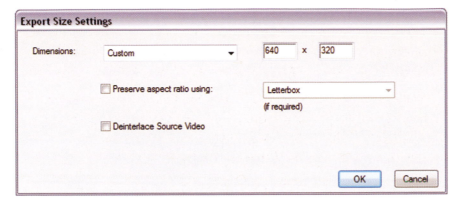

Export Size Settings			
Dimensions:	Custom ▾	640	x 320
	☐ Preserve aspect ratio using:	Letterbox ▾	
		(if required)	
	☐ Deinterlace Source Video		
		OK	Cancel

Figure 2.40: *Make sure the Export Size matches the Stage dimensions.*

11. Quit out of all other applications so only Flash is running. Click **Export**. A dialog box will appear when the QuickTime movie is complete. Click **OK**.

12. Go to the **03_ActionScript** folder on your hard drive where you will find the QuickTime movie. Launch the QuickTime movie in the QuickTime player. The ability to export ActionScript-driven content is a great improvement for Flash and opens the door wider in creating content for After Effects (Figure 2.41).

RocketshipCode

Figure 2.41: *The QuickTime Exporter recorded the code-driven animation.*

13. To see how this Flash animation was used to create the Space Wars title sequence, open **SpaceWars.aep** in the **Completed** folder.

14. The Project panel contains the exported QuickTime movie as a footage item. Other footage includes two audio files, a sound effect and background music. A starfield was created in Photoshop. The title was created in Illustrator as a vector shape so that it can be scaled without losing detail (Figure 2.42).

15. Let's deconstruct how the final composition was created. It was set to the same duration and frame rate as the **RocketshipCode.mov** file. All of the footage items were added to the composition as layers:

 ▶ The **space.tif** layer's height is slightly larger than the composition's. Two Position keyframes animate in a downward movement, like a camera pan.

SpaceWars

Figure 2.42: *The Project panel contains all the footage files used.*

- ► The **RocketshipCode.mov** layer has no effects or keyframes applied. The alpha channel generated by the QuickTime Exporter makes compositing easy to do in After Effects. The layer reveals the starfield underneath it.

- ► The **SpaceWarsTitle.ai** layer contains the vector art. The Scale property is reduced from 4000% to 100%. An important note worth mentioning is the **Continuously Rasterize** switch that is available for all vector layers in the Timeline (Figure 2.43). Activate this switch to maintain the smooth detail in the vector artwork as the layer scales larger than its original size.

Figure 2.43: *The Continuously Rasterize button is used on vector layers to maintain their smoothness and detail as the layer is scaled larger than its original size.*

16. At the eight-second mark (08:00) the title "Space Wars" begins to fade off the screen using a combination of scale, reducing opacity, and an applied effect. The effect used is located at **Effect > Generate > CC Light Burst 2.5**. It simulates rays of light emanating from the layer. To create the "warp speed" effect, two

Figure 2.44: *The CC Light Burst 2.5 effect was applied to the title layer to produce the blurred special effect.*

keyframes were set for the Ray Length value. The value was increased from 0 to 500 in the Effect Controls panel (Figure 2.44).

17. A solid layer was created to hold a laser beam that shoots out of a rocketship (Figure 2.45). To create the lasers, the Beam effect was used. This is located at **Effect > Generate > Beam**. This simple effect is used quite frequently to produce amateur light saber duels that you see online.

Figure 2.45: *The Beam effect was applied to a solid layer to create the laser beams.*

In the Effect Controls panel, the beam's starting and ending points were set at the left edge and right edge of the solid layer. Keyframes were set for the Time property. Its value changes from 0 to 100, creating the movement of the beam. This solid layer was then duplicated six times and repositioned in the Timeline. A couple of layers were moved in the Comp panel to align the beam to the laser cannon at the end of the rocketship.

18. The audio files were added to the Timeline as separate layers (Figure 2.46). An audio layer can be positioned anywhere within the stack of layers. A good practice to adopt is to either position all the audio at the top or at the bottom of the layers to keep them out of the way while you work.

The sound effect, **Laser.mp3**, was duplicated six times and aligned to sync up with the animation. The background music spans the entire duration of the composition. The last step was rendering the final output.

Figure 2.46: *Audio was added last in the Timeline.*

SpaceWars
24,505 KB

SpaceWars
733 KB

19. The composition was rendered as a QuickTime movie and a Flash Video (FLV) file. Both files were rendered at the same size and frame rate. Notice the file size difference between the two formats. The FLV file was linked through the FLVPlayback video component in **SpaceWars.fla**. You can see the final results by double-clicking on the published file—**SpaceWars.swf**.

Summary

This completes the chapter. Some key concepts to remember include:

► Frame aspect ratio is the relationship between the width and height of an image. There are two common video aspect ratios: 4:3 and 16:9.

► Computers use square pixels and video does not. To compensate for this, adjust the dimensions of your square pixel art to properly display on video.

► Frame rate is the speed at which video plays back its frames. NTSC uses a frame rate of 29.97 fps. PAL and SECAM use 25 fps. Film is 24 fps.

► Computer screens use a progressive scan while television uses an interlaced scan. The interlaced scan is broken up into two fields of scan lines and can affect the display of thin lines and small text.

► Title Safe and Action Safe guides solve the problem of television overscan.

► When publishing an SWF file for After Effects, use graphic symbols and vector shapes. Movie clips within the SWF will not display properly in After Effects.

► To export movie clips to After Effects, use the QuickTime Exporter. It will export content on the Flash Stage over a set timespan to video.

CHAPTER 3

From After Effects to Flash

There are different techniques used for exporting movies from After Effects to Flash. This chapter explores each method, and when and why you should use After Effects to create Flash content.

© 2010 Elsevier, Inc. All rights reserved.
doi: 10.1016/B978-0-240-81351-6.50003-3

Working with Vector and Raster Images

File size plays an important role when designing web-based content. Flash is a great web tool for producing animation and interactive projects with small file sizes. After Effects is the preferred choice for motion graphics, but it renders rather large video files. How can these two applications be integrated and still maintain a respectable file size for web delivery?

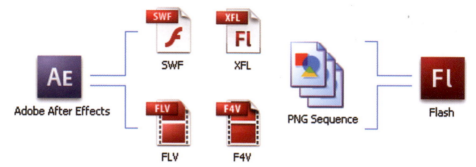

Figure 3.1: *After Effects can export files to Flash SWF, XFL, PNG Image Sequences, and Flash Video (F4V and FLV) files. These files are then imported into Flash.*

After Effects can export compositions as Flash Video files (F4V or FLV formats), editable layered Flash XFL files, and published SWF files. The exported SWF file will play back immediately in the Flash Player or it can be imported into another Flash project. XFL files can be opened in Flash as editable FLA files (Figure 3.1).

Flash publishes SWF files that are typically composed of vector graphics. Although After Effects can import and display vector art, it is pixel-oriented. When a composition is exported as an SWF file, After Effects tries to retain the vector art as much as possible. Some content may be rasterized which will generate a larger file size. So what does After Effects export as vectors?

Text is vector-based in After Effects. Static text layers and basic text animation export as vector objects. However, if the text layer is converted into a 3D layer, or an adjustment layer is applied, or any type of motion blur is used, the layer will be exported as a raster image (Figure 3.2).

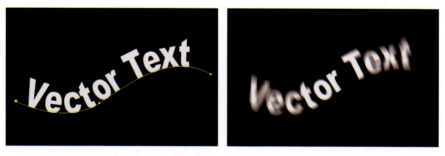

Figure 3.2: *Basic text layers and animation (left image) will export as vector objects. Once a motion blur has been applied (right image), the layer exports as a raster image.*

Adobe Illustrator files imported into After Effects will export as vector objects. The Illustrator artwork needs to contain only solid strokes and fills using either RGB or CMYK color spaces. Any gradient fills will cause the layer to be exported as a raster image (Figure 3.3).

Figure 3.3: *Imported Adobe Illustrator files with solid strokes and fills (left) will export as vector objects. If gradients are used (right), the artwork exports as a raster image.*

Solid layers that have a mask applied to them will render out as vector objects. Masks in After Effects work similar to masks in Flash. There are also three effects that export as vectors for use in Flash: Path Text, Audio Waveform, and Audio Spectrum. What happens to the rest of the layers when After Effects exports an SWF file?

If After Effects encounters something it can't export as a vector object, it will do one of two things. Which one depends on what you select in the SWF Settings dialog box. The first option rasterizes at full quality any object that can't be exported as vector art. This results in a larger file size. The second option ignores any unsupported layer or effect. This is the default setting. It ensures that only vector objects end up in the exported SWF file. This option is the best to use when you only want vector-based art (Figure 3.4).

Figure 3.4: *After Effects allows you to choose how to export unsupported features to a Flash SWF file.*

Exported XFL files and Flash Video contain only rasterized images, not vector art. The XFL file opens as a layered FLA file in Flash and can be published as an SWF file. Flash Video files can be output directly from the Render Queue in After Effects. Render settings allow you to specify size, compression, and other output options. The F4V or FLV files can then be imported into Flash.

Flash Video files can be imported into Flash using ActionScript or the Flash FLV Playback component. Components provide additional control of the visual interface that surrounds the imported video. You can also add graphic layers on top of the FLV Playback component for composite effects.

An alternative to saving a composition as an SWF file and Flash Video is to export it as an image sequence. After Effects renders each image file with a numerically sequential naming convention. Upon importing the first image, Flash recognizes the naming convention and prompts you to import the entire sequence (Figure 3.5). Image sequences should be imported into a movie clip or graphic symbol. This allows for more flexibility in your Flash project.

Figure 3.5: *After Effects can also export image sequences. It uses a sequential naming convention that Flash recognizes and allows you to import the entire sequence.*

Both applications include many tools that allow you to easily composite graphics and video. The previous chapter discussed how to save Flash content to After Effects. File size was not a concern since the final output was video. The exercises in this chapter focus on exporting After Effects content to Flash, with an emphasis on maintaining a respectable file size for web delivery.

Exporting SWF Files

Let's start by exporting compositions in After Effects to Flash SWF files. The goal is to export only vector objects to maintain a small file size. After Effects provides effects and animation presets that go beyond the capabilities that Flash provides. It can be a real production time saver. The first exercise illustrates this by creating a complex text animation in After Effects using only one effect.

Exercise 1: Export Text Animation as a Flash SWF

Text animation is rather difficult to do and time consuming in Flash. Each letter in the animation needs to be either ActionScript-driven or keyframed by hand in the Timeline. Either way, creating a complex text animation can be a real nightmare to a Flash designer. Here comes After Effects to the rescue!

 *Download (http://booksite.focalpress.com/companion/jackson) the **Chapter_03.zip** file to your hard drive. It contains all the files needed to complete the exercises.*

After Effects provides many text animation presets that can be applied in one step. To see the text animation you will build, locate and play the **Vertigo.swf** file in the **Completed** folder inside the **01_SWF** folder in **Chapter_03** (Figure 3.6). When you finish this exercise you will be able to use the Text Tool in After Effects to set up a text animation. You will export it as vectors for use in Flash.

Figure 3.6: *Title sequence uses text animation created in After Effects.*

1. Launch **Adobe After Effects**. It opens an empty project by default.

2. Select **Composition > New Composition**. You need to make the composition the same size as the Flash Stage you will be importing the text animation into. Make the following settings:

 ▸ Composition Name: **VertigoText**
 ▸ Width: **550**
 ▸ Height: **400**
 ▸ Pixel Aspect Ratio: **Square Pixels**
 ▸ Frame Rate: **15**
 ▸ Duration: **0:00:03:00**

 Click **OK**. The new composition opens with a black screen in the Comp panel. The Timeline opens a tab.

3. Click on the **Type** Tool ⊤ at the top left of the screen. Go to the Comp panel and click inside to start typing. Type "Vertigo". A text layer is automatically created in the composition and appears in the Timeline.

4. This can be any font or size that you want. Use the Character panel that opens by default when a text layer is created (Figure 3.7).

Figure 3.7: *The Type Tool automatically generates a text layer and opens the Character panel that allows you to change the font, size, leading, etc.*

5. With the text layer still highlighted, select **Window > Paragraph**. In the Paragraph panel, select the **Center text** option for the text alignment (Figure 3.8).

6. A new feature in After Effects CS5 is the ability to align layers to the composition itself. Prior to CS5, you could only align selected layers to each other. To use this new feature in After Effects CS5, select **Window > Align**.

 ▶ Select **Composition** from the **Align Layers to** options (Figure 3.8).
 ▶ Click on the horizontal and vertical center alignment buttons.

NEW
IN
CS5

Figure 3.8: *Use the Paragraph panel to set the text's alignment. The Align panel in After Effects CS5 allows you to align the text layer to the composition itself.*

Chapter 3: From After Effects to Flash

7. Click on the **Effects & Presets** tab to the left of the Character tab. This brings that panel forward. Twirl open the **Animation Presets** folder. Twirl open the **Text** folder. This contains all the different preset folders of text animation. Twirl open the **Animate In** folder and select **Center Spiral**. This effect rotates in each letter from the center of the text layer to form the word.

8. To apply the preset, click and drag the effect from the Effects & Presets panel to the text in the Comp panel. A red marquee box appears indicating the selected layer. Release the mouse and you will notice that the text disappears. This is because the text is at the beginning stage of the animation preset.

9. Click on the **RAM Preview** button. The letters spiral in to form the word "Vertigo" (Figure 3.9). That was easy. Imagine trying to keyframe the spiral movement by hand in Flash. Save your project.

Figure 3.9: *The text presets create complex text animation quickly and easily. When creating text, make sure you do not apply a stroke to it. This adds complexity to the animation and will increase the file size of the exported SWF file.*

Wouldn't it be nice to see a preview of each text animation preset before you applied it? You can. Go to the Effects & Presets panel and click on the menu arrow ▤ in the top right corner. Select **Browse Presets** from the popup menu. This opens Adobe Bridge. Double-click on the **Text** folder. Open any **Preset** folder and single-click on the effect you want to see. A preview of how the effect works appears in the Preview panel on the right side (Figure 3.10).

Figure 3.10: *Adobe Bridge allows you to preview all preset effects before you apply.*

10. Press the **Home** key on the keyboard. This moves the Current Time Indicator to the beginning of the composition (00:00).

11. Select the **VERTIGO** text layer and press **S** on the keyboard to open the Scale property. Click on the **stopwatch** icon next to Scale to generate a keyframe.

 ▶ Scrub through the numeric value and set it to **50%**.

Figure 3.11: *Scrub through the Scale value and set it to 50%.*

12. Move the Current Time Indicator to where the text stops rotating (02:08).

13. Scrub through the Scale numeric value and set the text layer back to **100%**. A keyframe is automatically generated. Now the text will slowly scale up from 50% to 100% as it spirals in.

14. Click on the **RAM Preview** button. Save your project. It is time to export the composition as a Flash SWF file.

15. Select **File > Export > Adobe Flash Player (SWF)**. This opens the Save File As dialog box. Save the SWF file to the **01_SWF** folder in **Chapter_03**.

16. The SWF Settings dialog box appears. This is where you set up how the SWF will be exported. In the Images area, set After Effects to **Ignore Unsupported Features**. Anything that After Effects can't export as a vector object will be ignored and will not show up in the final SWF file. Since text in After Effects is vector-based, you don't need to worry about missing any letters.

Figure 3.12: *Set After Effects to ignore unsupported features when exporting vectors.*

17. There is no audio so leave that unchecked. Leave the rest of the settings as the default (unchecked). Click **OK**. After Effects creates a Flash SWF file.

18. Let's move to Flash. Double-click on **Vertigo.fla** in the **01_SWF** folder to open the file in Flash. It contains two layers: **spiralAnimation** and **eye**. The spiral animation is a movie clip that contains a spiral graphic symbol that rotates counter-clockwise creating a vortex tunnel effect (Figure 3.13).

Vertigo

Figure 3.13: *The Flash file contains two layers. The animation consists of a movie clip that contains a spiral graphic rotating counter-clockwise.*

19. Select **Insert > New Symbol**. Enter **mcTextAnimation** for the name and make sure that the type is set to Movie Clip. Click **OK**.

20. The Timeline for the new movie clip appears. Highlight the first blank keyframe and select **File > Import > Import to Stage** to open the Import dialog box. Choose the SWF file you created in After Effects (Figure 3.14). Click **Open**.

Figure 3.14: *Import the SWF file created in After Effects into a movie clip in Flash.*

21. When the SWF file is imported into the movie clip, it appears as a series of keyframes. Scrub through the Timeline to see the animation. Go to the Library. There is a graphic symbol for each letter in the text animation. Double-click on a graphic symbol and you will see that the letter form is a vector shape.

Figure 3.15: *The imported SWF file appears as a series of keyframes in the Timeline and each letter appears as a graphic symbol in the Library.*

22. Let's add to this animation. First, insert a frame (F5) at frame 85 (Figure 3.16). This will hold the text on the screen long enough to read it.

Figure 3.16: *Insert a frame (F5) at frame 85. This will extend the text's time on the screen to allow the viewer to read it.*

23. Next, create a spiral-out sequence using the exact same keyframes just in reverse order (Figure 3.17). To do this:

 ▸ Select the keyframes from frames 1 to 45.
 ▸ Select **Edit > Timeline > Copy Frames**.
 ▸ Click on the empty cell at frame 86. Select **Edit > Timeline > Paste Frames**.
 ▸ Highlight the pasted keyframes. Select **Modify > Timeline > Reverse Frames**.

Figure 3.17: *Create a spiral-out sequence by copying and pasting the frames at the end of the Timeline. Then reverse the frame sequence.*

24. Close out of the movie clip and return to the root Timeline. Click on the **New Layer** icon at the bottom of the Timeline panel. Rename the layer **text**.

25. Click and drag the **mcTextAnimation** symbol from the Library to the Stage.

26. Go to the Properties panel and set the X and Y position to **0** (Figure 3.18). This aligns the registration point to the upper left corner of the Stage. Since the composition in After Effects was set to the same dimensions as the Flash Stage, the text will be positioned in the center of the Flash movie.

Figure 3.18: *Set the X and Y positions to 0 to center the text on the Stage.*

Vertigo
Flash Movie
8 KB

VertigoText
Flash Movie
9 KB

27. Save and publish your movie. The text spirals in and then out. You may want to add a "stop" action on the last frame of the text movie clip.

Note that the final file size for the SWF file is around 8 KB. That is even smaller than the text animation SWF file exported from After Effects (9 KB). Flash provides better compression than After Effects when exporting SWF files.

Exercise 2: Export Illustrator Artwork as a Flash SWF

Let's export one more SWF file from After Effects. For this exercise, you will use footage created in Adobe Illustrator to export a Flash SWF web banner. The Illustrator file contains four layers and a bitmap image. The final SWF banner ad file will contain both the vector and raster art.

1. Create a new project in **Adobe After Effects**.

2. Import the footage file. Double-click inside the Project panel. This opens the **Import File** dialog box. Locate the **SpringBanner.ai** file inside the **01_Footage** folder in **01_SWF/Chapter_03**. Select the file (Figure 3.19).

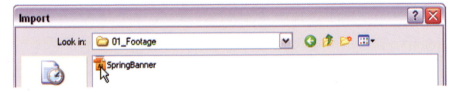

Figure 3.19: *Import the Adobe Illustrator file into the Project panel.*

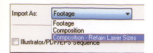

3. Before you import, choose **Composition – Retain Layer Sizes** (CS5) as the Import type in the Import dialog box. For CS4 users, import as **Composition – Cropped Layers**. Each layer will import with their original dimensions. Click **OK**.

4. Double-click on the **SpringBanner** composition in the Project panel to open it in the Timeline and Comp panels.

5. Select **Composition > Composition Settings**. Make sure the duration of the composition is set to five seconds (05:00). Click **OK**.

6. If you added more time to the original duration, click on the **Zoom out** button at the bottom of the Timeline to view the entire composition (Figure 3.20).

Figure 3.20: *Zoom out to view the entire composition's Timeline.*

7. Each layer's colored bar needs to extend to the end of the Timeline. Retrim the Out Point for each layer by clicking and dragging it to the end (Figure 3.21).

Figure 3.21: *Retrim each layer's Out Point to the end of the Timeline.*

8. Let's animate the ladybug. Go to the Comp panel and click and drag the ladybug to the lower left side of the Comp panel. This will be the starting point for its animation (Figure 3.22).

Figure 3.22: *Reposition the ladybug to the bottom left corner in the Comp panel.*

9. Turn on the **Continuously Rasterize** switch for all the layers in the Timeline to maintain the smooth detail in the vector artwork (Figure 3.23).

Figure 3.23: *Turn on the Continuously Rasterize switch for all the layers in the Timeline.*

Motion Sketch

In addition to manually setting keyframes, After Effects provides a Motion Sketch Tool that records a motion path as you draw in the Comp panel.

10. Select **Window > Motion Sketch**. This opens the Motion Sketch panel in the bottom right corner of the Workspace.

11. Set the Smoothing to **10**. This reduces the number of keyframes recorded and produces a much smoother motion path. The higher the number, the smoother the motion. Don't set this value too high or the tool will not accurately preserve the motion path drawn. Ten is a good number to start with.

12. Make sure both checkboxes are checked for **Show Wireframe** and **Show Background**. This makes the drawing much easier to do, as you can see the layers you are working with (Figure 3.24).

Figure 3.24: *The Motion Sketch settings control the smoothness of the motion path.*

13. Click on **Start Capture** to activate the tool. It doesn't start recording keyframes until you click and drag a layer in the Comp panel.

14. The goal of this animation is to have the ladybug animate over the title and end at the top of the "i" in the word Spring. Click and drag the ladybug in the Comp panel. The Motion Sketch Tool records the keyframes as you move the cursor. Release the mouse button to stop the tool from recording.

Figure 3.25: *The Motion Sketch records keyframes for the motion path drawn.*

15. Let's orient the ladybug to follow the path. Select **Layer > Transform > Auto-Orient**. In the Auto-Orientation dialog box, select the option **Orient Along Path** (Figure 3.26). Click **OK**.

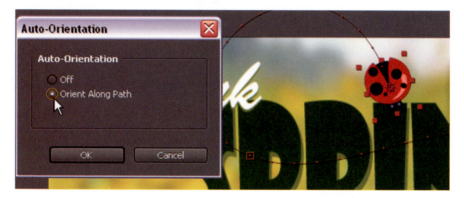

Figure 3.26: *Orient the ladybug to follow along the path.*

16. You can adjust the recorded motion path in the Comp panel and Timeline panel. Select the layer in the Timeline and press **P** on the keyboard to open the Position property. The recorded keyframes appear in the Timeline section.

Figure 3.27: *Open the Position property in the Timeline to view the recorded keyframes.*

17. Click on the **RAM Preview** button. Save your project. Now that the animation is done, it is time to export the web banner. As you saw in the first exercise, you can publish the composition as a Flash SWF file without using Flash at all.

18. Select **File > Export > Adobe Flash Player (SWF)**. This opens the Save File As dialog box. Save the SWF file to the **01_SWF** folder in **Chapter_03**.

19. Even though the footage is an Adobe Illustrator file, the background layer is a bitmap image. The SWF Settings dialog box appears. In the Images area, set After Effects to **Rasterize Unsupported Features**. All the other layers will export as vectors (Figure 3.28).

Figure 3.28: *Set After Effects to rasterize unsupported features.*

20. Click **OK**. Locate the exported Flash SWF file. Its file size is a respectable 42 KB. Notice that After Effects also saves a report HTML file (**SpringLogoR.html**) within the same folder as the Flash SWF file. This file contains a link to the Flash SWF file and allows you to play the file in a browser window (Figure 3.29).

One workflow drawback to exporting SWF files from After Effcts is that the rendered file is not editable. If you need to make any revisions to the SWF file, you need to go back to the original project file in After Effects. Can you export editable Flash files from After Effects? The answer is yes, as an XFL file format.

SpringBannerR

SpringBanner

Figure 3.29: *The report HTML file that allows you to play the animation in a browser.*

Exporting Flash Professional XFL Files

A feature introduced in After Effects CS4 is the ability to export a composition from After Effects as an XFL file format that Flash can open and edit. Why would you want to do this? For example, you can use ActionScript in Flash to add interactivity to an animation created in an After Effects composition.

The XFL file opens in Flash as an FLA file retaining as much of the Timeline from After Effects as possible. What does that mean? Unlike exporting SWF files, vector art is not preserved. The layers are rendered to a bitmap format (an FLV file or a sequence of PNG images). Layers that contain audio are not exported.

Layers affected by an adjustment layer in After Effects are merged together in the XFL file. Other layers that are rasterized together include 3D layers and layers that are composited together with blending modes and track mattes. Let's export the previous exercise as an XFL file to see the workflow.

1. Use the previous completed exercise, or open **SpringBanner_XFL.aep** inside the **02_XFL** folder in **Chapter_03**.

2. Make sure the **SpringBanner** composition is open. Select **File > Export > Adobe Flash Professional (XFL)**. This opens the XFL Settings dialog box (Figure 3.30).

Figure 3.30: *Export the composition as an XFL file.*

3. Enable the **Rasterize to** option. Select **PNG Sequence** from the menu options.

Figure 3.31: *Rasterize the layers to a PNG Sequence.*

4. Click **OK**. Since the compostiion contains a simple animation, a PNG Sequence is a good choice to use to rasterize the art. If the composition contained video, the FLV option would be the best choice.

5. Open the **SpringBanner.xfl** file in Adobe Flash Professional. The file contains four layers in the Timeline. Each layer has been converted into a movie clip in the Library. The PNG sequences are stored in separate folders (Figure 3.32).

Figure 3.32: *The XFL file retains the Timeline from After Effects. Each layer has been converted into a movie clip.*

6. A motion tween is applied to each layer. Let's animate the **Text** layer fading in. To do this you need to lock the **LadyBug** layer in Flash's Timeline.

7. Select the keyframe on **Frame 1** of the **Text** layer. Go to the Properties panel and set the **Alpha** property to **0** under the Color Effect options (Figure 3.33).

8. Scrub forward to **Frame 60** in the Flash Timeline.

Figure 3.33: *Change the Alpha property of the text to 0 in the Properties panel.*

9. Go to the Properties panel and set the **Alpha** property to **100** under the Color Effect options (Figure 3.34).

Figure 3.34: *Change the Alpha property of the text to 100 in the Properties panel.*

10. Select **Control > Test Movie** to see the edit (Figure 3.35).

Figure 3.35: *Save and test your movie to see the edit.*

Let's review some key concepts from this exercise. When you export an XFL file, After Effects attempts to retain as much information as it can for you to edit in Flash. Individual layers and basic transform keyframes are exported with no issues. All layers are rendered as bitmaps, either as a PNG or FLV file.

The ability to edit exported compositions from After Effects in Flash can be a real time-saver. Remember that vector art is not supported when exporting XFL files and the results are larger file sizes in Flash. Figure 3.36 compares the file sizes between two Flash SWF files. Notice the size difference in using the same composition with the two different workflows.

Figure 3.36: *File size comparison.*

Rendering PNG Image Sequences

An alternative to exporting an SWF or XFL file is to render a PNG image sequence. The raster images can then be imported into Flash as a frame-based animation. Even though the compression is quite good in a PNG file, the image size and the duration of the image sequence needs to be taken into consideration.

This exercise provides a step-by-step tutorial on rendering a PNG sequence from After Effects to Flash. The rendered PNG sequence will be imported into a Flash game. To see an example of the finished Flash game, launch the **MeteorBlast.swf** file in the **Completed** folder inside the **03_PNG** folder in **Chapter_03**. Blast the falling meteors out of the sky (Figure 3.37).

Figure 3.37: *The Flash game integrates a PNG sequence rendered from After Effects.*

Explosion

1. Open **Explosion.aep** inside the **03_PNG** folder in **Chapter_03**.

2. Double-click on the **Explosion** composition. It contains two layers of stock footage, courtesy of Artbeats. The top layer is a high-contrast grayscale video

copy of the bottom RGB explosion footage. You will use a track matte to create an alpha channel for this visual effect. A track matte is used to create transparency in one layer using another layer's alpha or luminance values.

3. To set up the track matte, you need to open the Modes column in the Timeline panel. If it is not already visible, you can right-click on the **Layer Name** column header and select **Columns > Modes**.

4. Select the bottom layer, **RE222.mov**. Click on the popup menu under **TrkMat** and select **Luma Matte "RE222M.mov"** to apply the track matte (Figure 3.38). Two layers are required to set up a track matte. One layer acts as the matte that creates a hole. The second layer fills the hole with content. The layer stacking order is important. Track mattes can only be applied to the layer directly beneath it. For multiple layers, group them (precompose) inside a composition and apply a track matte to the composition.

Figure 3.38: *Apply a track matte to the bottom layer through the Modes column.*

5. In the Comp panel, click on the **Toggle Transparency Grid** button ▦ to see the explosion on a transparent background (Figure 3.39). The luminance matte uses pixel values to create transparency. The high-contrast matte contains black areas that become completely transparent and white areas that turn opaque. Intermediate shades appear with a certain degree of transparency.

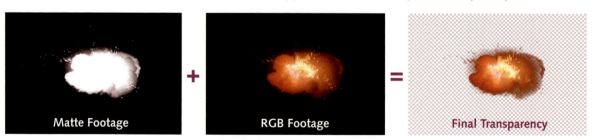

Figure 3.39: *Anatomy of a luminance track matte.*

6. Before you render the composition, crop the Comp panel to help reduce the file size for the PNG sequence. Click on the **Region of Interest** button ▣ at the bottom of the Comp panel.

7. Click and drag in the Comp panel to create a smaller region of interest. Scrub through the Timeline to make sure the explosion remains inside the area. Use the corner handles to resize the region if necessary (Figure 3.40).

Chapter 3: From After Effects to Flash

Figure 3.40: *Reduce the region of interest. This also helps improve the RAM preview.*

8. Select **Composition > Crop Comp to Region of Interest**. The size of the Comp panel is reduced to the dimensions of the region of interest bounding box.

9. Select **Composition > Make Movie**. This opens the Render Queue.

10. Click on **Best Settings** to open the Render Settings dialog box. Change the Resolution from Full to **Third** (Figure 3.41). In the Frame Rate area, set **use this frame rate** to **15** frames per second. These changes help reduce the final Flash file size by scaling down the dimensions of each PNG image and the number of images rendered from After Effects.

Figure 3.41: *Render the composition a third of its size.*

11. Click on **Lossless** next to Output Module. Set the Format to **PNG Sequence**. Under the Video Output section, set the channels to **RGB + Alpha**.

Figure 3.42: *Set the PNG files to render with an alpha channel.*

12. Click on **Output To**. In the dialog box that appears create a new folder in the **03_PNG** folder in **Chapter_03**. Name it **PNG Sequence**. Click **Open**. Click **Save**. It is always a good idea to store image sequences in their own folder.

Figure 3.43: *Create a new folder to save the PNG files into.*

13. Click the **Render** button. Save your project.

14. Locate the **PNG Sequence** folder. It now contains over 30 PNG files, each with a sequentially numbered file name. These files will be imported into a movie clip in the Flash game.

Figure 3.44: *The rendered PNG image sequence contains sequentially numbered file names that Flash can recognize.*

15. Before you import the PNG sequence into Flash, you can delete a couple of the PNG files that do not contain any pixel information. Select **Explosion_0000** and **Explosion_0024** through **Explosion_0032.** Delete the selected files or remove them from this folder.

16. Let's move to Flash. Double-click on **MeteorBlast.fla** in the **03_PNG** folder to open the file in Flash. It contains all the game assets minus the explosion visual effect. You will import the PNG sequence.

Flash games can be rather complex in terms of ActionScript. This game uses several ActionScript files that are linked to the main Flash FLA file. Let's first deconstruct the Flash code components. Here is the breakdown of the files:

- **MeteorBlast.fla** is the Flash document that stores all the game assets in its Library.

02_MeteorBlast

- **MeteorAttackClass.as** is the Document Class that initializes the game. It controls when to drop a meteor, shooting a missile, collision detection, and updating the dynamic text fields.

MeteorAttackClass

- **Cannon.as** is an ActionScript file that rotates the cannon.

- **Meteor.as** is an ActionScript file that controls placement and movement of each meteor on the Stage.

Cannon

- **Missile.as** is an ActionScript file that controls the rotation and movement of the missiles.

17. In the Flash file, go to the Library and double-click on the Meteor movie clip to open its Timeline. It contains five layers. Select the blank keyframe in **Frame 2** of the **explosion** layer (Figure 3.45).

Meteor

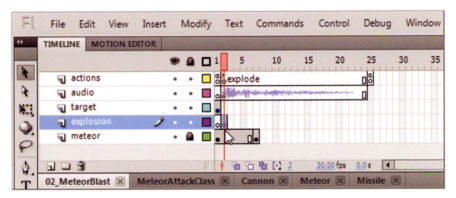

Missile

Figure 3.45: *Select the blank keyframe in Frame 2 inside the Meteor movie clip.*

18. Select **File > Import > Import to Stage** to open the Import dialog box. Choose the first image in the PNG sequence (**Explosion_00001**). Click **Open**.

19. Flash recognizes the file naming convention as a sequence and prompts you to import the entire sequence (Figure 3.46). Click **Yes**.

Figure 3.46: *Flash prompts you to import the entire image sequence.*

20. The PNG image sequence appears as a series of keyframes in the movie clip. Scrub through the Timeline to see the animation. Go to the Library. There is a bitmap icon for each image in the sequence.

21. Convert each bitmap image into a graphic symbol. By doing this, Flash will only store the bitmap images once in the final published file.

22. Organize the Library better. Create two new folders; one folder holds the imported PNG sequence and the other holds the graphic symbols.

23. Select **Control > Test Movie**. When a missile hits the meteor it explodes using the footage rendered out of After Effects. This adds a little bit of realism to the game. After the last PNG file is displayed on the Flash Stage, the meteor movie clip is removed. Here is the code that is triggering the explosion. The collision detection is located in the **MeteorAttackClass.as** file. Save your file.

```
// check for collisions
    if (missiles[missileNum].hitTestObject(myMeteor.target_mc)) {
            meteors[meteorNum].meteorHit();
            missiles[missileNum].deleteMissile();
            shotsHit++;
            showGameScore();
            break;
            }
        }
    }
```

There is a small movie clip with an instance name of **target_mc** inside each meteor. The code loops through all the missiles and meteors currently on the Flash Stage and checks to see if any missiles are touching any targets. If that happens, the Document Class calls a public function (meteorHit) inside the **Meteor.as** file that plays the imported PNG sequence (gotoAndPlay("explode")).

```
// meteor is hit by missile, show the explosion
    public function meteorHit() {
        removeEventListener(Event.ENTER_FRAME, moveMeteor);
        MovieClip(parent).removeMeteor(this);
        gotoAndPlay("explode");
    }
```

In this exercise you learned about track mattes and how they can define transparency in layers. They use values from either a layer's alpha channel or the luminance of its pixels. When a track matte is applied to a layer, After Effects converts the next layer above into a track matte. It turns off the video switch for the matte layer, and adds a track matte icon next to its name.

Rendering PNG sequences should be used for small visual effects in Flash, such as the explosion in this exercise or to enhance buttons. The rendered PNG image sequence adds about 100 KB to the Flash game. In some cases, embedding an FLV file can produce the same visual results, but with a smaller file size. In the next exercise you will export a composition as a Flash F4V file and learn how to import the Flash Video file into Flash.

Rendering Flash Video (F4V and FLV)

Flash Video is everywhere on the web. It provides great image quality and compression. After Effects can encode a video into two formats supported by Flash: F4V and FLV. The F4V video format uses the H.264 video codec which provides a higher quality-to-bitrate ratio, however, it is more computationally demanding than the Sorenson Spark and On2 VP6 video codecs used for the FLV video format. Table 3.1 offers a comparison between the two codecs.

Table 3.1: *What Is the Difference between F4V and FLV?*

F4V Video Format	FLV Video Format
H.264 codec (used for MPEG-4 video)	Sorenson Spark or On2 VP6 video codec
AAC audio codec	MP3 audio codec
Requires Flash Player 9.2 and higher	Requires Flash Player 7 and higher
Can not be embedded in a Flash file	Can be embedded in a Flash file
Does not support alpha channels	Suports alpha channels (On2 VP6 only)
Does not support cue points to trigger synchronized events with video playback	Supports embedded cue points to trigger synchronized events with video playback
Better quality than an FLV but computationally demanding	High quality and less computationally demanding than the H.264 codecs

 One important factor to keep in mind is that F4V does not support alpha video channels. If you want to export the explosion video from the previous exercise with its alpha channel, you must render the composition as an FLV file with the On2 VP6 video codec. Only FLV files can be embedded within the Flash document.

Exercise 1: Exporting an F4V in After Effects

1. Open the **04_F4V** folder in the **Chapter_03** folder. Open **01_AEtoF4V.aep** in After Effects. The project file contains the completed composition from the first chapter plus an audio layer.

1. Make sure the **DeepBlue_F4V** comp is open in the Timeline panel.

2. Select **Composition > Add to Render Queue**. This opens the Render Queue. It is a new tab that sits on top of the Timeline panel.

3. Click on **Best Settings** to open the Render Settings dialog box. Change the Resolution from Full to **Half** (Figure 3.47).

Figure 3.47: *Render the composition half of its original size.*

4. Click on **Based on Lossless** next to Output Module. This opens the Output Module Settings dialog box. Change the format to **F4V** (Figure 3.48).

Figure 3.48: *Change the format to Adobe Flash Video.*

5. Enable the **Audio Output** to export by clicking on its checkbox. Click **OK**.

Figure 3.49: *Enable to audio to export from the composition.*

6. Click on **Output To** and make sure you are saving your F4V file in the **04_F4V** folder in the **Chapter_03** folder.

7. Click **Render**. Next you will import the F4V file into Flash (Figure 3.50)

Figure 3.50: *The rendered F4V file can be imported into Flash using an FLV Playback Component or through ActionScript.*

When you import a video into Flash, you have a couple of options to choose from. You can either embed the video directly on the Timeline or load it externally as a separate file. Keep in mind that only Flash Video (FLV) files can be embedded in the Flash document. Table 3.2 offers some suggestions.

Table 3.2: *Embed the FLV or Load It Externally?*

Video/Purpose	Embed	External
5 seconds or under with no audio	X	
Used to trace frames for rotoscope animation	X	
Used for interface interactivity (buttons, preloaders)	X	
Longer than 5 seconds with audio		X
Used for instructional training		X
Used in conjunction with cue points		X

Exercise 2: Import Video Wizard

There are also a couple of ways you can import video into Flash. Let's start by using the Import Video Wizard. This tool walks you through a series of screens to import the FLVPlayback component that contains a link to an F4V or FLV video file and controls that allow you to interact with the playback.

1. Launch **Adobe Flash Professional**. Create a new **ActionScript 3.0** document.

2. Select **File > Import > Import Video**. This opens the Import Video Wizard.

Figure 3.51: *Launch the Import Video Wizard.*

3. The wizard first asks you to locate the video file. Make sure **On Your Computer** is selected. Click **Browse** (Figure 3.52). In the Open dialog box, locate the **DeepBlue_F4V.f4v** inside the **04_F4V** folder. Select it. Click **Open**.

Figure 3.52: *Locate the video to import on your computer.*

4. Note the path name for the file appears in the File Path field. This is the link to the external F4V file. Make sure to organize your videos before importing them.

5. Select the **Load external video with playback component** option. This option allows you to stream video using HTTP streaming. Flash will link to the F4V file externally. That file needs to be uploaded to the server along with the SWF file. Click **Next** to continue.

6. The skin provides video controls such as play, stop, and seek. Select **SkinUnder-PlayStopSeekMuteVol.swf** from the Skin popup menu. Change the skin color to a dark blue (Figure 3.53). Notice that the skin is an SWF file. Flash will save a copy of this file to the same folder it published the final Flash SWF file to.

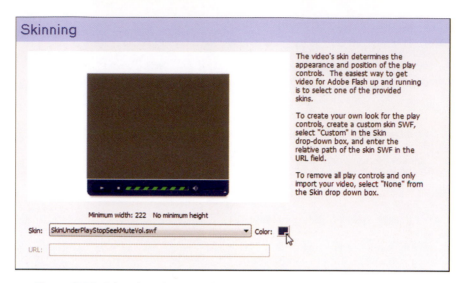

Figure 3.53: *Select the video controls. Flash refers to this as a Skin.*

7. Click **Next** to continue. Review the settings for the imported video file. Click **Finish** to import the video. Remember, the external F4V video file will need to be uploaded with the published SWF and skin SWF file to a web server.

8. When Flash is done importing the video, an FLVPlayback component appears. In Flash Professional CS5, you can preview the video live in the FLA file. Click the **Play** or drag the **Seek** button to watch the video directly in Flash.

> *For Flash Professional CS4 users, you will get a black box for the FLVPlayback video component. In order to view the video, you need to publish the Flash file.*

9. Select **Control > Test Movie**. Click on the FLVPlayback component controls.

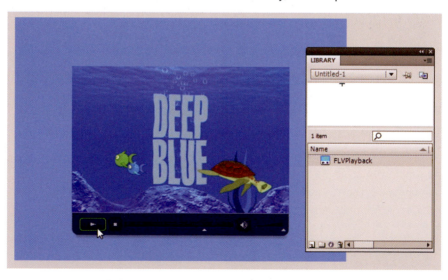

Figure 3.54: *Flash Professional CS5 provides live preview of the Flash Video inside the Flash document.*

Exercise 3: Loading Video Using ActionScript

ActionScript offers another way to load Flash Video. Similar to the Import Video Wizard, you must encode the video file in the F4V or FLV format using either After Effects or the Adobe Media Encoder prior to loading it with ActionScript.

Let's use the same F4V file from the previous exercise. Instead of using an FLVPlayback component, you will import the video file through ActionScript. The code that imports the F4V file follows a strict procedure that first connects to the F4V file and then streams its content into a Video object added to the Flash Stage (Figure 3.55).

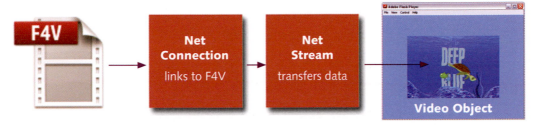

Figure 3.55: *Loading F4V/FLV files using ActionScript.*

1. Launch **Adobe Flash Professional**. Create a new **ActionScript 3.0** document.

2. On the main Timeline rename **Layer 1** to **actions**. Select the blank keyframe in **Frame 1** and open the Actions panel. Enter the following ActionScript.

```
// create a NetConnection
var nc:NetConnection = new NetConnection();
nc.connect(null);
// create a NetStream
var ns:NetStream = new NetStream(nc);
```

The first step is to create a **NetConnection** object. This object links, or provides directions, to the F4V file. **Null** is used for the connection name since you are accessing the F4V files locally from your hard drive. Finally, create a **NetStream** object to control the playback of the video. In order to stream the data correctly, the NetConnection is passed into the NetStream.

Flash Professional CS5 automatically imports the custom classes into your ActionScript. As you enter the code above, you will notice the NetConnection and NetStream classes are imported at the top of the Actions panel.

3. The Flash Player receives descriptive information embedded in the F4V file being played. This information is referred to as **metadata**. It could contain the title, author, comments, and so on. You need to set up an object that will listen for this metadata information. This object will be linked to the NetStream object since that is what is transferring the data into Flash.

Enter the following code in the Actions panel. Add it after the code you entered in Step 2. The code **ns.client** attaches the metadata object to the NetStream object. The metadata listener calls a function named **onMetaData**. This function will trace the duration of the video file.

```
// create a metaData listener
var metaDataListener:Object = new Object();
metaDataListener.onMetaData = function(meta:Object) {
    trace(meta.duration)  // display the length of the video
}
ns.client = metaDataListener
```

4. The next step is to create a **Video Display** object that will hold the loaded F4V file. The code creates a new object with a size of 360 x 240 pixels. The horizontal and vertical position is set to center the Video object on the Stage. Enter the following code:

```
// create a video display object
var myVidContainer:Video = new Video(360, 240);
// set the location of the video
myVidContainer.x = stage.stageWidth/2 - myVidContainer.width/2;
myVidContainer.y = stage.stageHeight/2 - myVidContainer.height/2;
// add the video to the Stage
addChild(myVidContainer);
// attach the NetStream to the video object
myVidContainer.attachNetStream(ns);
```

The statement, **addChild(myVidContainer)**, draws the object on the Stage. Finally, the NetStream object is attached to the Video object.

5. The last step is to tell Flash which video to play inside the Video object. The code **ns.play("DeepBlue_F4V.f4v")** plays the video in the Video object. Enter the following code.

```
// play the Flash Video file
ns.play("DeepBlue_F4V.f4v");
```

6. Select **Control > Test Movie** (Figure 3.56). The F4V video plays from start to finish. Notice that the skin controls inherent in the FLVPlayback component are missing. If you are importing your video files using ActionScript, you will need to create and code its controls. The next chapter focuses on that very topic.

The FLVPlayback component uses the NetStream as well. It just encapsulates all this coding logic into an easy-to-use component. The price for not having to code, of course, is file size. The FLVPlayback component adds roughly 60 KB

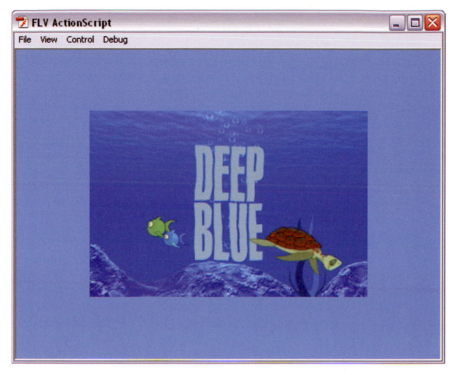

Figure 3.56: *Save and publish your Flash document.*

to the published SWF file. Figure 3.57 compares the file sizes between two Flash SWF files. Notice the size difference in using the same F4V file with the two different workflows. Anything that the component can do, you can also accomplish with the Video object and NetStream classes. ActionScript provides a lot more control over video that will be discussed in the next chapter.

Figure 3.57: *File size comparison.*

Summary

This completes the chapter. As you can see, there are several different options available to you when exporting After Effects files to Flash. No matter which option you choose, always optimize the image size and the video encoding to maintain a respectable file size for web delivery. Exporting vector art from After Effects creates small file sizes but does have its limitations. Rasterized content should be exported as either an image sequence or Flash Video.

When working with Flash Video you can either import the video into an FLV Playback component or stream the video into a Video Display object using ActionScript. Which is better? Using the FLVPlayback component can be quite useful and a big time-saver in most cases. It provides a lot of functionality with little or no coding effort on your part.

If there is a very strict requirement in terms of file size, creating the Video Display object is better than using components for a number of reasons. First, it creates a lower file size. Components tend to include extra features that you may never actually use. Secondly, if you want to make a video player with more customizable features than what the component includes, you can build them using ActionScript and in the process, learn more about programming.

CHAPTER 4

Interactive Video

Flash can take video to the next level through its interactive capabilities. ActionScript provides the tools to enhance the user experience. This chapter focuses on adding interactivity to your Flash Video.

© 2010 Elsevier, Inc. All rights reserved.
doi: 10.1016/B978-0-240-81351-6.50004-5

Interactivity in Flash

This chapter explores using ActionScript to add interactivity to your Flash Video. ActionScript is Flash's programming language. It allows you to create a variety of interactions from simple to complex.

ActionScript uses object-oriented programming (OOP). Objects are the types of data that Flash can store. Examples of objects include graphics, video, sound, and text. Objects belong to a larger group called a class. Examples of classes include the **MovieClip** class, **Sound** class, and **FLVPlayback** class.

Each object and class has a unique set of properties and methods that can be accessed through ActionScript. The previous chapter illustrated an easy way to import Flash Video using the FLVPlayback component. Table 4.1 highlights the methods associated with controlling the FLVPlayback component.

Table 4.1: *FLVPlayback Methods to Control Its Playback and Properties*

Method	Definition
play	Plays the video stream
pause	Pauses playing the video stream
stop	Stops the video from playing
seek	Seeks to a given time in the file
seekToNavCuePoint	Seeks to a navigation cue point that matches the specified time, name, or time and name
setScale	Sets the scaleX and scaleY properties simultaneously

The Main Event

Creating buttons to control video involve understanding how Flash processes events. Events can be external or internal. External events are the ways that the user interacts with the file. Examples of external events include: clicking with the mouse, moving the mouse, and pressing a key on the keyboard. The user does not have control over internal events. Internal events can be the playback marker leaving one frame to play the next or the completion of a video.

Flash uses an **Event Listener** to detect, or "listen" for specific events. Once the event is detected, an **Event Handler** creates a response to the action in Flash. Here is a simple event: a user clicks with the mouse on a button. This is an external event. If the button has an Event Listener called **CLICK** attached to it, it will detect the click. Flash responds to the user through an Event Handler that instructs the Flash Video to play, pause, or stop its playback.

Before you can add interactivity to video in Flash, you must first prepare the video for Flash delivery. Chapter 3 demonstrated how easy it is in After Effects to encode video into F4V and FLV formats. There are numerous other software

packages available to encode video for Flash. Adobe Media Encoder is a stand-alone video encoding application that ships with Adobe Flash Professional. In addition to encoding F4V and FLV files for the web, Adobe Media Encoder can also export video for devices ranging from DVD players, to mobile phones, to standard- and high-definition television. Let's take a closer look.

Using Adobe Media Encoder

Even though After Effects can easily render F4V and FLV files, it is not always the best choice for Flash Video. By default, Adobe Media Encoder encodes video for use with Flash using the F4V or FLV video format. It offers a lot of options to fine-tune the encoding process and often produces better results.

 Download (http://booksite.focalpress.com/companion/jackson) the **Chapter_04.zip** *file to your hard drive. It contains all the files needed to complete the exercises.*

The first exercise provides a step-by-step tutorial on using Adobe Media Encoder. To view the video you will encode, locate and play the **FlashAE_Ad.mov** inside the **01_MediaEncoder** folder (Figure 4.1). This QuickTime movie was rendered from After Effects. Very little compression was added to the 25-second movie and its file size is 165 MB. The encoded video files file will be around 2 MB.

Figure 4.1: *The QuickTime video that will be used in this exercise.*

1. Launch **Adobe Media Encoder**. To add source video clips to the list of files to encode, click **Add** (**File > Add**). You can also drag a file into the list.

2. Locate the **FlashAE_Ad.mov** file. Click **Open**.

Figure 4.2: *Adobe Media Encoder can import compositions from After Effects.*

3. In addition to adding QuickTime movies to the encoding list, you can also import After Effects Compositions. Click on the **File** menu to see the option (Figure 4.2). For this exercise, you will use the rendered QuickTime movie.

4. Adobe Media Encoder provides a list of presets for different delivery scenarios. Each preset automatically sets the appropriate encoding options for the video and audio. You can also customize these options. Click on the **Preset** menu arrow and select **Edit Export Settings** (Figure 4.3).

Figure 4.3: *Edit the export settings for the source QuickTime movie.*

Chapter 4: Interactive Video

5. The Export Settings panel opens. The panel is divided into four quadrants. The top-left area displays a preview of the video. The lower-left area allows you to trim and add cue points. The top-right area summarizes the export settings. The lower-right area provides options to customize the export settings for both video and audio. First, click on the **Format** tab and select **F4V** (Figure 4.4).

Figure 4.4: *Select a format to encode the video.*

6. Click on the **Video** tab. The video settings are divided into three sections: basic video settings, bit rate settings, and advanced settings. Let's focus on bit rate. Bit rate is the number of "bits per second" (bps) at which the data in a video is being delivered. Video can be encoded with a **constant bit rate (CBR)** or a **variable bit rate (VBR)**.

A constant bit rate (CBR) compresses each frame in the video to a fixed limit. A variable bit rate (VBR) compresses complex frames less and compresses simple frames more. A VBR file tends to have a higher image quality, because VBR tailors the amount of compression to the image content.

Change the **Bitrate Encoding** to **VBR, 2 Pass** (Figure 4.5). The encoder makes two passes through the file ensuring greater encoding efficiency and quality.

Figure 4.5: *Select the type of video encoding to be used.*

7. Click on the **Audio** tab. It is important to understand that the bit rate contains two tracks: a video track and an audio track. The total bit rate for a video file is the sum of the video and the audio bit rates. To reduce the overall file size, choose **Mono** instead of **Stereo** for the **Output Channels** options (Figure 4.6). You will not notice too much of an audio difference from the built-in speakers on your computer.

8. Change the **Bitrate Setting** to **96 kbps** (Figure 4.6). Click **OK** to close the settings.

Figure 4.6: *Select the type of audio encoding to be used.*

9. Let's also encode an FLV file from the source QuickTIme movie to compare it to the F4V format. Click on **Duplicate** to create a copy in the list (Figure 4.7).

Figure 4.7: *Duplicate the source file in the encoding list.*

10. Click on **Custom** under the **Preset** column. This will launch the Export Settings dialog box. Let's customize the encoding options for the FLV file.

 ▶ Click on the **Format** tab and select **FLV.**

 ▶ Click on the **Video** tab and select **VBR** for the **Bitrate Encoding**.

 ▶ Select **Two** for the video **Encoding Passes**.

 ▶ Set the video **Bitrate** setting to **300**. This is a good starting value for broadband web delivery using FLV files (Figure 4.8).

 ▶ Click on the **Audio** tab and select **Mono** for the **Output Channels**.

 ▶ Change the audio **Bitrate Setting** to **96** kbps.

 ▶ Click **OK** to close the Export Settings dialog box.

11. Click on **Start Queue**. Adobe Media Encoder starts encoding the first file in the video encoding list. While a file is being encoded, the Status column of the video encoding list provides information on the status of each video.

Chapter 4: Interactive Video

Figure 4.8: *Select the type of video encoding to be used for the FLV file.*

Completed files in the queue appear with a check mark in the Status column. They cannot be run through the queue again, but they can be duplicated to create a new item in the queue.

Figure 4.9: *Adobe Media Encoder displays the encoding progress.*

12. Locate the F4V/FLV encoded files. They are saved to the same folder as the source video files with an .flv or .f4v file type to identify them (Figure 4.10).

Figure 4.10: *The files are saved to the same folder as the source QuickTime video.*

13. To view both files, open them in Adobe Media Player (Figure 4.11).

Figure 4.11: *The final F4V and FLV files can be viewed in Adobe Media Player.*

14. Notice the subtle differences in image quality between the F4V and the FLV. As mentioned in Chapter 3, the F4V video format provides a higher quality-to-bitrate ratio than the FLV. See the comparison below in Figure 4.12.

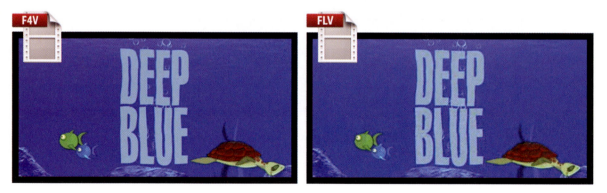

Figure 4.12: *Notice the visible compression in the FLV file.*

Now that the QuickTime video has been prepared for Flash delivery, it is time to import it and add some playback controls. Adding video to your Flash projects can be as easy as placing it within an FLVPlayback component on the Stage, or dynamically loading it using ActionScript. If you are a newcomer to ActionScript, you are in luck. Flash Professional CS5 has a new feature that makes coding a breeze and helps reduce the learning curve.

Chapter 4: Interactive Video

Using ActionScript Code Snippets

Flash Professional CS5 offers **Code Snippets** as part of its coding improvements and workflow enhancements. Code Snippets are reusable bits of code that you can apply to buttons and movie clips. The following exercise explores this new feature in Flash CS5 and demonstrates how to easily add interactivity to the encoded video you just created.

 Code Snippets are only available in Flash Professional CS5. The ActionScript that is generated is the same that you would use in Flash CS4. The only difference is that CS4 users need to enter the code manually.

1. Double-click on **02_FLV_CodeSnippets.fla** in the **02_CodeSnippets** folder to open the file in Flash. It contains four layers: **actions**, **video**, **buttons**, and **background**. Select the keyframe in **Frame 1** on the **video** layer (Figure 4.13).

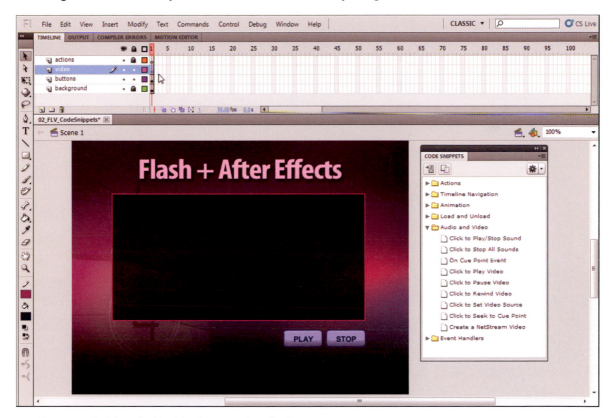

Figure 4.13: *Select the blank keyframe on the* **video** *layer.*

2. Select **File > Import > Import Video**. This opens the Import Video Wizard.

3. Make sure **On Your Computer** is selected. Click **Browse**. In the Open dialog box, locate the **FlashAE_Ad.f4v** inside the **02_CodeSnippets** folder. Select the Flash Video file or use the video you created. Click **Open**.

4. Select the **Load external video with playback component** option.

5. Click **Next** to continue. Since there are already buttons provided in the Flash document, select **None** from the Skin popup menu (Figure 4.14).

Figure 4.14: *Select no skin for the imported video.*

6. Click **Next** to continue. Review the settings for the imported video file. Click **Finish** to add the FLVPlayback component to the Stage.

7. Reposition the component on the Stage. Go to the Properties panel and enter **myVideo** for the instance name of the FLVPlayback component (Figure 4.15). This name will be referenced in the ActionScript to control the video playback.

Figure 4.15: *Reposition the FLVPlayback component and give it an instance name.*

Chapter 4: Interactive Video

8. Select the PLAY button on the Stage. Go to **Window > Code Snippets** to open its panel. The Code Snippets panel includes code for common features, such as timeline navigation, animation, audio, and video. To apply the code:

▶ Twirl open the **Audio and Video** folder (Figure 4.16).

▶ While the PLAY button is still selected, double-click on **Click to Play Video**.

Figure 4.16: *Double-click on the code snippet to apply the ActionScript.*

9. The Actions panel opens with the correct ActionScript in place. The code snippet includes helpful comments and clear instructions right in the code (Figure 4.17). Notice that the **play_btn** instance name is automatically added to the Event Listener. The listener is set up to "listen" for a mouse click.

```
ACTIONS - FRAME

 5  Instructions:
 6  1. Replace video_instance_name below with the instance name of the
    FLVPlayback component that you want to play the video.
 7     The specified instance of FLVPlayback video component on stage will
    play.
 8  2. Make sure you have assigned a video source file in the properties of
    the FLVPlayback component instance.
 9  */
10
11  play_btn.addEventListener(MouseEvent.CLICK, fl_ClickToPlayVideo);
12
13  function fl_ClickToPlayVideo(event:MouseEvent):void
14  {
15      // Replace video_instance_name with the instance name of the video
    component
16      video_instance_name.play();
17  }
18

actions : 1
```

Figure 4.17: *The code snippet includes helpful comments and instructions.*

10. The instructions state to replace **video_instance_name** with the instance name of the video component. Change the code in line 16 to **myVideo.play()**.

11. Select the STOP button on the Stage. Go to the Code Snippets panel and double-click on **Click to Pause Video** (Figure 4.18).

Figure 4.18: *Double-click on the code snippet to apply the ActionScript.*

12. The code snippet is added to the previous ActionScript in the Actions panel (Figure 4.19). Change the code in line 31 to **myVideo.pause()**.

```
25
26   stop_btn.addEventListener(MouseEvent.CLICK, fl_ClickToPauseVideo);
27
28   function fl_ClickToPauseVideo(event:MouseEvent):void
29   {
30       // Replace video_instance_name with the instance name of the video
     component
31 ⊟     myVideo.pause();
32   }
33
```

Figure 4.19: *Change the code to the correct instance name of the video component.*

13. Save the Flash file. Select **Control > Test Movie** (Figure 4.20).

Figure 4.20: *Easily add interactivity with ActionScript Code Snippets.*

Adding ActionScript Cue Points

In addition to ActionScript Code Snippets, Flash Professional CS5 provides an enhanced cue point workflow. A **cue point** is a point at which the video player dispatches an event while a video file plays. In CS5, you can scrub and preview video directly on the Stage and can now use the Property inspector to find and add cue points to the video.

1. Open **03_FLV_CuePoint.fla** file in the **03_CuePoints** folder in **Chapter_04**. An FLVPlayback component has already been imported to the Stage. Its instance name is **myVideo**. Its skin has been added in the Properties panel.

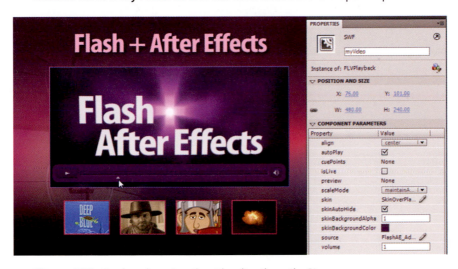

Figure 4.21: *Scrub and preview the video directly on the Stage.*

2. Click and drag the seek button in the FLVPlayback component to preview the video file. Stop the video at the beginning of the "Deep Blue" title sequence.

3. Go to the Properties panel and twirl open the **Cue Points** section. Click on the "**+**" icon to add a cue point. Rename it **DeepBlue**. You can also scrub through the time code to reassign the time for the cue point to occur (Figure 4.22).

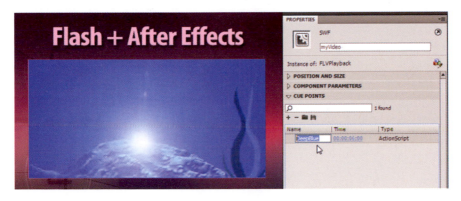

Figure 4.22: *Add an ActionScript cue point in the Properties panel.*

4. Click and drag the seek button to the beginning of the "Cowboy" video sequence. Go to the Properties panel and twirl open the **Cue Points** section. Click on the "**+**" icon to add a cue point. Rename it **Cowboy** (Figure 4.23).

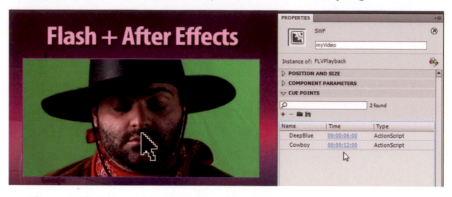

Figure 4.23: *Add an ActionScript cue point in the Properties panel.*

5. Click and drag the seek button to the beginning of the Roman soldiers video sequence. Go to the Properties panel and twirl open the **Cue Points** section. Click on the "**+**" icon to add a cue point. Rename it **Romans** (Figure 4.24).

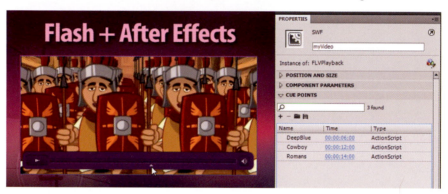

Figure 4.24: *Add an ActionScript cue point in the Properties panel.*

6. Click and drag the seek button to the beginning of the "Meteor Blast" video sequence. Go to the Properties panel and twirl open the **Cue Points** section. Click on the "**+**" icon to add a cue point. Rename it **Explosion** (Figure 4.25).

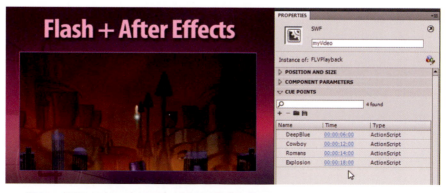

Figure 4.25: *Add an ActionScript cue point in the Properties panel.*

7. Now that the ActionScript cue points are in place, let's add the code to the buttons. Select the "Deep Blue" button on the Stage. Go to the Code Snippets panel and double-click on **Click to Seek to Cue Point** (Figure 4.26).

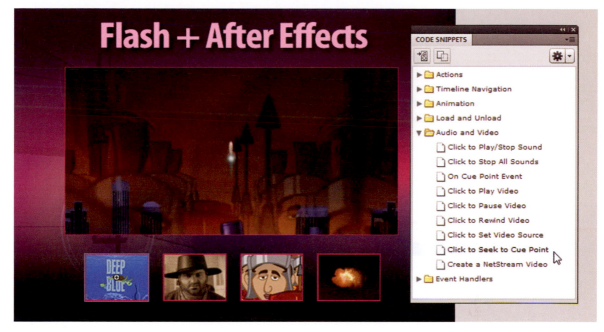

Figure 4.26: *Double-click on the code snippet to apply the ActionScript.*

8. The Actions panel opens with the ActionScript in place. Follow the instructions in the code. Replace **video_instance_name** with **myVideo**. Replace **"Cue Point 1"** with **"DeepBlue"** (Figure 4.27).

```
12  function fl_ClickToSeekToCuePoint(event:MouseEvent):void
13  {
14      // Replace video_instance_name with the instance name of the video component.
15      // Replace "Cue Point 1" with the name of the cue point to seek to.
16      var cuePointInstance:Object = myVideo.findCuePoint("DeepBlue");
17      myVideo.seek(cuePointInstance.time);
18  }
```

Figure 4.27: *Change the code to the correct instance name of the video component.*

9. Select the "Cowboy" button on the Stage. Go to the Code Snippets panel and double-click on **Click to Seek to Cue Point**. In the Actions panel replace **video_instance_name** with **myVideo**. Replace **"Cue Point 1"** with **"Cowboy"**.

```
30  function fl_ClickToSeekToCuePoint_2(event:MouseEvent):void
31  {
32      // Replace video_instance_name with the instance name of the video component.
33      // Replace "Cue Point 1" with the name of the cue point to seek to.
34      var cuePointInstance:Object = myVideo.findCuePoint("Cowboy");
35      myVideo.seek(cuePointInstance.time);
36  }
```

Figure 4.28: *Change the code to the correct instance name of the video component.*

10. Select the "Romans" button on the Stage. Go to the Code Snippets panel and double-click on **Click to Seek to Cue Point**. In the Actions panel replace **video_instance_name** with **myVideo**. Replace **"Cue Point 1"** with **"Romans"**.

```
48   function fl_ClickToSeekToCuePoint_3(event:MouseEvent):void
49   {
50       // Replace video_instance_name with the instance name of the video component.
51       // Replace "Cue Point 1" with the name of the cue point to seek to.
52       var cuePointInstance:Object = myVideo.findCuePoint("Romans");
53       myVideo.seek(cuePointInstance.time);
54   }
```

Figure 4.29: *Change the code to the correct instance name of the video component.*

11. Select the "Explosion" button on the Stage. Go to the Code Snippets panel and double-click on **Click to Seek to Cue Point**. In the Actions panel replace **video_instance_name** with **myVideo**. Replace **"Cue Point 1"** with **"Explosion"**.

```
66   function fl_ClickToSeekToCuePoint_4(event:MouseEvent):void
67   {
68       // Replace video_instance_name with the instance name of the video component.
69       // Replace "Cue Point 1" with the name of the cue point to seek to.
70       var cuePointInstance:Object = myVideo.findCuePoint("Explosion");
71       myVideo.seek(cuePointInstance.time);
72   }
```

Figure 4.30: *Change the code to the correct instance name of the video component.*

12. Save the Flash file. Select **Control > Test Movie**. Click on the buttons to jump to a specific cue point in the video (Figure 4.31).

Figure 4.31: *Easily add interactivity with ActionScript cue points.*

Creating Playback Controls in ActionScript

The FLVPlayback component, used in conjunction with Code Snippets and ActionScript cue points, can be quite useful and a big time-saver in building interactive video. The FLVPlayback component is a UI wrapper that uses a Video object internally. If you want to build a customized video player, ActionScript provides a Video object and the NetConnection and NetStream set of classes.

This exercise focuses on creating video playback controls using ActionScript. You will build a video player so that you can understand exactly how it is working. In addition, your published SWF file size will not be as bloated from the use of an FLVPlayback component. To see an example of the finished video player, launch the **04_VideoControls.swf** file in the **Completed** folder inside the **04_VideoControls** folder in **Chapter_04** (Figure 4.32).

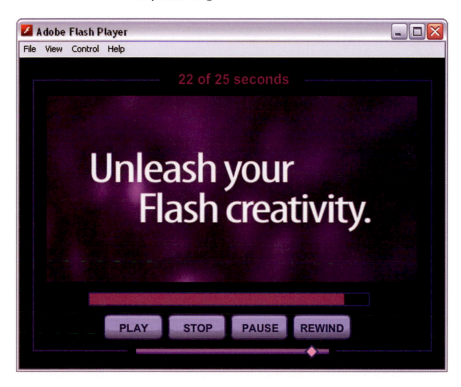

Figure 4.32: *The video player uses ActionScript instead of the FLVPlayback component.*

04_Video_Controls

1. Open **04_VideoControls.fla** file in the **04_VideoControls** folder in **Chapter_04**. The Flash document contains all the assets needed to build the video player. The buttons, progress bars, and dynamic text field have all been given unique instance names in the Properties panel.

 A Video object has been added to the Stage. This object was created in the Flash Library (Library menu > New Video). Its width and height is scaled to match the dimensions of the source video. It has an instance name of **myVidContainer**.

2. Select the blank keyframe in **Frame 1** of the **actions** layer. Open the Actions panel and enter the following ActionScript to create a NetConnection and NetStream object. The NetConnection object links, or provides directions, to the external video file. The NetStream object controls the playback of the video. In order to stream the data correctly, the NetConnection is passed into the NetStream.

```
// create a NetConnection
var nc:NetConnection = new NetConnection();
nc.connect(null);
// create a NetStream
var ns:NetStream = new NetStream(nc);
```

3. The Flash Player receives information embedded in the F4V file called **metadata**. You need to set up an object that will listen for this metadata information. This object will be linked to the NetStream object since that is what is transferring the data into Flash. The metadata will be stored in a variable called **nsDuration** —the duration of the video. Enter the following code:

```
// create a variable to store the video's duration
var nsDuration:Number
// create a metaData listener
var metaDataListener:Object = new Object();
metaDataListener.onMetaData = function(meta:Object){
    nsDuration = meta.duration;
    myVidContainer.addEventListener(Event.ENTER_FRAME, displayTime);
}
ns.client = metaDataListener;
```

4. Next, let's create some volume control for the video. The SoundTransform class contains properties for volume and panning. Its volume property is a numerical value ranging from 0 (silent) to 1 (full volume). Set the initial volume to 50% and attach it to the NetStream object. Enter the following code:

```
// create volume control for the video
var audioTransform:SoundTransform = new SoundTransform();
audioTransform.volume = .5;
ns.soundTransform = audioTransform;
```

5. Tell Flash which video to play inside the Video object. You need to attach the NetStream object to the Video object on the Stage. Enter the following code:

```
// tell Flash which video to play in the video object
myVidContainer.attachNetStream(ns);
ns.play("FlashAE_Ad.f4v");
```

6. In Step 3 you added an Event Listener to the Video object. This "listens" for an internal event and can be used to display the current time of the video as it plays back in the Video object. The data will be passed into the dynamic text field above the Video object. Enter the following Event Handler:

```
// create an Event Handler to update the dynamic text field
function displayTime(e:Event):void {
    var nPercent:Number = ns.time/nsDuration;
    if (nPercent >= 1) { nPercent = 1 };
    progressBar_mc.scaleX = nPercent;
    progress_txt.text = Math.floor(ns.time) +" of " + String(Math.
        floor(nsDuration)) + " seconds";
}
```

7. Save the Flash file. Select **Control > Test Movie**. The video loads into the Video object on the Stage and its metadata is passed into the dynamic text field. The progress bar above the buttons scales to visually represent the video playback.

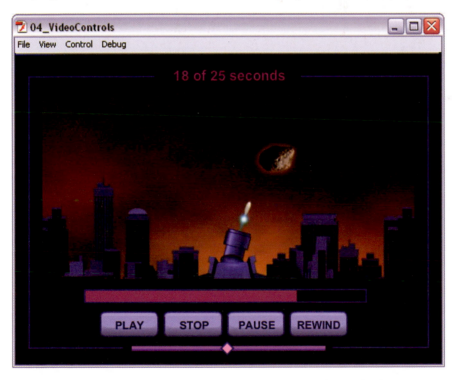

Figure 4.33: *The Video object passes the source video's metadata to the dynamic text field and also controls the scaling of the progress bar.*

8. So far, so good. Let's add the code for the buttons. Each button has a unique instance name and will receive its own Event Listener. The Event Listeners all call the same function (Event Handler). The Event Handler determines which button the user clicked and what method to apply to the NetStream object.

```
// add Event Listeners to the buttons
pause_btn.addEventListener(MouseEvent.CLICK, videoControl);
play_btn.addEventListener(MouseEvent.CLICK, videoControl);
stop_btn.addEventListener(MouseEvent.CLICK, videoControl);
rewind_btn.addEventListener(MouseEvent.CLICK, videoControl);

// add an Event Handler to respond to the buttons
function videoControl(e:MouseEvent):void {
    if (e.target.name == "pause_btn"){
        ns.pause();
    } else if (e.target.name == "play_btn"){
        ns.resume();
    } else if (e.target.name == "stop_btn"){
        ns.pause();
        ns.seek(0);
    } else if (e.target.name == "rewind_btn"){
        ns.seek(0);
    }
}
```

The **videoControl** Event Handler checks to see which button called the function based on its instance name. The methods that are applied to the NetStream object include the following:

▶ **pause()**—Pauses playback of a video stream

▶ **resume()**—Resumes playback of a video stream that is paused

▶ **seek()**—Seeks the keyframe closest to the specified location; a numeric value of 0 rewinds the video to the first frame

9. Save the Flash file. Select **Control > Test Movie**. Click on the buttons to control the video playback (Figure 4.34).

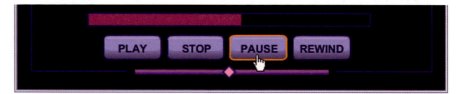

Figure 4.34: *The buttons call different methods that control the NetStream object.*

10. The last thing you need to code is the scrubber underneath the buttons. It is made up of two movie clips. The diamond shape movie clip has an instance name of **mySlider_mc**. The bar that the scrubber will be constrained to has an instance name of **bar_mc**.

Three Event Listeners are added to the scrubber movie clip. When the user clicks on it, the scrubber will be draggable. When the user releases the mouse, the scrubber stops dragging. The third listener constantly updates the Video object on the Stage depending on the scrubber's position in relation to the bar.

```
// create a variable that is either true or false
var videoPlaying:Boolean = true;

// position the scrubber movie clip relative to the bar movie clip
mySlider_mc.x = bar_mc.x;
mySlider_mc.y = bar_mc.y;
mySlider_mc.buttonMode = true;

// add the Event Listeners to the scrubber
mySlider_mc.addEventListener(MouseEvent.MOUSE_DOWN, moveSlider);
mySlider_mc.addEventListener(MouseEvent.MOUSE_UP, stopSlider);
mySlider_mc.addEventListener(Event.ENTER_FRAME, changeVideo);

// add the Event Handlers to respond to the listeners
function moveSlider(e:MouseEvent):void {
    var myBoundaries:Rectangle = new Rectangle(bar_mc.x, bar_mc.y, bar_mc.width, 0);
    e.target.startDrag(false, myBoundaries);
    ns.pause();
    videoPlaying = false;
    stage.addEventListener(MouseEvent.MOUSE_UP, stopSlider);
}
function stopSlider(e:MouseEvent):void {
    stopDrag();
    videoPlaying = true;
    ns.resume();
    stage.removeEventListener(MouseEvent.MOUSE_UP, stopSlider);
}
function changeVideo(e:Event):void {
    var ratio:Number = bar_mc.width/nsDuration;
    var barEnd:Number = bar_mc.x + bar_mc.width;
    if (videoPlaying){
        e.target.x = bar_mc.x + ns.time * ratio;
        if(e.target.x >= barEnd) { e.target.x = barEnd;};
    } else {
        ns.seek(Math.floor(((e.target.x - bar_mc.x)/(bar_mc.width)) * nsDuration));
    }
}
```

11. Save the Flash file. Select **Control > Test Movie**. Click and drag the scrubber to control the video playback (Figure 4.35). This completes the exercise. You now have a completed video player template. The last exercise in this chapter explores how to make a basic video gallery to load multiple external video files.

Figure 4.35: *The scrubber movie clip also controls the NetStream object.*

Building a Video Gallery

A Flash Video gallery can be a popular application to showcase one's personal video work. As a continuing exploration into interactivity and video, let's wrap this chapter up by building a couple of basic video galleries that you can use as a jumping-off point for your own work. To see an example of the first video gallery, launch the **05_VideoGallery.swf** file in the **Completed** folder inside the **05_Gallery** folder in **Chapter_04** (Figure 4.36).

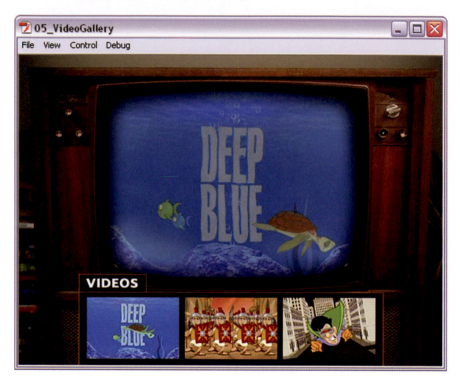

Figure 4.36: *The video gallery loads the external F4V files using ActionScript.*

Exercise 1: Loading Multiple Videos Using ActionScript

1. Open **05_VideoGallery.fla** located in the **05_Gallery** folder in **Chapter_04**. The project is already assembled using three layers: **buttons**, **TV**, and **Screen**.

05_VideoGallery

Figure 4.37: *The Flash document contains all the artwork you need.*

Let's deconstruct how the imagery was created in Photoshop. The photo of the vintage television set has a transparent hole where the actual picture tube is. Using the Pen Tool, the shape of the picture tube was traced, selected and deleted. The **Screen** layer holds a PNG image of reflective glass. Its opacity was set to 50% in Photoshop. The video will play underneath both layers giving the illusion of a television broadcast (Figure 4.38).

Figure 4.38: *The television set is made up of two PNG images. The imported video will play back underneath the two layers, adding to the illusion of a television broadcast.*

The **buttons** layer holds a movie clip instance. The panel artwork was created in Photoshop and imported as a PNG file. A button symbol was created in Flash and placed over each thumbnail image. Each button has a unique instance name that can be referenced through ActionScript. When the buttons are clicked, Flash will load a specific F4V file into a Video object (Figure 4.39).

Figure 4.39: *The buttons are invisible button symbols created in Flash. Each has a unique instance name that will load a specific FLV file when clicked on.*

The movie clip also contains an animation of the panel moving up and down. A mask layer is used to hide the panel when not in use. Frame labels are assigned to reference specific frames through code (Figure 4.40). For example, each time a thumbnail image is clicked, ActionScript instructs this movie clip to jump to the frame labeled "close" and play the frames that follow it.

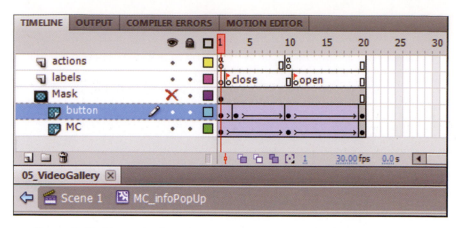

Figure 4.40: *The movie clip contains an animation. Frame labels are used to identify the movement of the video panel.*

Videos

Video1
Flash Video File

Video2
Flash Video File

Video3
Flash Video File

The videos are kept external from this Flash file. Locate the **Videos** folder inside the **05_Gallery** folder. It contains three F4V files that were rendered out of After Effects through the Render Queue. These files will be loaded externally into Flash using ActionScript. Now that you have an idea of how the Flash file is set up, let's start programming.

2. On the main Timeline add a new layer labeled **actions**. Select the blank keyframe in Frame 1 and open the Actions panel.

3. The first step is to create a NetConnection and NetStream object. In order to stream the data correctly, pass the NetConnection into the NetStream. Enter the following code:

```
// add NetConnection and NetStream object
var nc:NetConnection = new NetConnection();
nc.connect(null);
var ns:NetStream = new NetStream(nc);
```

4. Set up an object that will listen for the metadata information. This object will be linked to the NetStream object since that is what is transferring the data into Flash. Enter the following code in the Actions panel.

```
// add a metadata listener
var metaDataListener:Object = new Object();
metaDataListener.onMetaData = function(meta:Object){
    dropStatus = false;
    infoPop_mc.gotoAndPlay("close");
}
ns.client = metaDataListener
```

5. The next step is to create a Video Display object that will hold the loaded F4V file. The code creates a new object with a size of 360 x 240 pixels. The horizontal and vertical position is set to align the Video object with the television screen.

```
// create a Video Display object
var myVideo:Video = new Video(360, 240);
myVideo.x = 100;
myVideo.y = 46;
addChild(myVideo);
setChildIndex(myVideo, 0);
myVideo.attachNetStream(ns);
```

The statement, **addChild(myVideo)**, draws the object on the Flash Stage. To affect the layer stacking order, use the **setChildIndex** command. A value of **0** sets the object at the bottom, underneath all other layers. Finally, the NetStream object is attached to the Video object.

6. Once the NetConnection, NetStream, and Video objects are in place, define all variables and Event Listeners. The variable named **dropStatus** determines whether the video panel opens or closes on the Stage. The Event Listeners are attached to the buttons on the thumbnail images. Enter the following code:

```
// define popUp menu variable
var dropStatus:Boolean = true;

// add Event Listeners for buttons
infoPop_mc.popUp_btn.addEventListener(MouseEvent.CLICK, OpenOrClose);
infoPop_mc.info_mc.image1.addEventListener(MouseEvent.CLICK, playVideo1);
infoPop_mc.info_mc.image2.addEventListener(MouseEvent.CLICK, playVideo2);
infoPop_mc.info_mc.image3.addEventListener(MouseEvent.CLICK, playVideo3);
```

7. The last step is to add the Event Handlers. For this exercise you will add five handlers, one for each button Event Listener and a handler for the metaDataListener. The code **ns.play("FLV file name")** plays the video in the Video object. Enter the code below and on the following page.

```
// add Event Handlers to respond to the buttons
function OpenOrClose(e:MouseEvent):void {
   if (!dropStatus ) {
      dropStatus = true;
      infoPop_mc.gotoAndPlay("open");
   } else {
      dropStatus = false;
      infoPop_mc.gotoAndPlay("close");
   }
}
```

```
// add Event Handlers to respond to the buttons
function playVideo1(e:MouseEvent):void {
    ns.play ("Videos/Video1.f4v");
}
function playVideo2(e:MouseEvent):void {
    ns.play("Videos/Video2.f4v");
}
function playVideo3(e:MouseEvent):void {
    ns.play("Videos/Video3.f4v");
}
stop();
```

8. Select **Control > Test Movie**. Click on a thumbnail image to load a video. The next exercise will build on this concept of loading multiple video files. It will use an XML file as a playlist to load and play a sequence of separate video files using an FLVPlayback component.

Exercise 2: Playing a Video Sequence Using an XML File

1. Before you start coding in ActionScript, let's take a look at the XML file. Using Adobe Dreamweaver or a text editor, open **videoList.xml** in the **05_Gallery** folder in **Chapter_04**. XML stands for Extensible Markup Language and is designed to transport and store data (Figure 4.41).

videoList

```
1   <?xml version="1.0" encoding="utf-8"?>
2
3   <videoList>
4       <vid>
5           <file> Videos/Video1.f4v </file>
6           <name> Deep Blue Title Sequence </name>
7       </vid>
8
9       <vid>
10          <file> Videos/Video2.f4v </file>
11          <name> Romans Opening Title </name>
12      </vid>
13
14      <vid>
15          <file> Videos/Video3.f4v </file>
16          <name> Super Guy Animation </name>
17      </vid>
18
19  </videoList>
```

Figure 4.41: *XML is designed to transport and store data.*

XML uses a custom markup language for structuring sharable data. It is sort of like HTML, except you get to define your own tags. The root child of the XML document is **videoList**. It houses three separate children, each called **vid**. Each **vid** contains two child elements that reference the file path to the F4V file and a name. The **file** element will be used to load the video file into the FLVPlayback component. The **name** element will be added into a dynamic text field on the Flash Stage as the video plays.

2. Close the XML file. Open **06_VideoPlaylist.fla** located in the **05_Gallery** folder in **Chapter_04**. The project is already assembled using three layers: **text**, **FLVPlayback**, and **background**. The FLVPlayback component has already been set up with a skin and has an instance name of **videoPlayer** (Figure 4.42).

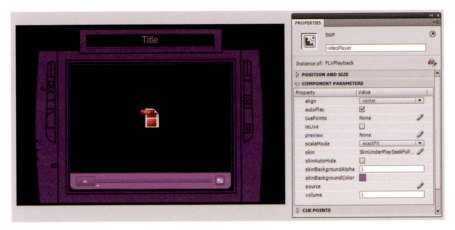

06_VideoPlaylist

Figure 4.42: *The FLVPlayback component is in position with an instance name.*

3. On the main Timeline add a new layer labeled **actions**. Select the blank keyframe in Frame 1 and open the Actions panel.

4. When using ActionScript in conjunction with the FLVPlayback component you first need to import the Flash Video package. A **package** contains a group of classes that provide functionality to Flash. Enter the following code:

```
// import Flash Video package
import fl.video.FLVPlayback;
import fl.video.VideoEvent;
```

5. The beauty of XML is that various programs including Flash can read it easily. Let's load the XML data into Flash. To do this, we need a few lines of code.

 First define a variable to hold the XML data. Next create an **XMLList** object. This provides methods for accessing one or more XML elements. To import the XML file you need a **URLLoader**. Enter the code on the following page.

```
// code for the XML data
var xml:XML;
var xmlList:XMLList;
var xmlLoader:URLLoader = new URLLoader;
xmlLoader.load(new URLRequest("videoList.xml"));
xmlLoader.addEventListener(Event.COMPLETE, xmlLoaded);
```

The **load** method requests that the loader gets data from our file, **videoList.xml**. The URLLoader needs an Event Listener that "listens" when the loader has completed its job. It will call a function, **xmlLoaded**, that loads the first video.

6. Create a variable that will be used to tell Flash which **vid** child element in the XML file to load. The value of **currentChildNum** is initially set to zero.

```
// create a variable to load the video children
var currentChildNum:int = 0;
```

Each child property listed has an index number associated with it. For example, the code **xmlList[0].file** will return a value of "Videos/Video1.f4v" and **xmlList[0].name** returns a value of "Deep Blue Title Sequence" (Figure 4.43).

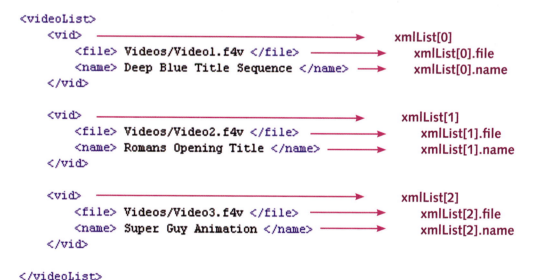

Figure 4.43: *Each XML child property has an index number associated with it.*

7. Add the **xmlLoaded** Event Handler. This function is called when the **videoList.xml** data has completely loaded into Flash. This function stores the data in the **xml** object and then parses the XML children into the **xmlList** object. The FLV-Playback's source file is assigned and the dynamic text is updated on the Stage. The **videoPlayer** needs an Event Listener that "listens" for the video to finish playing. Enter the following code in the Actions panel.

```
// add Event Handler for the loaded xml data
function xmlLoaded(e:Event):void {
    xml = XML(e.target.data);
    xmlList = xml.children();
    videoPlayer.source = xmlList[currentChildNum].file;
    title_txt.text = xmlList[currentChildNum].name;
    videoPlayer.addEventListener(VideoEvent.COMPLETE, changeVid);
}
```

8. Add the **changeVid** Event Handler. This function is called when the current video playing in the FLVPlayback component has completed playing all its frames. It increments the **currentChildNum** variable by a value of one. This determines the next video in the XML data to load. Enter the following code:

```
// add function to load the next video
function changeVid(e:VideoEvent):void {
    currentChildNum++;
    if (currentChildNum < xmlList.length()) {
        videoPlayer.source = xmlList[currentChildNum].file;
        title_txt.text = xmlList[currentChildNum].name;
    } else {
        currentChildNum = 0;
        videoPlayer.source = xmlList[currentChildNum].file;
        title_txt.text = xmlList[currentChildNum].name;
    }
}
```

9. Select **Control > Test Movie**. The video sequence plays (Figure 4.44).

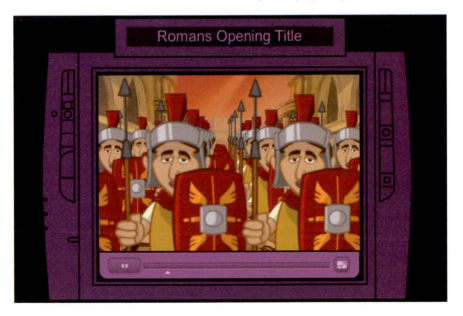

Figure 4.44: *Test your Flash movie to see the video playlist in action.*

10. Notice that the FLVPlayback skin has a full-screen toggle button. If you click it while testing your movie nothing happens. To use this button you must set the publish settings to use the **Allow Full Screen** template. To do this:

 ▸ Select **File > Publish Settings**.
 ▸ Make sure both the Flash and HTML options are selected.
 ▸ Click on the HTML tab and select **Flash Only - Allow Full Screen** from the Templates menu (Figure 4.45).
 ▸ Click **OK**.

Figure 4.45: *Use the full screen template.*

11. You need to test the movie in your default browser to see the full-screen results. Select **File > Publish Preview > HTML**. Click on the full-screen toggle button.

Summary

This completes the chapter. As you can see, there are several different options available to you to load, play, and control video using ActionScript. The exercises in this chapter built several Flash templates that you can modify. Each template helps you design a better, more comprehensive video experience for your users.

Using the FLV Playback component can be quite useful and a big time-saver in most cases. Flash Professional CS5 offers Code Snippets and ActionScript cue points as part of its coding improvements and workflow enhancements. If you want to build your own customized video player you can use the NetConnection, NetStream, and Video classes. The next chapter incorporates alpha channels to enhance the interactivity further.

CHAPTER 5

Alpha Channels

Importing video into Flash is nothing new. Flash also supports an 8-bit alpha channel opening up more creative possibilities for Flash designers. Alpha channels can enhance the user experience in your video-based Flash applications.

© 2010 Elsevier, Inc. All rights reserved.
doi: 10.1016/B978-0-240-81351-6.50005-7

What Are Alpha Channels?

An RGB image contains three color channels—red, green, and blue. When combined, these channels produce the full color image. The alpha channel is a fourth channel that contains an 8-bit grayscale image. This image determines the transparency of each pixel. Black pixels become transparent, and white pixels are opaque. Any value in-between black and white has a certain degree of transparency. A 32-bit color image contains 24-bit color information with an 8-bit alpha channel (Figure 5.1).

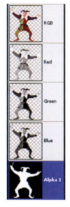

Figure 5.1: *An alpha channel determines the transparency of each pixel.*

When they hear the words alpha channel, most Flash designers think of Adobe Photoshop and PNG files. Those alpha channels are working with still images. Video can also contain an alpha channel and After Effects can create this through **keying**. Keying takes a selected color (the key) in video and removes it from the shot. A prime example is your local weatherman on TV. He is standing in front of a blue or green screen. The colored screen is removed, or keyed out, and a weather map is placed in the resulting transparent area (Figure 5.2).

Figure 5.2: *Keying takes a selected color (usually blue or green) in video and removes it from the shot.*

Chapter 5: Alpha Channels

In this chapter, you will use the Keylight plug-in in After Effects to key out the background in video. The rendered video with an alpha channel will be layered over different background images in Flash. In addition to keying, you will also learn about embedding cue points in After Effects that can trigger other events in Flash. Let's start by creating an alpha channel video.

 Download (http://booksite.focalpress.com/companion/jackson) the **Chapter_05.zip** *file to your hard drive. It contains all the files needed to complete the exercises.*

Keying in After Effects

Keylight is a keying effect designed for blue or green screen footage. With a couple of clicks of the mouse, you can key out a color from a video clip. This high-end keying plug-in is licensed from The Foundry, *www.thefoundry.co.uk*, a visual effects software company.

Before you use the Keylight plug-in, let's talk about what goes into setting up the shot to produce a clean key. It may seem quite simple; stand in front of a green screen and shoot some video. The actual setup is much more involved. The key, forgive the bad pun, starts with good lighting.

Lighting is critical. Typically two or more lights are used to light the green screen. Your background needs to be evenly and brightly illuminated. You want to set up your lights so that they remove as many shadows as possible. A preferred method involves lighting the background and the subject separately. If your subject is framed waist-up have him/her stand at least six feet in front of the background. Make sure that they are not wearing a similar color in their clothing. Figure 5.3 shows the setup used for this chapter. These are general ltips to follow. Learning what goes into setting up a green screen shoot is a subject for an entirely different book.

Figure 5.3: *Good lighting is critical in producing a clean chroma key.*

Keying begins with a video clip. Once you have shot your footage in front of the green screen, import the video into After Effects to remove the green color. The word "remove" may not be the best word to use. The keying process actually generates an alpha channel mask around your subject. This mask hides the green background; it doesn't remove it. To see what you will build in this exercise, locate and launch the **Welcome.swf** file in the **Completed** folder inside the **01_AlphaChannel** folder in **Chapter_05** (Figure 5.4).

Figure 5.4: *The final SWF file integrates an FLV file with an alpha channel.*

01_Alpha

1. In **Adobe After Effects**, select **File > Open Project**. Open the **01_AlphaChannel** folder inside **Chapter_05**. Select **01_Alpha.aep** and click **Open**. The Project panel contains the footage needed to complete this exercise.

2. If the **Welcome** composition is not open, double-click on it in the Project panel. The woman was recorded in front of a green screen. Notice that you can see the clamps and sand bags that hold the green screen in place. You need to eliminate them first, before you apply the Keylight plug-in.

3. Select the **Welcome.mov** layer. Select the **Pen** Tool from the Tools panel. This creates a mask that will remove unwanted areas in the Comp panel.

4. Go to the Timeline and move the Current Time Indicator (CTI) to three seconds (03:00). The woman is raising her hand. This gives you a better idea of the unwanted areas that you need to mask out.

5. Go to the Comp panel and create a mask shape around the woman using the Pen Tool. Click to plot points. When you close the path, the area outside of the mask disappears (Figure 5.5). Scrub through the Timeline to make sure that you do not lose any of the subject in the mask. To adjust the mask, click on the **Selection** (arrow) **Tool**. Click and drag a point to alter the shape of the mask.

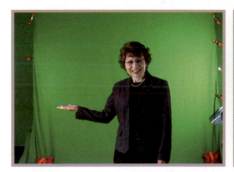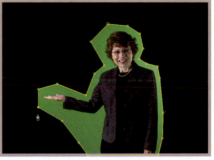

Figure 5.5: *Use the Pen tool to create a mask around the woman.*

You just created a **garbage matte**. This is commonly done when dealing with green screen footage. It serves a couple of purposes. First, it removes unwanted areas from the shot. Secondly, it reduces the area that you need to key.

6. Make sure the **Welcome.mov** layer is still selected in the Timeline. Select **Effect > Keying > Keylight (1.2)**. This applies the plug-in to the layer.

7. In the Effect Controls panel, go to the **Screen Colour** property and select the **eye dropper** icon ![eyedropper icon] to activate the tool.

8. With the Eye Dropper Tool selected, go to the Comp panel and click on the green area surrounding the woman. As soon as you click, the green screen background disappears or turns black (Figure 5.6). That was easy!

Figure 5.6: *Select the color key using the Eye Dropper Tool to remove it.*

9. In the Effect Controls panel, select **Screen Matte** from the **View** popup menu.

10. The Screen Matte displays the alpha channel mask in your keyed footage as a grayscale image. Remember, areas of black are transparent; areas of white are opaque. Notice that there are still shades of gray near the bottom. Although the Keylight plug-in is very effective at keying, you still need to help it out a little. Twirl open the **Screen Matte** properties.

Figure 5.7: *The Screen Matte view displays the alpha channel as a grayscale image.*

11. In the Screen Matte properties, make the following changes to each value:

- ▶ Change the **Screen Pre-blur** property to **1.0**. This smoothes the edges.
- ▶ Change the **Clip Black** property to **15**. This increases the black levels.
- ▶ Change the **Clip White** property to **90**. This increases the white levels.

12. In the Effect Controls panel, select **Final Result** from the **View** popup menu. In the Comp panel, click on the **Toggle Transparency Grid** button ⊞ to see the image on a transparent background (Figure 5.8). Click on the toggle button again to bring back the black background.

Figure 5.8: *Adjust the Screen Matte properties to fine-tune the keying.*

13. Before you render the composition, crop the Comp panel to help reduce the file size of the FLV file. Click on the **Region of Interest** button at the bottom of the Comp panel. The region of interest is the area that is previewed in the Comp panel.

14. Click and drag in the Comp panel to create a smaller region of interest. Scrub through the Timeline to make sure the woman remains inside the area. Use the corner handles to resize the region if necessary (Figure 5.9).

Figure 5.9: *Reduce the region of interest. Creating a smaller region requires less processing power and helps improve the RAM preview.*

15. Select **Composition > Crop Comp to Region of Interest**. The size of the Comp panel is reduced to the dimensions of the region of interest bounding box.

16. Select **Composition > Make Movie**. This opens the Render Queue.

17. Click on **Best Settings** to open the Render Settings dialog box. In the Frame Rate area, set **use this frame rate** to **15** frames per second (Figure 5.10).

Figure 5.10: *Change the frame rate of the rendered movie.*

18. Click on **Lossless** next to Output Module. Set the Format to **FLV**. Click on **Format Options** and set the Bitrate setting to **400** (Figure 5.11). Click **OK**.

Figure 5.11: *Set the bitrate for the Flash Video file.*

19. Under **Channels**, encode the alpha channel. Select **RGB + Alpha** (Figure 5.12).

Figure 5.12: *Render the Flash Video file with an alpha channel.*

20. Click on the **Audio Output** checkbox. Click on **Format Options** and set the Bitrate setting to **96** (Figure 5.13). Click **OK**.

Figure 5.13: *Export the audio. Set the Bitrate to 96.*

21. Click on **Output To** and select the **01_AlphaChannel** folder in the **Chapter_05** folder on your hard drive as the final destination for the rendered movie. Click the **Render** button. Save your project.

01_Welcome

22. Let's move to Flash. Double-click on **01_Welcome.fla** in the **01_AlphaChannel** folder to open the file in Flash. It contains two layers: a background image for a fictitious company called Global Trends, and a video layer.

23. Select the blank keyframe on Frame 1 of the **video** layer. Select **File > Import > Import Video**. The Import Video Wizard appears. To import the FLV file:

▶ Locate the **Welcome.flv** file you rendered out of After Effects.

▶ Select the **Load external video with playback component** option.

▶ Set the Skin to **None**.

▶ Click **Finish** to create the FLVPlayback component on the Flash Stage.

24. With the FLVPlayback component selected, go to the Properties panel and enter an instance name of **display** (Figure 5.14).

Figure 5.14: *Position the video component in the lower right corner of the Stage.*

25. Change the position of the FLVPlayback component on the Stage. In the Properties panel, set the **X** value to **220.0** and the **Y** value to **74.0**. The video component moves to the lower right corner of the Stage (Figure 5.14).

26. Select **Control > Test Movie**. The video plays the alpha channel in place.

The FLVPlayback component adds about 50K to the published file size. When the file plays from your web server, currently your hard drive, there is a very slight delay before the video starts. The video just pops up out of nowhere. There are a number of ways to integrate the video in a more seamless fashion. For this exercise, you will use a screen shot of the first frame of the video already layered in the Flash project. The screen shot is provided.

27. Click on the **New Layer** icon at the bottom of the Timeline panel. Rename the layer **image**. Click and drag the **mcWelcomeFrame1** movie clip from the Library to the Stage. This is a screen shot capture of the first frame. It was saved as a JPEG file and imported into Flash.

28. Go to the Properties panel and enter an instance name of **frame1_mc**. Change the position of the movie clip on the Stage to align with the video. In the Properties panel, set the **X** value to **435.5** and the **Y** value to **238.0** (Figure 5.15).

Figure 5.15: *Position the screen capture on the Flash Stage to align with the video.*

29. Click on the **New Layer** icon at the bottom of the Timeline panel. Rename the layer **actions**. Click on the blank keyframe in Frame 1 and open the Actions panel. Add the following code:

```
// import Flash Video package
import fl.video.*;
import fl.video.VideoEvent;

// set variables
var flvScene = display;

// add Event Listeners
flvScene.addEventListener(VideoEvent.READY, videoReady);

// Event Handler removes image when video is loaded
function videoReady(e:VideoEvent):void {
    frame1_mc.visible = false;
}
```

The code first imports the Flash Video package. The asterisk causes the Flash compiler to import all classes within the video package, some of which you will not use in this exercise. If file size is a concern, you can import the specific class path you need, such as **fl.video.FLVPlayback**.

Next, a variable name is assigned to the FLVPlayback component on the Stage. As you saw earlier, the component pauses the external video until it is ready to view. An Event Listener is attached that "listens" to timing events broadcasted from the FLVPlayback component. Once the video is ready to play, the screen shot is no longer required and is hidden.

Another alternative is to load all the images after the video is loaded into the FLVPlayback component. In addition, it is common practice to display a progress bar while the video is loading. This can be accomplished by using the ProgressBar UI component. That is what you will do in the next exercise.

30. Select **Control > Test Movie**. Having the first frame of the video already on the Flash Stage provides a more seamless video experience versus the video just popping up from nowhere and playing. This completes the exercise.

The goal of this project was to introduce you to the Keylight plug-in in After Effects. It is an effective tool for creating video with alpha channel content. Flash can reference the alpha information contained within the FLV file. This can greatly impact the user experience in your video-based Flash projects. Now that you are aware of how to create alpha channels in video, let's build on your knowledge by adding cue points into the equation.

Embedding Cue Points

Watching video does not have to be a passive experience. In Chapter 4 you added ActionScript cue points. These cue points can only be accessed in Flash. You can also embed cue points into the video in After Effects. These become part of the file's metadata. These assigned navigation or event-based points can be referenced through ActionScript to synchronize the video to the content in the Flash movie. This exercise focuses on embedding cue points in your video.

To see what you will build in this exercise, launch the **WantedMan.swf** file in the **Completed** folder inside the **02_CuePoints** folder in **Chapter_05** (Figure 5.16). Move the cursor over the outlaw's nose and mouth. Be careful he doesn't eat your cursor. Click on his left eye to give him a good poke in the eye.

Figure 5.16: *The final SWF file contains a video with embedded cue points.*

02_WantedPoster

1. Open the **02_WantedPoster.aep** inside the **02_CuePoints** folder in **Chapter_05**. The Project panel contains the footage needed to complete this exercise.

2. If the **WantedPoster** composition is not open, double-click on it in the Project panel. The outlaw was recorded in front of a green screen. Scrub through the Timeline. The outlaw has three different facial reactions that dissolve back into the same static image. Select the **WantedPoster.mov** layer in the Timeline.

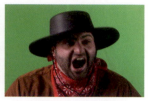

Figure 5.17: *The QuickTime movie contains three different scenarios for the outlaw.*

3. Select **Effect > Keying > Keylight (1.2)**. This applies the plug-in to the layer.

4. In the Effect Controls panel, go to the **Screen Colour** property and select the **eye dropper** icon 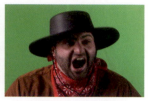 to activate the tool. Go to the Comp panel and click on the green area surrounding the outlaw. As soon as you click, the green screen background disappears or turns black (Figure 5.18).

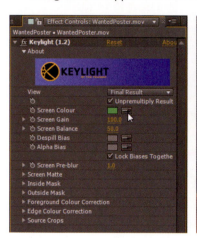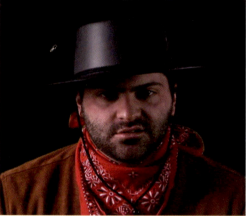

Figure 5.18: *Select the color key using the Eye Dropper Tool to remove it.*

5. In the Effect Controls panel, select **Screen Matte** from the **View** popup menu. Twirl open the **Screen Matte** properties. Make the following changes:

 ▸ Change the **Screen Pre-blur** property to **1.0**. This smoothes the edges.

 ▸ Change the **Clip Black** property to **15**. This increases the black levels.

 ▸ Change the **Clip White** property to **85**. This increases the white levels.

6. Select **Final Result** from the **View** popup menu. Now that you have keyed out the green background, it is time to add layer-time markers to identify certain frames within the Timeline. These markers can include Flash Video cue points that will be embedded in the rendered FLV file. First, save your project.

7. Make sure the **WantedPoster.mov** layer is still selected. Move the CTI to the one second mark (01:00). Select **Layer > Add Marker**. A triangular marker appears on the selected layer duration bar. Double-click on it.

8. The Layer Marker dialog box opens. Go to the **Flash Cue Point** section; enter **nose** for the name. Set the cue point to **Navigation** (Figure 5.19). When you render the final composition as a Flash Video file, this marker will be embedded as a cue point. Flash can reference this cue point through ActionScript and navigate to it. Click **OK**.

Figure 5.19: *Add a Flash Video cue point at the one-second mark.*

9. Create two more navigation-based cue points. Here is what you need to do:

 ▶ Move the CTI to the four-second (04:00) mark. Add a marker and create a Flash Video cue point named **eye**. Set the cue point to **Navigation.**

 ▶ Move the CTI to the seven-second (07:00) mark. Add a marker and create a Flash Video cue point named **mouth**. Set the cue point to **Navigation.**

10. Flash will be able to jump to these three navigation-based cue points. You need to set up a couple more cue points to trigger other events internal to the Flash file. Move the CTI to the eight-second mark (08:00). Select **Layer > Add Marker**.

11. Double-click on the marker. Go to the **Flash Cue Point** section; enter **eat** for the name. Set the cue point to **Event** (Figure 5.20). What is the difference between Event and Navigation? Event-based cue points cause some event to happen in Flash. Navigation-based cue points let you shift to a specific frame in the video.

Figure 5.20: *Add a Flash Video cue point at the eight-second mark.*

12. Create three more event-based cue points. Here is what you need to do:

 ▶ Move the CTI to the **03:20** mark. Add a marker and create a Flash Video cue point named **noseDone**. Set the cue point to **Event.**

 ▶ Move the CTI to the **06:20** mark. Add a marker and create a Flash Video cue point named **eyeDone**. Set the cue point to **Event.**

 ▶ Press the **End** key to move the CTI to the end of the Timeline. Add a marker and create a Flash Video cue point named **end**. Set the cue point to **Event.**

13. With the cue points in place, add one last effect to the layer. Select **Effect > Color Correction > Hue/Saturation**. You are going to colorize the video to a sepia tone. This will blend in better with the artwork in the Flash file.

14. Go to the Effect Controls panel. Click on the **Colorize** checkbox. Set the **Colorize Hue** to **+30.0** degrees. Set the **Colorize Saturation** to **25** (Figure 5.21).

Figure 5.21: *Use the Hue/Saturation effect to colorize the video.*

15. Let's add another effect that will enhance the illustrative look of a wanted poster. Select **Effect > Stylize > Cartoon**. Experiment with the parameters for the fill and edges (stroke) until you like the final results (Figure 5.22).

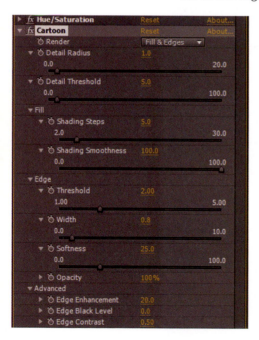
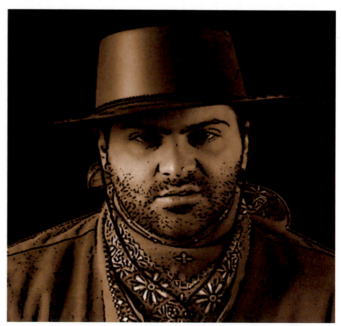

Figure 5.22: *Use the Cartoon effect to stylize the video.*

16. The composition is done. Select **Composition > Make Movie**. Click on **Best Settings** to open the Render Settings dialog box. Set the Resolution to **Half**. In the Frame Rate area, set **use this frame rate** to **15** frames per second.

Figure 5.23: *Render the Flash Video file with an alpha channel.*

17. Click on **Lossless** next to Output Module. Set the Format to **FLV**. Click on **Format Options** and set the Bitrate setting to **400**. Click **OK**.

18. Under **Channels**, encode the alpha channel. Select **RGB + Alpha**.

19. Click on **Output To** and select the **02_CuePoints** folder in the **Chapter_05** folder on your hard drive as the final destination for the rendered movie. Click the **Render** button.

20. Let's move to Flash. Double-click on **02_WantedMan.fla** in the **02_CuePoints** folder to open the file in Flash.

WantedMan

21. The Flash file is already set up with five layers. The **poster** layer contains a PNG file with a transparent hole where the actual video will appear. The video will play underneath this layer on top of a **background** image. This image was imported into Flash as a JPEG image. Both images were converted into movie clip symbols with instance names of **poster_mc** and **scene_mc**. Both movie clip instances will be hidden initially before the video loads (Figure 5.24).

Figure 5.24: *The imported FLV file is layered between two Photoshop images.*

pBar

The **progressBar** layer holds a Flash ProgressBar UI component. This bar will provide user feedback as the video progressively downloads from the web. Its instance name is **pBar**. The **buttons** layer holds three invisible button symbols. When the cursor rolls over or clicks on a button, the FLVPlayback component will navigate to embedded cue points. Let's add the video.

22. Select the blank keyframe on Frame 1 of the **video** layer. Select **File > Import > Import Video**. The Import Video Wizard appears. To import the FLV file:

 ▶ Locate the **WantedPoster.flv** file you rendered out of After Effects.

 ▶ Select the **Load external video with playback component** option.

 ▶ Set the Skin to **None**.

 ▶ Click **Finish** to create the FLVPlayback component on the Flash Stage.

 ▶ Go to the Properties panel and enter an instance name of **display**.

23. Click on the **New Layer** icon at the bottom of the Timeline panel. Rename the layer **actions**.

24. Select the keyframe in Frame 1 of the **actions** layer. Open the Actions panel. Enter the code to import the Flash packages needed for this project. Also define the variables that will be used later.

```
// import Flash packages
import fl.video.*;
import fl.video.VideoEvent;
import fl.controls.ProgressBarMode;

// set variables
var flvScene = display;
var flvRespond:Boolean = false;
```

25. Set up the progress bar to manually update the number of bytes loaded using the **setProgress()** method later in the code. The code **pBar.indeterminate** tells Flash that the file you are importing has a determinate (known) file size. Also, hide the poster and background image movie clips by setting their visible properties to false.

```
// Set progress bar state
pBar.mode = ProgressBarMode.MANUAL;
pBar.indeterminate = false;

// hide movie clips
poster_mc.visible = false;
scene_mc.visible = false;
```

26. Define the Event Listeners for the FLVPlayback component and the buttons.

```
// add Event Listeners and load the video
flvScene.addEventListener(VideoProgressEvent.PROGRESS, onLoading);
flvScene.addEventListener(VideoEvent.READY, videoReady);
flvScene.addEventListener(MetadataEvent.CUE_POINT, onCue);

// add Event Listeners for the buttons
nose_btn.addEventListener(MouseEvent.ROLL_OVER, cueNose);
mouth_btn.addEventListener(MouseEvent.ROLL_OVER, eatCursor);
eye_btn.addEventListener(MouseEvent.CLICK, pokeEye);
```

27. Define the Event Handlers that respond to the listeners. The first Event Handler manually updates the ProgressBar UI component. It monitors the bytesLoaded versus the bytesTotal values in the setProgress function.

```
// Event Handler controls the ProgressBar
function onLoading(e:VideoProgressEvent):void {
    var bLoaded = Math.round(e.bytesLoaded/1000);
    var bTotal = Math.round(e.bytesTotal/1000);
  // Update progress...
    pBar.setProgress(bLoaded, bTotal);
}
```

28. The next Event Handler removes the progress bar from the Stage and turns the visibility of the image layers back on. This occurs when the video is loaded.

```
// Event Handler removes ProgressBar when video is loaded
function videoReady(e:VideoEvent):void {
  flvScene.stop();
  removeChild(pBar);
  scene_mc.visible = true;
  poster_mc.visible = true;
}
```

29. Enter the code that controls the embedded navigation-based cue points. The code **seekToNavCuePoint(cueName)** accurately jumps to the embedded navigation cue point by using the cue point's name. The video plays from there.

```
// create Event Handlers for navigation-based cue points
function cueNose(e:MouseEvent):void {
  if(!flvRespond){
    playCue("nose");
  }
}
```

... code continues on the next page

Embedding Cue Points

```
function pokeEye(e:MouseEvent):void {
    if(!flvRespond){
        playCue("eye");
    }
}
function eatCursor(e:MouseEvent):void {
    if(!flvRespond){
        playCue("mouth");
    }
}

function playCue(cueName){
    flvRespond = true;
    flvScene.seekToNavCuePoint(cueName);
    flvScene.play();
}
```

30. The last function handles the event-based cue points embedded in the Flash Video file. These cue points tell the FLVPlayback component to stop the video playback when a certain cue point is reached. It also hides the cursor when the outlaw eats it. The cursor reappears when the video reaches the end.

```
// Event Handler for event-based cue points
function onCue(e:MetadataEvent):void{
    if(e.info.name == "noseDone"){
        flvRespond = false;
        flvScene.stop();
    }
    if(e.info.name == "eyeDone"){
        flvRespond = false;
        flvScene.stop();
    }
    if(e.info.name == "eat"){
        Mouse.hide();
    }
    if(e.info.name == "end"){
        flvRespond = false;
        flvScene.stop();
        Mouse.show();
    }
}
```

31. Select **Control > Test Movie**. This completes the exercise. In addition to keying out the green screen in a video, you can embed cue points to your After Effects skills. Cue points allow you to turn linear video into a nonlinear, interactive experience for the user. The next exercise continues with the western theme. You will build a simple shootout game using cue points and ActionScript.

Creating an Interactive Video Game

The previous two exercises used the FLVPlayback component to display the video and access the embedded cue points. How do you control streamed video with cue points using just code without a video component? This exercise answers this question as you build a basic interactive video game (Figure 5.25).

To see an example of what you will build in this exercise, locate and launch the **HighNoon.swf** file located in the **03_VideoGame** folder inside **Chapter_05**. The video is loaded using the NetConnection and NetStream objects. As mentioned, this exercise continues with the western theme. You will now become the outlaw, Rattlesnake McGraw. The sheriff in town has you cornered. Click on the bull's-eye when the sheriff draws his gun. Who will survive?

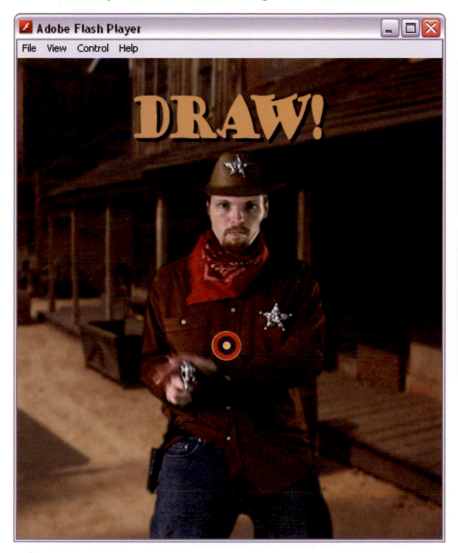

Figure 5.25: *The final SWF file is an interactive video game.*

03_Sheriff

1. Open the **03_Sheriff.aep** inside the **03_VideoGame** folder in **Chapter_05**. The Project panel contains the footage needed to complete this exercise.

2. If the **Sheriff** composition is not open, double-click on it in the Project panel. The sheriff was recorded in front of a green screen. Scrub through the Timeline. The video has four basic sections: ready to shoot, drawing the gun, getting shot, and winning the gunfight. Select the **Sheriff.mov** layer in the Timeline.

Figure 5.26: *The QuickTime movie contains four different scenarios for the sheriff.*

3. Select the **Pen** Tool [icon] from the Tools panel. This creates a mask that will remove unwanted areas in the Comp panel.

4. Use the Pen Tool to create a garbage matte around the sheriff (Figure 5.27). Scrub through the Timeline to make sure that you do not lose any of the sheriff in the mask.

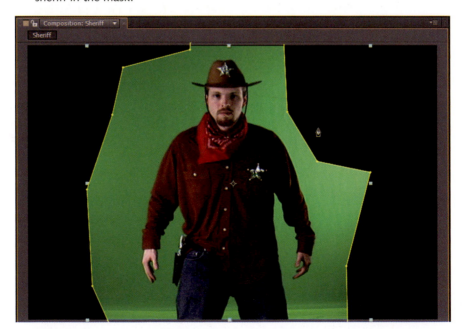

Figure 5.27: *Use the Pen Tool to create a mask around the sheriff.*

5. Select **Effect > Keying > Keylight (1.2)**. This applies the plug-in to the layer.

6. In the Effect Controls panel, go to the **Screen Colour** property and select the **eye dropper** icon 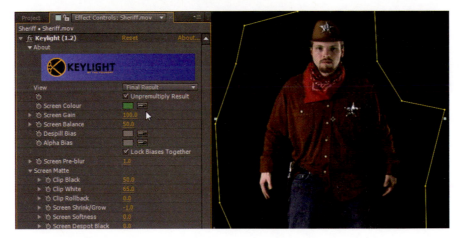 to activate the tool. Go to the Comp panel and click on the green area surrounding the outlaw. As soon as you click, the green screen background disappears or turns black (Figure 5.28).

Figure 5.28: *Select the color key using the Eye Dropper tool to remove it.*

7. In the Effect Controls panel, select **Screen Matte** from the **View** popup menu. Twirl open the **Screen Matte** properties. Make the following changes:

 ► Change the **Screen Pre-blur** property to **1.0**. This smoothes the edges.
 ► Change the **Clip Black** property to **50**. This increases the black levels.
 ► Change the **Clip White** property to **65**. This increases the white levels.
 ► Change the **Screen Shrink** property to **–1**. This clips the sheriff's outline.

8. Select **Final Result** from the **View** popup menu. Now that you have keyed out the green background, it is time to add layer-time markers and the Flash Video cue points that will be embedded in the rendered FLV file.

9. Make sure the **Sheriff.mov** layer is still selected. For this exercise, you will create all event-based cue points. Here is what you need to do:

 ► Move the CTI to the **02:00** mark. Add a marker and create a Flash Video cue point named **loop**. Set the cue point to **Event.**
 ► Move the CTI to the **02:06** mark. Add a marker and create a Flash Video cue point named **draw**. Set the cue point to **Event.**
 ► Move the CTI to the **03:00** mark. Add a marker and create a Flash Video cue point named **bang**. Set the cue point to **Event.**
 ► Move the CTI to the **05:09** mark. Add a marker and create a Flash Video cue point named **dead**. Set the cue point to **Event.**
 ► Press the **End** key to move the CTI to the end of the Timeline. Add a marker and create a Flash Video cue point named **end**. Set the cue point to **Event.**

10. Click on the **Region of Interest** button 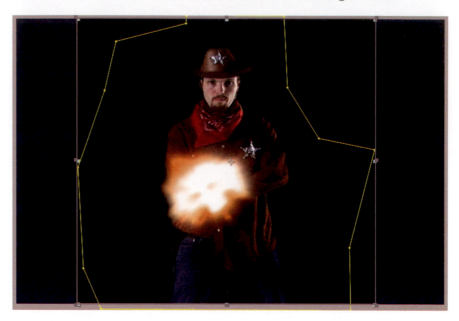 in the Comp panel. Click and drag in the Comp panel to create a smaller region of interest. Scrub through the Timeline to make sure the sheriff remains inside the area (Figure 5.29).

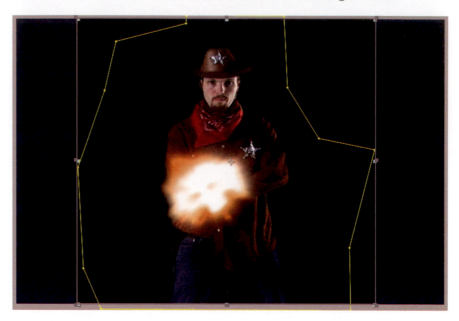

Figure 5.29: *Reduce the region of interest. Creating a smaller region requires less processing power and helps improve the RAM preview.*

11. Select **Composition > Crop Comp to Region of Interest**. The size of the Comp panel is reduced to the dimensions of the region of interest bounding box.

12. The composition is done. Select **Composition > Make Movie**. Click on **Lossless** next to Output Module. Set the Format to **FLV**. Click on **Format Options** and set the Bitrate setting to **400**. Under **Channels**, encode the alpha channel. Select **RGB + Alpha**.

13. Click on the **Audio Output** checkbox. Click on **Format Options** and set the Bitrate setting to **96** (Figure 5.30). Click **OK**.

Figure 5.30: *Export the audio. Set the Bitrate to 96.*

14. Click on **Output To** and select the **03_VideoGame** folder in the **Chapter_05** folder on your hard drive as the final destination for the rendered movie. Click the **Render** button.

03_HighNoon

15. Let's move to Flash. Double-click on **03_HighNoon.fla** in the **03_VideoGame** folder to open the file in Flash.

16. The Flash file is already set up with three frames. Frames 1 and 3 play and restart the game on Frame 2 (Figure 5.31). The **actions** layer contains code for each button on the screen. Click on **Frame 2**.

Figure 5.31: *The artwork is in place on Frame 2. You will add the video through code.*

17. The second frame in the Flash file contains a background JPEG image, a movie clip instance that contains the word "draw," and a bull's-eye movie clip instance. Select the keyframe in Frame 1 of the **actions** layer. Open the Actions panel. You will add the video to this frame using the NetConnection and NetStream objects. Enter the following code:

```
// create video NetConnection and NetStream
var nc:NetConnection = new NetConnection();
nc.connect(null);
var ns:NetStream = new NetStream(nc);
```

The **NetConnection** object links to the FLV file. **Null** is used for the connection name since you are accessing the FLV files locally from your hard drive. The **NetStream** object controls the playback of the video. In order to stream the data correctly, the NetConnection is passed into the NetStream.

18. The Flash Player receives the cue point information embedded in the FLV file being played. You need to set up an object that will listen for this information. Enter the following code in the Actions panel. Add it after the code you entered in Step 17. The code **ns.client** attaches the metadata object to the NetStream object. The listener calls a function named **onCuePoint**. This function will be added later.

```
// create a cuePoint listener
var client:Object = new Object();
client.onCuePoint = onCuePoint;
ns.client = client;
```

19. The next step is to create a **Video Display** object that will hold the loaded FLV file. The code creates a new object with a size of 418 x 480 pixels, the size of the video file. You may need to adjust this to match your video size if it is different. The vertical position is set to align the Video object at the bottom of the screen. The statement, **addChild(myVideo)**, draws the object on the Flash Stage. The NetStream object is attached to the Video object.

```
// create a Video Display object
var myVideo:Video = new Video(418, 480);
myVideo.y = 60;
addChild(myVideo);
myVideo.attachNetStream(vStream);
ns.play("Sheriff.flv");
```

20. Next, create a new Sound object that will play a rifle sound effect when the user clicks on the target. The audio file is stored externally from the Flash movie in a folder labeled **Audio**. Enter the following code:

```
// create Sound object
var rifle:Sound;
// create new Sound objects and link audio files
rifle = new Sound(new URLRequest("audio/rifle.mp3"));
```

21. Once the NetConnection, NetStream, and Video objects are in place, define the variables needed for the game. The variable **loopTime** will store the position in time for the cue point labeled loop. This will be used to cycle a small portion of the video before the sheriff draws his gun. The Boolean variable **hitHim** will be set to true if the user clicks on the target on the Stage. Enter the code:

```
// define variables
var loopTime;
var hitHim:Boolean = false;
```

22. Define the Event Listeners for the target movie clip. Set its visible property to false, hiding it on the Stage.

```
// create Event Listeners and hide objects on Stage
target_mc.addEventListener(MouseEvent.CLICK, shoot);
target_mc.buttonMode = true;
target_mc.visible = false;
draw_mc.visible = false;
```

23. Define the Event Handler that responds to the **onCuePoint** listener. To reference the cue point name use the code **cuePoint.name**. To reference the specific time of the cue point, use **cuePoint.time**. To jump to a certain point in time, use the code **ns.seek (time in seconds)**.

```
// add Event Handler to respond to the metadata loading
function onCuePoint(cuePoint:Object):void {

    if(cuePoint.name == "loop"){
        loopTime = cuePoint.time;
    }

    if(cuePoint.name == "draw"){
        var randomLoop:Number = Math.random()*10; // random number 0 to 9
        // if random number is greater than 2
        if(randomLoop > 2){
            ns.seek(loopTime);                     // cycle the video loop
        }else{
            setChildIndex(target_mc, numChildren - 1); // set target on top
            target_mc.visible = true;
            draw_mc.visible = true;
        }
    }

    if(cuePoint.name == "bang"){
        draw_mc.visible = false;
        target_mc.visible = false;
        if(!hitHim){
            ns.seek(6);
        }
    }
    if(cuePoint.name == "dead"){
        ns.close();
        myVideo.clear();
        gotoAndStop(3);
    }
    if(cuePoint.name == "end"){
        gotoAndStop(3);
    }
}
```

24. The last function you need to create sets the Boolean variable **hitHim** to true if the user clicks on the target movie clip while it is visible. It also plays the sound effect of the rifle. Enter the code:

```
function shoot(e:MouseEvent):void {
    rifle.play();
    hitHim = true;
}

stop();
```

25. Select **Control > Test Movie**. This completes the exercise. The code used to reference cue points using the NetStream object is not that much different than the ActionScript used for the FLVPlayback component. Save your project.

Figure 5.32: *The final SWF file uses the cue points to determine user feedback.*

Using the Roto Brush Tool

The previous three exercises used a green screen. What if you don't have a green screen? Can you still separate out the foreground elements from the background? After Effects CS5 has a new tool called the **Roto Brush**. It isolates moving foreground elements from their backgrounds in a fraction of the time it used to take. It works similarly to the Quick Selection Tool in Photoshop.

The concept of rotoscoping was invented by Max Fleischer, who used it to animate the character Koko the Clown in the series *Out of the Inkwell* (1915). Fleischer traced over live-action film movement in *Gulliver's Travels* (1939) and in an animated series based on the *Superman* cartoons. This long and tedious process has now been drastically improved in After Effects CS5.

 The Roto Brush is only available in After Effects CS5. An older method to rotoscoping in previous versions is to use the Pen Tool and create a mask outline on every frame.

1. Open the **04_RotoBrush.aep** inside the **04_RotoBrush** folder in **Chapter_05**. The Project panel contains the footage needed to complete this exercise.

2. If the **BlackCat** composition is not open, double-click on it in the Project panel. In this composition, you will use the Roto Brush to identify the foreground (cat) and background elements. Then let the Roto Brush automatically create the transparency for you. Finally, you will refine the edges easily for extremely precise results. Select the **Roto Brush** from the Tools panel (Figure 5.33).

Figure 5.33: *Select the Roto Brush Tool from the Tools panel.*

3. Double-click on the **BlackCat.mov** layer in the Timeline or Comp panel. This opens a separate Layer panel that allows you to paint with the Roto Brush. Make sure that you are viewing the layer in **Full** resolution.

4. To change the Roto Brush size, hold down the **Command (Mac)/Control (Windows)** key and drag. With the Roto Brush selected, click and paint brush strokes over the black cat (Figure 5.34). You do not have to be precise in brushing to the edge. Release the mouse and the Roto Brush will do its best to create a matte around the cat. Surprisingly, it does an amazing job at edge detection.

Figure 5.34: *Paint over the foreground element in the video.*

5. You need to train the Roto Brush on what to ignore. Let's identify the background elements by holding down the **Option (Mac)/Alt (Windows)** key and click and paint over the background. Notice that this brush stroke is red to differentiate the background from the foreground element. You can also use this technique to fine-tune the matte created by the Roto Brush.

Figure 5.35: *The Roto Brush creates a matte based on your brush strokes.*

6. Click on the **Toggle Alpha** button in the Layer panel. You can use this in conjunction with the **Toggle Transparency Grid** button ⊞ (Figure 5.36).

Figure 5.36: *Turn on the Alpha transparency to see the mask created by the Roto Brush.*

7. The Roto Brush effect is added to the Effect Controls panel. The parameters allow you to refine edges easily for extremely precise results (Figure 5.37).

 ▶ Click on the checkbox for **Refine Matte**.

 ▶ Twirl open the Decontamination parameter. Increase the **Decontamination Radius** to **5**. This will remove any background colors that spill into the edges.

 ▶ Under the Matte parameter, increase the **Feather** value to **40%**.

 ▶ Increase the **Choke** to **10%**.

Figure 5.37: *Refine the matte created by the Roto Brush.*

Chapter 5: Alpha Channels

8. Press **Page Down** to move forward one frame. After Effects uses a variety of techniques to propagate the information from the base frame to the current frame to determine where to draw the segmentation boundary (Figure 5.38).

Figure 5.38: *The Roto Brush Span is used to propagate segmentation forward and backward in time. The first segment spans to a little over a half a second in duration.*

9. Let's create another segment. Move the Current Time Indicator (CTI) to the **1**-second mark in the Layer panel. With the Roto Brush selected, click and paint brush strokes over the black cat (Figure 5.39). This propagates information into a new segment that connects to the first Roto Brush Span you created.

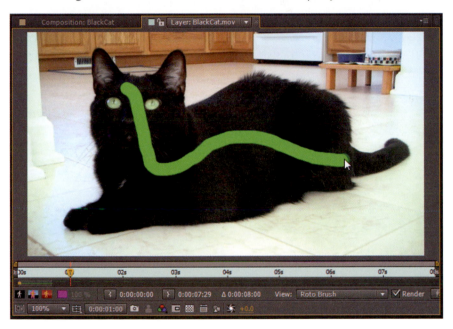

Figure 5.39: *Move forward in time to propagate the segmentation.*

10. Repeat the steps until you have created a segmentation boundary for the entire duration of the composition. Draw foreground strokes and background strokes as needed to correct the segmentation.

 ▶ Move the CTI to **2:15** and paint brush strokes over the black cat.

 ▶ Move the CTI to **3:15** and paint brush strokes over the black cat.

 ▶ Move the CTI to **4:15** and paint brush strokes over the black cat.

 ▶ Keep moving forward in time to propagate segmentation (Figure 5.40).

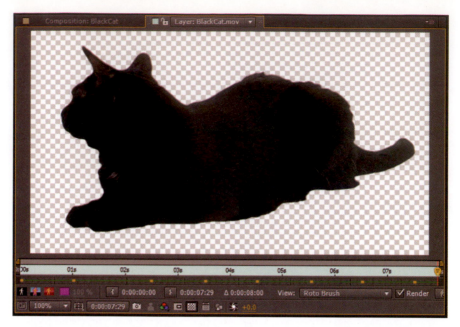

Figure 5.40: *Draw foreground and background strokes as needed to correct the matte.*

11. When the composition is done select **Composition > Make Movie**. Click on **Lossless** next to Output Module. Set the Format to **QuickTime**. Click on **Format Options** and set the Compression to **Animation**. Under **Channels**, encode the alpha channel. Select **RGB + Alpha** (Figure 5.41).

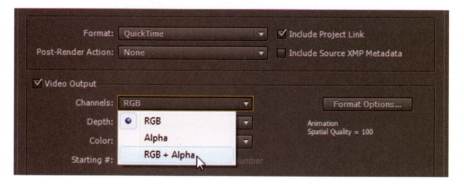

Figure 5.41: *Render the QuickTime file with an alpha channel.*

12. Click on **Output To** and rename the file **BlackCat_Alpha.mov**. Select the **04_RotoBrush** folder in the **Chapter_05** folder on your hard drive as the final destination for the rendered movie.

13. Click the **Render** button. Save your project.

14. The Roto Brush can be processor intensive. Import the rendered QuickTime movie with alpha channel. You can add more effects to this footage without taxing your computer as much. Let's add the movie to another composition.

Chapter 5: Alpha Channels

15. Open the **Catnapped_FINAL** composition in the Project panel.

16. Click and drag the newly imported **BlackCat_Alpha.mov** file from the Project panel to the Timeline. Position it at the top of the Timeline.

 ▶ Type **S** on the keyboard to show only the Scale property.

 ▶ Scrub through the numeric value and set it to **85%** (Figure 5.42).

 ▶ Hold down the Shift key and type **R** to also open the Rotation property.

 ▶ Scrub through the second numeric value and set it to **5.0 degrees**.

Figure 5.42: *Add the QuickTime movie to the final composition.*

17. Position the black cat in the Comp panel (Figure 5.43).

Figure 5.43: *Position the black cat in the Comp panel.*

18. Notice that the QuickTime video is only 8 seconds long and the composition is 16 seconds long. Let's change the timing. To do this you need to activate the Time Remapping parameter for the movie. Single-click on the **BlackCat_Alpha. mov** layer in the Timeline. Select **Layer > Time > Enable Time Remapping**.

Time Remapping allows you to change the flow of time for a layer. It adds two keyframes by default, one at the beginning of the layer and one at the end.

19. Single-click on the first keyframe to highlight it. Select **Edit > Copy**.

20. Extend the layer so that its duration is the same as the composition's. Retrim its Out Point by clicking and dragging it to the end of the composition (Figure 5.44).

Figure 5.44: *Retrim the Out Point of the video layer to the end of the composition.*

21. Press the **End** key on the keyboard. This moves the Current Time Indicator (CTI) to the end of the Timeline. Select **Edit > Paste** to paste the first keyframe's value. Scrub through the Timeline to see the video play forward then reverse playback. Since the first and last keyframe are identical, you have created a looping video.

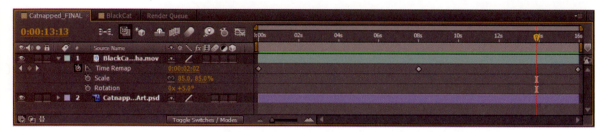

Figure 5.45: *Enable Time Remapping for the QuickTime movie to loop it.*

22. This completes the exercise. If you want to export the file to Flash, render the composition as a Flash Video (F4V or FLV) file. Import the video into Flash.

Summary

This completes the chapter on creating alpha channels, embedding cue points, and using the new Roto Brush Tool. Some key concepts to remember include:

▶ Keying takes a selected color (the key) in video and removes it from the shot.

▶ In After Effects, the keying process actually generates an alpha channel mask around your subject.

▶ A garbage matte removes unwanted areas from the shot and reduces the area that you need to key.

▶ Event-based cue points cause some event to happen in Flash.

▶ Navigation-based cue points let you shift to a specific frame in the video.

▶ With the Roto Brush Tool, you draw strokes on the foreground and background elements. After Effects uses that information to create a matte.

▶ Time Remapping allows you to change the flow of time for a layer.

The next chapter continues your journey into the world of motion graphics where After Effects is the industry standard. You will learn more about the Type Tool, using prebuilt text animation presets and custom animators.

CHAPTER 6

Type in Motion

Motion Graphics has become synonymous with text, specifically animated text. This chapter shows you how to apply typography and movement to create a variety of motion graphics solutions in After Effects that can be integrated into Flash.

doi: 10.1016/B978-0-240-81351-6.50006-9

Creating and Animating Type

The text engine in After Effects is an incredible tool. It is one of the best out there. You have at your disposal an arsenal of text animators and properties to control and animate over time. With all this power comes a certain amount of complexity. Figure 6.1 shows a typical text layer in the Timeline. It may look a little intimidating with all those properties, but by the time you complete this chapter, you'll discover that creating text in After Effects is as easy as A-B-C.

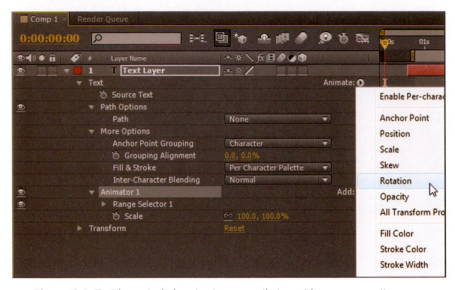

Figure 6.1: *Text layers include animator groups that provide many properties.*

Adding text to a composition is a simple process. Select the **Type** Tool in the Tools panel, click anywhere in the Comp panel, and start typing. When you finish, press the Enter key on the numeric keypad to exit typing mode. If you press the Return/Enter key on the main keyboard, the type cursor drops down to the next line, just like in a word processor. You can also click anywhere outside the Comp panel or select another tool such as the Selection (arrow) Tool when you are done typing (Figure 6.2).

Figure 6.2: *There are two Type Tools: the Horizontal and the Vertical Type Tool.*

When you click in the Comp panel an insertion point for the text appears at the cursor's location. If you want to center the text in the Comp Window select **Layer > New > Text**. After Effects places the insertion point in the center of the Comp panel. The text is set to center alignment as well. A text layer is automatically created in the composition and appears in the Timeline. It does not appear in the Project panel.

Text in After Effects falls into two categories, **Point Text** and **Paragraph Text**. When you click and start typing in the Comp panel you are creating Point Text. Each line of type is a continuous block of text (Figure 6.3). New lines will only be created when you press the Return/Enter key.

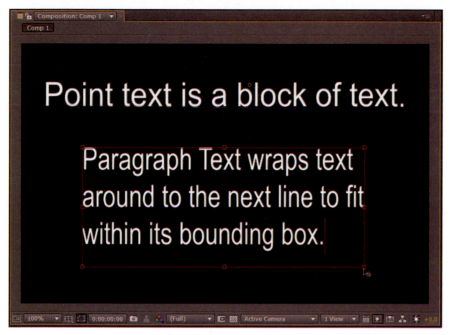

Figure 6.3: *Point Text is one block of text. Paragraph Text automatically wraps the text to fit inside its bounding box.*

Click and drag the Type Tool in the Comp panel to create Paragraph Text. Paragraph Text automatically wraps text around to the next line to fit within the bounding box (Figure 6.3). The text's bounding box is defined by how far you dragged the cursor when you created the **Paragraph Text** layer.

If needed, you can resize the bounding box for Paragraph Text by first selecting the text using the Type Tool. Then click and drag on one of the handles around the perimeter of the bounding box. Hold down the Shift key to constrain the proportions of the bounding box.

Double-clicking a text layer in the Comp panel will highlight all of the text and switch you to the Type Tool. Once the text is selected, you can adjust Text properties such as font size and alignment using the Character and Paragraph panel. Both panels, by default, open when a text layer is created.

You can select all of the text or individual characters. Based on your selection, the adjustments you make only affect the highlighted characters. You can control the font, its size, leading (space between lines), kerning (space between individual characters), and tracking (space between all characters).

1. Launch **Adobe After Effects**. Select **Composition > New Composition**. You will set up the project for a typical Flash movie. Make the following settings:

 ▶ Composition Name: **SupernovaText**
 ▶ Width: **550**
 ▶ Height: **400**
 ▶ Pixel Aspect Ratio: **Square Pixels**
 ▶ Frame Rate: **15**
 ▶ Duration: **0:00:05:00**

 Click **OK**. The new composition opens with a black screen in the Comp panel. The Timeline opens a tab.

2. Select **Layer > New > Text**. After Effects places the insertion point in the center of the Comp panel. Type "SUPERNOVA". A text layer is automatically created in the composition and appears in the Timeline.

 The type layer in the Timeline is automatically named after the text you type. You can change its name the same way you'd change any layer name—select the layer name and press the Return/Enter key to rename the layer.

3. Double-click on the text to select all. Change the font and font size to whatever you want using the Character panel. Arial Black was used for this exercise. The font size was set to 60 pixels (Figure 6.4).

Figure 6.4: *Double-click on the text to highlight all the characters. Change the Character properties to whatever you want.*

4. In the Timeline twirl open the **SUPERNOVA** text layer to reveal its properties. There are two: Text and Transform. Twirl open the transform properties. These are the same layer properties that you have been working with in the previous chapters: Anchor Point, Position, Scale, Rotation, and Opacity.

5. The position of a layer's Anchor Point affects how it scales and rotates. It is the point at which all the transform properties are calculated from. Set the **Anchor Point** value to **0.0, –20.0**. This changes the vertical position of the layer's anchor point from the baseline of the text to the center of the text.

6. Let's animate some of the transform properties. Move the Current Time Indicator (CTI) to the two-second mark (02:00). Click on the **stopwatch** icon ⏱ for Position, Scale, and Rotation. This sets keyframes for each property at that point in time.

7. Press the **Home** key to move the CTI to the beginning of the composition (00:00). Make the following changes to the transform properties:
 ▶ Set the **Scale** value to **600%**.
 ▶ Set the **Rotation** value to **–30.0**.

8. Reposition the text in the Comp panel. Click and drag the text layer down, off the bottom right corner of the window (Figure 6.5).

Figure 6.5: *Reposition the text layer in the Comp panel.*

9. Click on the **RAM Preview** button. The text layer flies in from the right side of the Comp panel. The transform properties affect the entire layer of text, similar to other footage layers in a composition. Save your project.

10. Let's apply a blur effect to add more dynamic movement to the composition. Make sure the text layer is still selected in the Timeline. Move the Current Time Indicator (CTI) to the two-second mark (02:00) so that you can see the effect. Select **Effect > Blur & Sharpen > CC Radial Fast Blur** (Figure 6.6).

Figure 6.6: *Apply the CC Radial Fast Blur to the text layer.*

11. Go to the Effect Controls panel and change the **Amount** value to **100**. This increases the amount of blur, producing what looks like rays of light coming from the text. Click on the **stopwatch** icon to set a keyframe.

12. Move the CTI to the three-second mark (03:00).

13. Go to the Effect Controls panel and change the CC Radial Fast Blur **Amount** value to **30**. Click on the **stopwatch** icon next to the **Center** property. This property controls the position of the radial blur.

14. Move the CTI to the four-second mark (04:00). Change the **Center** value to **0.0, 200.0**. This moves the radial blur to the left edge of the Comp panel.

15. Move the CTI to the five-second mark (05:00). Change the **Center** value to **550.0, 200.0**. This moves the radial blur to the right edge of the Comp panel.

16. Select **Effect > Color Correction > Hue/Saturation**. Go to the Effect Controls panel and click on the **Colorize** checkbox. Make the following changes:

 ▸ Set the **Colorize Hue** to **–140** degrees.

 ▸ Set the **Colorize Saturation** to **100**.

 ▸ Set the **Colorize Lightness** value to **–30**.

17. Click on the **RAM Preview** button. The animation resembles the opening credits to the *Superman* movies (Figure 6.7). The only thing that is missing is a starfield. Let's add that using a solid layer and an effect.

Figure 6.7: *The final text animation using the CC Radial Fast Blur.*

18. Make sure the Timeline panel is highlighted. Select **Layer > New > Solid**. The Solid Settings dialog box appears. Make the following changes:

 ▸ Enter **Starfield** for the solid name.

 ▸ Click on the **Make Comp Size** button.

 ▸ Set the color of the solid layer to white.

 ▸ Click **OK**.

19. A solid layer of color appears at the top of the Timeline and in the Comp panel. Reposition the **Starfield** solid layer underneath the **SUPERNOVA** text layer (Figure 6.8).

Figure 6.8: *Rearrange the staking order so that the solid layer is underneath the text.*

20. Make sure the solid layer is still highlighted in the Timeline. Select **Effect > Simulation > CC Star Burst**. This effect generates an animated starfield (Figure 6.9). Go to the Effect Controls panel and make the following changes:

 ▸ Set the **Speed** to **.50**.

 ▸ Set the **Size** to **30**.

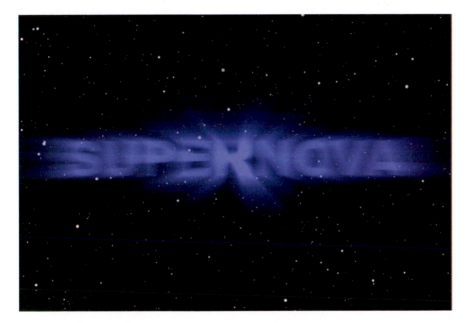

Figure 6.9: *Create a starfield effect to complete the exercise.*

21. Click on the **RAM Preview** button. This completes this exercise on creating and animating a text layer. If you want to export the file to Flash, render the composition as a Flash Video (F4V or FLV) file. Save your project.

 As you can see, you can animate text layers as you would any other layer in a composition. But there is so much more you can do, such as animating the individual characters or words. You can also attach text to a curved path. In the next exercise, you will place your text on a mask path and animate it sliding along that path. Masks can also be animated by keyframing the Mask Shape property so your attached text can follow a morphing, undulating path.

Animating Text along a Path

In this exercise you will attach a text layer to a mask path to create a simple text animation for a fictional perfume called "Captivate." The path is created using the Pen tool in the Tools panel. Let's get started.

 Download (http://booksite.focalpress.com/companion/jackson) the **Chapter_06.zip** *file to your hard drive. It contains all the files needed to complete the exercises.*

TextonPath

1. Open the **TextonPath.aep** inside the **01_AnimatingType** folder in **Chapter_06**. The Project panel contains the footage needed to complete this exercise.

2. If the **Captivate** composition is not open, double-click on it in the Project panel. It contains one layer, a photo of a woman (courtesy of *www.istockphoto.com*).

3. Select **Layer > New > Text**. After Effects places the insertion point in the center of the Comp panel. Type "CAPTIVATE". A text layer is automatically created in the composition and appears in the Timeline.

4. Double-click on the text to select all. Change the font and font size to whatever you want using the Character panel. Felix Titling was used for this exercise. The font size was set to 72 pixels (Figure 6.10)

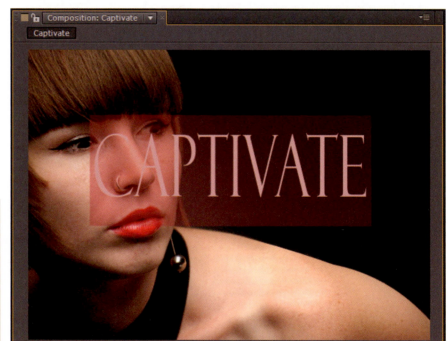

Figure 6.10: *Create a text layer in the Comp panel.*

5. Select the **Captivate** text layer in the Timeline. Select the **Pen** Tool from the Tools panel. This creates the path for the text. The path can be open or closed. If you close the mask path, set its mode to None and attach the text.

6. Go to the Comp panel and create a mask path that follows the contour of the woman's shoulder using the Pen Tool. Start the path on the left side of the Comp panel. To adjust the mask, click on the **Selection** (arrow) Tool. Click and drag a point to alter the shape of the mask (Figure 6.11).

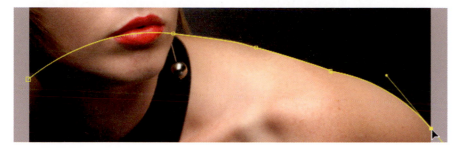

Figure 6.11: *Create a mask path using the Pen Tool on the text layer.*

7. In the Timeline, twirl open the **Captivate** layer to reveal its properties. Twirl open the **Text** properties. Twirl open the **Path Options** property group.

8. Select **Mask 1** from the Path property's popup menu (Figure 6.12). After Effects will instantly attach the text to the path in the Comp panel.

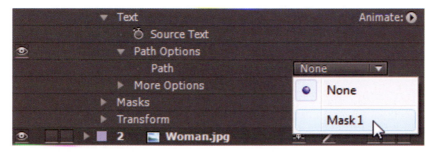

Figure 6.12: *Attach the text layer to the mask path.*

9. Several new properties appear under the Path Options. Scrub through the **First Margin** value to move the text off the right side of the screen. To animate the text moving along the path, keyframe the First Margin property by clicking on its **stopwatch** icon.

10. Press the **End** key on the keyboard to move the CTI to the end of the composition. Go to the Timeline and scrub through the First Margin property to move the text off the left side of the Comp panel.

11. Click on the **RAM Preview** button. The text animates in from the right side of the Comp panel and follows the woman's shoulder across the screen. Save your project.

12. Experiment with the other Path Options. Turn the **Perpendicular to Path** option **OFF** and your text remains vertically aligned as it animates across the woman's shoulder (Figure 6.13).

Figure 6.13: *Turn off the Perpendicular to Path option (right image).*

As you learned in Chapter 3, text is vector-based in After Effects. Static text layers and basic text animation export as vector objects. The best way to save this animation to Flash is to export the text as an Adobe Flash SWF file.

13. Turn off the visibility of the **Woman.jpg** layer by clicking on its Video switch 👁. You do not need this layer exported because it will be included in the Flash file.

14. Select **File > Export > Adobe Flash Player (SWF)**. This opens the Save File As dialog box. Save the SWF file to the **01_AnimatingType** folder in **Chapter_06**.

15. The SWF Settings dialog box appears. In the Images area, set After Effects to **Ignore Unsupported Features**. There is no audio so leave that unchecked. Leave the rest of the settings as the default (unchecked). Click **OK**. That's it.

Captivate

16. To see the final results, double-click on **Captivate.fla** in the **Completed** folder. The Flash file is already built. The SWF file was imported into a movie clip and layered underneath a PNG image of the woman. The final file size is 145 KB.

Figure 6.14: *Export the text animation as an Adobe Flash SWF file.*

Simulating Handwriting with a Stroke

The Pen Tool in After Effects serves a variety of purposes. As you can see from the previous exercise, it is similar in operation to the Pen Tools in Photoshop and Illustrator. You can create a Bezier mask using the Pen Tool on a selected layer in the Composition or Timeline panel. If you draw with the Pen Tool in the Comp panel with no layer selected, you create a vector shape on a new shape layer.

The Stroke effect creates a stroke along a Bezier path created with the Pen Tool. You can specify the stroke's color, opacity, and spacing. In addition, you can also set the stroke to appear on top of the image or use it to reveal the original alpha channel. Add a couple of keyframes and you can simulate a text layer being "written" on the screen. To see an example of this effect, locate and play **StrokeEffect.mov** in the **Completed** folder in the **02_HandwritingText** folder.

StrokeEffect

Figure 6.15: *The finished project simulates handwriting using the Stroke effect.*

1. Open the **StrokeText.aep** inside the **02_HandwritingText** folder in **Chapter_06**. The Project panel contains the footage needed to complete this exercise.

2. If the **StrokeText** composition is not open, double-click on it in the Project panel. It contains three layers. Select the **Stroke** layer in the Timeline (Figure 6.16).

StrokeText

Figure 6.16: *Select the **Stroke** layer in the Timeline.*

3. Select the **Pen Tool** from the Tools panel. Go to the Comp panel and trace the letter "S" starting at the top of the letter. Click and drag to create a curved path (Figure 6.17). When you are done, hold down the **Command (Mac)/Control (Windows)** key and mouse click to stop drawing.

Figure 6.17: *Trace the letter form using the Pen Tool.*

4. With the **Stroke** layer still highlighted in the Timeline, trace over the remaining letters. Remember to hold down the **Command (Mac)/Control (Windows)** key and mouse click to stop drawing once you have completed each tracing.

 ▶ The letters "t" and "k" should be made up of two strokes.

5. Each Bezier path created with the Pen Tool appears as a property layer in the Timeline. To reveal all of the masks for a layer, select the layer and type **M** on the keyboard (Figure 6.18).

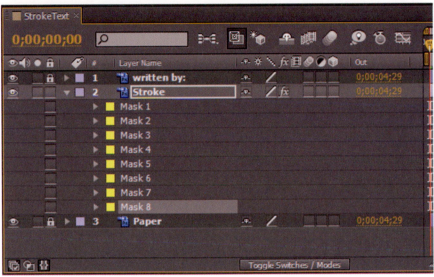

Figure 6.18: *Trace the remaining letters form using the Pen Tool. Each Bezier path is added as a property layer in the Timeline.*

6. Select **Effect > Generate > Stroke** to apply the Stroke effect to the layer.

7. Go to the Effect Controls panel. You can have the stroke follow one or more paths created using the Pen Tool. Since you have multiple paths, click on the checkbox for **All Masks** (Figure 6.19).

Figure 6.19: *Apply the Stroke effect to all of the paths created with the Pen Tool.*

8. The color of the stroke doesn't matter since it will be used to reveal the letters in the **Stroke** layer. Increase the **Brush Size** to **5.0**.

9. Move the Current Time Indicator (CTI) to the one-second mark (01:00). In the Effect Controls panel, change the **End** value to **0**. Click on its **stopwatch** icon to add a keyframe.

10. Move the CTI to the three-second mark (03:00). In the Effect Controls panel, change the **End** value back to **100**. This will create the animation of the strokes drawing sequentially in the Comp panel.

11. To create the final effect of handwriting, select **Reveal Original Image** from the Paint Style drop-down menu (Figure 6.20).

Figure 6.20: *Change the Paint Style to reveal the letters in the original image.*

12. Click on the **RAM Preview** button. The text appears as if being magically handwritten on the screen. Save your project. If you want to export the file to Flash, render the composition or just the **Stroke** layer as an FLV file with an alpha channel. The next exercise focuses on text animation presets in After Effects.

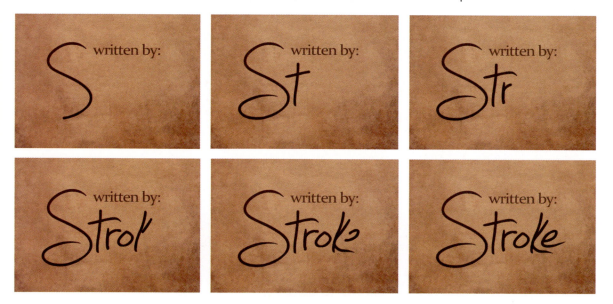

Figure 6.21: *The finished project simulates handwriting.*

Applying Text Animation Presets

After Effects ships with a ton of text animation presets. These are prebuilt animation effects sorted by category in the Effects & Presets panel. They can be easily applied to a text layer by a simple drag and drop interaction.

For this exercise, you will build a Flash ad using the Web Banner composition preset. The motion graphics banner ad will be created using the text animation presets. You will build a movie teaser trailer for a direct-to-DVD fictional horror movie called *Contagion*. Let's start by creating the new composition.

1. Create a new project in **After Effects**. Select **Composition > New Composition**. Enter **DVDAd** as the Composition Name. Select **Web Banner, 468 x 60** from the Preset popup menu. Set the duration to **0:00:20:00**. Click **OK**.

2. Select **Layer > New > Text**. After Effects places the insertion point in the center of the Comp panel. Type "Deep inside..." Go to the Character panel and change the font to whatever you want. Arial Black was used for this exercise. The font size was set to 30 pixels (Figure 6.22).

3. Type **A** on the keyboard to display the layer's Anchor Point property. Change its second value to **−9.0**. This vertically centers the text in the Comp panel.

Figure 6.22: *Change the Anchor Point value to center the text in the Comp panel.*

4. Select **Layer > New > Text**. Type "a new terror awaits." The font and font size are set automatically to match the previous text layer. Vertically center the text in the Comp panel using the Anchor Point transform property (Figure 6.23).

Figure 6.23: *Create a new Point Text layer.*

5. Select **Layer > New > Text**. Type "Coming soon to DVD." Vertically center the text in the Comp panel using the Anchor Point transform property.

Figure 6.24: *Create a new Point Text layer.*

6. One last text layer is needed — the title of the movie. Select **Layer > New > Text**. Type "CONTAGION". Go to the Character panel and change the font to whatever you want. The Stencil font was used for this exercise. The font size was set to 60 pixels and the color changed to a light green. Vertically center the text in the Comp panel using the Anchor Point transform property.

Figure 6.25: *Create the title text layer. Vertically center it in the Comp panel.*

7. All the text is created. Notice that each layer's duration bar spans the entire Timeline. You need to reposition some of the duration bars so that the text layers appear at different times in the Comp panel. To do this:

 ▸ Move the CTI to the three-second mark (03:00). Click and drag the **"a new terror awaits."** duration bar so that its starting point (left edge) aligns with the Current Time Indicator (Figure 6.26).

Figure 6.26: *Reposition the layer's duration bar in the Timeline to align with the CTI.*

 ▸ Move the CTI to the 15-second mark (15:00). Click and drag the **"Coming soon to DVD."** duration bar so that its starting point (left edge) aligns with the Current Time Indicator.

 ▸ Move the CTI back to the eight-second mark (08:00). Click and drag the **"CONTAGION"** duration bar so that its starting point (left edge) aligns with the Current Time Indicator (Figure 6.27).

Figure 6.27: *Reposition the layer's duration bar in the Timeline to align with the CTI.*

8. Press the **Home** key to move the CTI back to the beginning of the composition (00:00). Select the **"Deep inside..."** layer in the Timeline.

 ▸ Type **T** on the keyboard to display the layer's Opacity property. Set its value to **0**. Click on the Opacity **stopwatch** icon to add a keyframe.

 ▸ Move the CTI to the one-second mark (01:00). Set the layer's Opacity value back to **100**. The text now fades in.

9. Move the CTI to the three-second mark (03:00). Select the **"a new terror awaits."** layer in the Timeline.

► Type **T** on the keyboard to display the layer's Opacity property. Set its value to **0**. Click on the Opacity **stopwatch** icon to add a keyframe.

► Move the CTI to the four-second mark (04:00). Set the layer's Opacity value back to **100** to fade the text layer in.

10. Let's apply some text animation presets to the text layers. Go to the **Effects & Presets** panel. Twirl open the **Animation Presets** folder. Twirl open the **Text** folder. This contains all the different preset folders of text animation. Here is what you need to do:

► Move the CTI to the three-second mark (03:00). Open the **Miscellaneous** preset folder. Click and drag the **Explosion** effect from the Effects & Presets panel to the **"Deep inside..."** layer in the Timeline. This effect scatters each letter randomly as if the text exploded.

► Move the CTI to the six-second mark (06:00). Twirl open the **Animate Out** preset folder. Click and drag the **Fade Out Slow** effect from the Effects & Presets panel to the **"a new terror awaits."** layer in the Timeline. This effect fades each letter from left to right.

► Move the CTI to the eight-second mark (08:00). Open the **Miscellaneous** preset folder. Click and drag the **Wiggly Lines** effect from the Effects & Presets panel to the **"CONTAGION"** layer in the Timeline.

► Move the CTI to the 14-second mark (14:00). Make sure you still have the **Miscellaneous** preset folder twirled open. Click and drag the **Explosion 2** effect from the Effects & Presets panel to the **"CONTAGION"** layer in the Timeline. This is a variation of the first explosion effect.

► Move the CTI to the 15-second mark (15:00). Twirl open the **Organic** preset folder. Click and drag the **Insects** effect from the Effects & Presets panel to the **"Coming soon to DVD."** layer in the Timeline.

11. Click on the **RAM Preview** button to preview your motion graphics project. With just a simple drag and drop interaction, you can easily create effective text animation quickly. With the basic animation in place, let's tweak it a bit. Before you do that, save your project.

12. The title animation could be more dynamic. Turn on the **Motion Blur** switch for the **"CONTAGION"** layer in the Timeline. This switch simulates the motion blur captured by a camera. In order to see the motion blur in the Comp panel, click on the **Enable Motion Blur** button at the top of the Timeline. Whenever this button is activated, any layer with the Motion Blur switch enabled will display the blur in the Comp panel (Figure 6.28).

Figure 6.28: *Enable the Motion Blur switch and button to enhance the animation.*

13. Turn on the **Motion Blur** switch for the **"Coming soon to DVD."** text layer in the Timeline. That one switch can greatly enhance the motion in the text animation. It is also important to note that these two layers will no longer export as vectors.

Figure 6.29: *Enable the Motion Blur switch for the second text layer.*

14. Click on the **RAM Preview** button. This completes the text animation. What's missing is a good, creepy background. In addition to text animation presets, After Effects also ships with several animated background presets.

15. Deselect all text layers in the Timeline. Make sure nothing is highlighted. Go to the **Effects & Presets** panel. Twirl open the **Backgrounds** folder. Double-click on **Germs**. A new solid layer is added to the Timeline and Project panel. In the Comp panel you see the background effect—instant undulating germs.

Figure 6.30: *Add a background preset to the composition.*

16. In the Timeline, move the **Solid 1** layer to the bottom of the stack. Type the **U** key to reveal all its keyframed properties. The **Evolution** property for Fractal Noise appears twice. This property controls the undulating movement. Click and drag both keyframes at the five-second mark to the end of the composition.

17. Now that the background preset animates for the entire duration of the composition, the last step is to adjust the preset colors to provide better contrast between the text and the floating germs.

18. Go to the Effect Controls panel. It contains all the effects used to create the background preset animation. Go to the **Colorama** effect and twirl open the **Output Cycle**. Select **Solarize Green** from the **Use Preset Palette** popup menu.

19. Double-click on the bright green ▲ triangle at the bottom of the color wheel. The Color dialog box appears. Select a darker green color. Click **OK**.

Figure 6.31: *Adjust the Colorama effect to darken the green color. This creates better contrast between the text and background animation.*

20. Click on the **RAM Preview** button. This completes this exercise on applying text animation presets. If you want to export the file to Flash, render the composition as a Flash Video (F4V or FLV) file.

Think about what you just built. This entire composition was created in After Effects without any imported footage. Twirl open the text layers and look at the properties used by the presets (Figure 6.32). A good way to start learning about text animation in After Effects is to dissect a text animation preset. In the next exercise you will use some of these properties and animator groups to create your own custom text animation.

Figure 6.32: *Examine the animated properties of a text animation preset to start learning about the different animators and properties available.*

Using Text Animators

Let's create a text animation from scratch. For this technique you will not use any of the text animation presets. First you need to create a composition the same size as your Flash movie.

1. Create a new project in After Effects. Select **Composition > New Composition**. Make the following settings:

 ▸ Composition Name: **DownloadText**

 ▸ Width: **550**

 ▸ Height: **400**

 ▸ Pixel Aspect Ratio: **Square Pixels**

 ▸ Frame Rate: **15**

 ▸ Duration: **0:00:05:00**

 ▸ Click **OK**.

2. Select **Layer > New > Text**. After Effects places the insertion point in the center of the Comp panel. Type "DOWNLOAD".

3. Double-click on the text to select all. Change the font and font size to whatever you want using the Character panel. Arial Bold was used for this exercise. The font size was set to 60 pixels (Figure 6.33).

Figure 6.33: *Double-click on the text to highlight all the characters. Change the Character properties to whatever you want.*

4. Duplicate the layer in the Timeline. Turn off the visibility of the original text layer by clicking on its Video switch ◉ (Figure 6.34).

Figure 6.34: *Duplicate the text layer. Hide the original text layer by clicking on its Video toggle switch.*

5. Select the duplicate text layer (**DOWNLOAD 2**) and twirl open the text layer to display the Text and Transform options. On the **Text** layer click on the arrow next to the word **Animate**. The popup menu contains all the Text properties you can animate on a per-character basis. Select **Scale** (Figure 6.35).

Figure 6.35: *Select the Scale animation property.*

6. The Timeline instantly has more layers added that may be a little confusing at first. Let's deconstruct the layers you need to work with. **Animator 1** is an animator group that holds the property that you chose to animate and a **Range Selector**. Let's focus on the Range Selector and the Scale property. Scrub through the Scale value and set it to **500%**. All the letters scale up at once.

Figure 6.36: *Increase the scale of each character to 500%.*

7. What happens if you want the letters to scale separately? To do this, twirl open the **Range Selector**. Scrub through the **Offset** value to scale each letter separately. The Offset value ranges from 0 to −100 or +100. Set the Offset value to **0**. Click on its **stopwatch** icon to set a keyframe at the current time.

Figure 6.37: *Scrub through the Offset value in the Range Selector.*

8. Move the Current Time Marker (CTI) to the two-second mark (02:00). Set the **Offset** value to **100**. A new keyframe is automatically generated.

9. Click on the **RAM Preview** button to see the results. Each letter starts out at 500% and scales down to its original size at 100%. It's a good start, but let's add more properties to create a more interesting animation. Save your project.

10. Now that you have set up the keyframes for the Range Selector, this will be applied to any additional property added to the text layer. On the **Animator 1** layer, select the popup menu next to the word **Add**. Select **Property > Opacity**.

Figure 6.38: *Add the Opacity animation property to the animator group.*

11. The Opacity property is added underneath Scale. Just like with the Scale property, the Opacity's value indicates the starting property for the text. Scrub through the value and set it to **0**. Now each letter will fade in one-by-one as they scale down to 100% (Figure 6.39).

Figure 6.39: *The text now fades in as it scales to 100%.*

12. The animation is getting better, but the scaling occurs at the baseline of the text. What if you want to scale from the center of the text? On the **Animator 1** layer, select the popup menu next to the word **Add**. Select **Property > Anchor Point**.

13. The Anchor Point property is added to the Animator 1 group. Scrub through the second value and set it to **–20**. This lowers the text vertically. Each letter will fade in and scale from the center of the text. Click on the **RAM Preview** button to see the results. Now that you have added a couple of text animation properties, let's experiment with some of the advanced settings.

14. In the **Range Selector 1**, twirl open the **Advanced** section. Turn on **Randomize Order**. Click on the **RAM Preview** button to see the results. Each letter animates in random order (Figure 6.40).

Figure 6.40: *Turn on Randomize Order in the Advanced settings.*

15. In the Advanced section, go to the **Based On** layer; click on the popup menu and select **Words** instead of Characters. Click on the **RAM Preview** button. Now the whole word animates. Change the property back to **Characters.**

Figure 6.41: *You can animate the entire word or the individual characters.*

Let's take a quick break from After Effects. Currently, this text animation could be used in Flash as a preloader animation. It will export as vector art. The exported SWF file size is 2 KB. To see an example of a preloader in Flash, locate and open the **Loader.fla** file in the **Preloader** folder inside **Chapter_06**.

DownloadText
Flash Movie
2 KB

The file contains two layers: preloader and actions. The SWF file was imported into a movie clip symbol with an instance name of **text_mc**. The text animation appeared as a series of keyframes in the Timeline. A graphic symbol for each letter appeared in the Library.

Loader

The animation was set up to loop back and forth by copying and pasting the keyframes and then reversing the frames. Click on the keyframe in Frame 1 of the **actions** layer. Open the Actions panel to see the ActionScript. The Loader class is used to import an external JPEG image.

```
// import Flash package
import flash.display.LoaderInfo;
import flash.net.URLRequest;

// define new loader object and URL request
var myLoader:Loader = new Loader();
var myFile:URLRequest = new URLRequest("JPEG/image1.jpg");
myLoader.load(myFile);

// create Event Listener
myLoader.contentLoaderInfo.addEventListener(Event.COMPLETE, loadImage);

// create Event Handler
function loadImage(e:Event){
    text_mc.visible = false;
    addChild(myLoader);
}
```

To simulate the file download, select **Control > Test Movie**. In the new SWF window that opens, select **View > Download Settings**. Make a selection from the different bandwidth profiles in the popup menu. Select **View > Simulate Download** to preview how fast the image will load under the chosen bandwidth. The text animation loops until the image is completely loaded (Figure 6.42).

Figure 6.42: *In Flash you can simulate file download for different bandwidths.*

The break is over. Let's get back into After Effects and explore another advanced technique using text selectors. In this next part of the exercise, you are going to focus on animating the original text layer that is currently hidden.

16. Turn off the visibility of the duplicate text layer by clicking on its video switch. Turn on the visibility of the original text layer (**DOWNLOAD**).

17. Double-click on the text to select all. Change the text color to a bright green. Increase the font size so that the text fills the width of the Comp panel (Figure 6.43). For this exercise, the font size was set to 95 pixels.

Figure 6.43: *Change the text color and increase the font size.*

18. In the Timeline, twirl open the text layer to display the Text and Transform options. Click on the arrow next to the word **Animate** and select **Position**.

19. In the **Range Selector 1** section, scrub through the Position value and set it to **0.0, 500.0**. This changes the vertical position of the text in the Comp panel.

20. On the **Animator 1** layer, select the popup menu next to the word **Add**. Select **Selector > Wiggly**. A new Wiggly Selector appears underneath the Range Selector 1 in the Timeline. The letters appear at different vertical locations in the Comp panel (Figure 6.44). A Wiggly Selector adds randomness to the overall text animation. You can control its affect through the Wiggly properties.

Figure 6.44: *Apply the Wiggly Selector to the text layer.*

21. Twirl open the **Wiggly Selector 1**. Change the **Wiggles/Second** value to **20.0**. The text now "wiggles" much faster in the Comp panel. To enhance the motion, let's activate the motion blur for this layer.

22. Turn on the **Motion Blur** switch for both text layers in the Timeline. Click on the **Enable Motion Blur** button at the top of the Timeline. Whenever this button is activated, any layer with the Motion Blur switch enabled will display the blur in the Comp panel.

23. Turn on the visibility of the duplicate text layer (**DOWNLOAD 2**) by clicking on its Video switch.

24. Click on the **RAM Preview** button. Your motion graphics project is starting to look like it belongs in the opening credits to *The Matrix*. Save your project.

25. Press the **Home** key to move the CTI to the beginning of the composition.

26. Deselect all text layers in the Timeline. Make sure nothing is highlighted. Go to the **Effects & Presets** panel. Twirl open the **Backgrounds** folder. Double-click on **Circuit**. A new solid layer is added to the Timeline and Project panel.

27. In the Timeline, move the **Solid 1** layer to the bottom of the stack. Type the **U** key to reveal all its keyframed properties. The **Scale** and **Evolution** properties appear. Click and drag both keyframes to the beginning of the composition.

28. Type **T** on the keyboard to display the layer's Opacity property. Set its value to **40%**. This provides better contrast between the text and the background. Click on the **RAM Preview** button to see the final results (Figure 6.45).

Figure 6.45: *The final composition includes an animated background preset.*

29. The composition is done. The project has evolved from a Flash preloading animation to a title sequence. Since you added motion blur to the text layers, exporting to a SWF file is now not the best solution. Render the composition as a Flash Video (F4V or FLV) file.

30. Select **Composition > Make Movie**. Click on **Lossless** next to Output Module.

 ▶ Set the Format to **FLV**.

 ▶ Click on **Format Options** and set the Bitrate setting to **400**.

31. Click on **Output To** and select the **Chapter_06** folder on your hard drive as the final destination for the rendered movie. Click the **Render** button. The final file size for the FLV file is 276 KB.

Comparing Text Capabilities in Flash

The exercises in this chapter focused exclusively on After Effects. As you can see, the text engine in After Effects is quite impressive. What about Flash? Prior to CS5, the text options in Flash left something to be desired when comparing it to After Effects or Adobe InDesign. Wouldn't it be great if Flash had a lot of the same typographical control? Well now it does.

Flash Professional CS5 supports **Text Layout Framework (TLF)** as well as the Classic text from previous versions. TLF provides advanced text editing capabilities in Flash targeted specifically for Flash Player 10 and ActionScript 3.0. Figure 6.46 shows some of the new editing features located in the Properties panel.

In CS5, you can create three types of text blocks with TLF text:

 ▶ **Read Only:** when published as an SWF file, the text cannot be selected or edited.

 ▶ **Selectable:** when published as an SWF file, the text is selectable and can be copied to the clipboard, but is not editable. This setting is the default for TLF text.

 ▶ **Editable:** when published as an SWF file, text is selectable and can be edited.

The Properties panel provides options that allow you to perform advanced text styling such as kerning, ligatures, tracking, and leading using TLF. You can now reflow text to another text box. Thread together as many text blocks as you want.

If you work on multilingual projects, you can reflow text right to left, bottom to top; any direction you want. TLF supports bidirectional text input to work with languages such as Arabic. East Asian typography is now supported. These new features allow you to take control over your text with print-quality typography. What about animation? Flash also offers motion presets that act similar to the Effects and Presets panel in After Effects.

Figure 6.46: *TLF text properties in CS5.*

Flash CS4 introduced **motion presets**. This feature gives you the ability to take just your animation, save it as something that you can reuse, and apply to a different object fairly easily. If you open the Motion Presets panel, you can select any of the already-provided presets. Notice that you see a preview of what the preset actually looks like. Simply click on **Apply** to create an animation using a selected object on the Stage (Figure 6.47).

Figure 6.47: *Flash provides Motion Presets to easily apply and reuse saved animation.*

While the motion presets are convenient and easy-to-use in Flash, they do not match the complexity in animation capabilities that After Effects provides. You have at your disposal an arsenal of text animators and properties to control and animate over time. The possibilities are endless.

Summary

This completes the chapter on type in motion. You covered a lot of ground with text and all its properties. This chapter only scratches the surface of what you can do with the text engine in After Effects. The best way to keep learning is to apply the text animation presets and examine their structure. From there, you can start creating your own custom presets. In the next chapter you cross over into the third dimension.

CHAPTER 7

. .

The Third Dimension

Step into the third dimension. Both After Effects and Flash allow you to position and animate layers in 3D space. This chapter continues your journey in creativity for Flash web and broadcast design using the Z-axis as your guide.

doi: 10.1016/B978-0-240-81351-6.50007-0

Entering 3D Space in After Effects

Up to this point in the book, you have worked exclusively in two dimensions—X and Y. Both After Effects and Flash travel beyond 2D by allowing you to move layers along the Z-axis (depth). In addition, in After Effects you can add cameras, and even lights that illuminate 3D layers, creating realistic cast shadows.

 *Download (http://booksite.focalpress.com/companion/jackson) the **Chapter_07.zip** file to your hard drive. It contains all the files needed to complete the exercises.*

The first two exercises start with the basics, converting layers into 3D layers in After Effects. Any layer, other than an adjustment layer, can be positioned in 3D space as long as it contains content. You will create a 3D animation using an animation preset and render the composition as an FLV optimized for the web.

Once imported into Flash, the FLV file will be positioned in 3D space inside Flash. As a result, you will be able to compare how both After Effects and Flash utilize 3D space respectively. To see what you will build, locate and launch the **3DSpaceConsole.swf** file in the **Completed** folder inside the **01_3DSpace** folder in **Chapter_07** (Figure 7.1). Click on the video. The Flash playback head jumps to another frame and plays an animation that zooms out of the scene.

Figure 7.1: *The planet and text are 3D layers in After Effects.*

1. In **Adobe After Effects**, select **File > Open Project**. Navigate to the **01_3DSpace** folder inside **Chapter_07**. Select **01_3DSpace.aep**, and click **Open**. The project contains one composition named **3DSpace**. Open the composition.

2. Select the **Planet30.mov** layer. Type **P** on the keyboard to display the layer's Position property. Hold down the **Shift** key and type **R** to open the Rotation property as well. Notice that these properties work in two-dimensional space (Figure 7.2). The layer's position can only move along the X-axis (left and right) and the Y-axis (up and down).

Figure 7.2: *By default, all layers in After Effects are displayed in two-dimensional space.*

3. In the Timeline panel, locate the **3D Layer** switch in the switches column. Its icon is a cube. Select the 3D Layer switch for the **Planet30.mov** layer. You just crossed over into the third dimension. Exciting... huh? Well, nothing much happened in the Comp panel, but take a look at the transform properties you opened in the previous step (Figure 7.3).

Figure 7.3: *3D layers acquire additional transform properties.*

When a layer is converted into a 3D layer, it acquires the Z-axis. There are now six Rotate properties to choose from. A new transform property called **Orientation** represents the layer's absolute rotational XYZ angles. It is best to use the other XYZ Rotation properties for any type of 3D animation. Only use Orientation to set a 3D layer's rotation angle that does not animate.

4. Let's rotate the planet in 3D space. Select the **X Rotation** value. Scrub through the second value by moving your cursor left and right. The layer rotates around the X-axis (Figure 7.4). The Rotation value is measured in degrees.

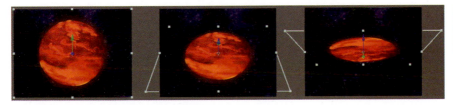

Figure 7.4: *X Rotation rotates the layer around the X-axis.*

5. When you are done, set the **X Rotation** property back to **0** degrees.

6. Select the **Y Rotation** value. Scrub through the second value by moving your cursor left and right. The layer rotates around the Y-axis (Figure 7.5).

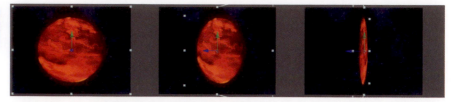

Figure 7.5: *Y Rotation rotates the layer around the Y-axis.*

7. When you are done, set the **Y Rotation** property back to **0** degrees.

8. Select the **Z Rotation** value. Scrub through the second value by moving your cursor left and right. The layer rotates around the Z-axis (Figure 7.6).

Figure 7.6: *Z Rotation rotates the layer around the Z-axis.*

9. Set the **Z Rotation** property back to **0** degrees. Deselect the layer.

ℹ️ *You may have noticed that the 3D layer does not contain any thickness to it. After Effects allows you to position flat 2D layers in three-dimensional space. Think of it as holding a sheet of paper up in front of you and turning it from side to side.*

10. Let's continue by adding a 3D text animation preset. Make sure that none of the layers are selected in the Timeline. Go to the **Effects & Presets** panel. Twirl open the **Animation Presets** folder. Twirl open the **Text** folder.

Figure 7.7: *Double-click on the 3D animation preset to add it to the composition.*

11. Twirl open the **3D Text** folder and double-click on **3D Rotate around Circle**. This creates a text layer in the Timeline. It is already set as a 3D layer (Figure 7.7).

12. A yellow circle appears around the layers in the Comp panel. You need to adjust its rotation on the X-axis to see the letters. Go to the Timeline and select the 3D text layer. Type **R** on the keyboard to open its Rotation property.

13. Scrub through the **X Rotation** value and set it to **–85** degrees.

14. Go to the Comp panel. Double-click on the yellow line to select the path. The best place to double-click is in the gray area. Click and drag the bottom left handle in closer to the planet. Do the same with the right handle.

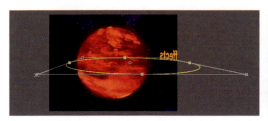

Figure 7.8: *Scale the 3D text path to be closer to the planet.*

15. Type the **U** key on the keyboard to reveal all the keyframed properties for the layer. The **First Margin** property appears with two keyframes in the Timeline. This controls the text animation around the circular path.

16. Press the **Home** key on the keyboard. This moves the Current Time Indicator to the beginning of the composition (00:00).

17. Scrub through the **First Margin** value to position the text behind the planet.

18. Press the **End** key to move the CTI to the end of the Timeline.

19. Click and drag the second keyframe to the end of the composition. Hold the Shift key while dragging and the keyframe will snap to the CTI.

 ▶ Scrub through the **First Margin** value to position the text behind the planet.

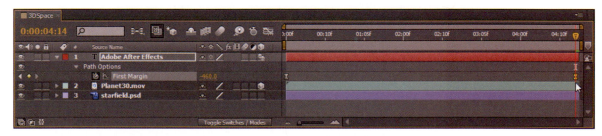

Figure 7.9: *Click and drag the second keyframe to the end of the composition.*

20. Scrub through the Timeline until the text is in front of the planet in the Comp panel. Select the Text tool and highlight all the text.

 ▶ Change the default text from **Adobe After Effects** to **Launch Mission**.

- Go to the Character panel and change the text to whatever font and size you want. Arial Black was used for this exercise at 24 points.
- The text color is set to yellow.

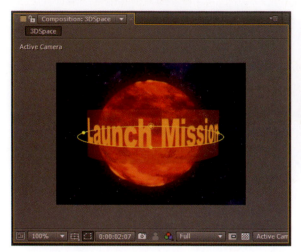

Figure 7.10: *Change the 3D text's font and color using the Character panel.*

21. Click on the **RAM Preview** button. Notice that the text goes behind the planet even though in the Timeline the text layer is stacked on top of the planet layer. Why is this happening? 3D layers ignore the stacking order. The layer's distance from the active camera determines which layer is in front (Figure 7.11).

Figure 7.11: *3D layers ignore the stacking order in the Timeline panel.*

22. Leave the **starfield.psd** layer as a 2D layer. You can mix 2D and 3D layers within the same composition. Save your project. Select **Composition > Make Movie**.

23. Click on **Lossless** next to Output Module. Set the Format to **FLV**. Click on **Format Options** and set the Bitrate setting to **400**. The correct dimensions (320 x 240) and frame rate (15 fps) were set when the composition was initially created using the Web Video (320 x 240) preset.

24. Click on **Output To** and select the **Chapter_07** folder on your hard drive as the final destination for the rendered movie. Click the **Render** button. This completes the first part. Let's take a look at the 3D space in Flash.

Entering 3D Space in Flash

Flash CS4 introduced the ability to position and animate objects in 3D space. Prior to that, Flash designers simulated depth through scaling objects. The 3D Rotation Tool and the 3D Translation Tool allow you to maneuver movie clip symbols in 3D space.

 These 3D tools only work on movie clips and no other types of symbols. Also, the 3D capabilities of Flash only work in Flash Player 10 and ActionScript 3.0.

Similar to After Effects and any 3D modeling application, Flash divides its screen coordinate system into three axes (Figure 7.12).

- The **X-axis** runs horizontally across the Stage with its origin, or 0-point at the left edge of the Stage.
- The **Y-axis** runs vertically, with its 0-point at the top edge of the Stage.
- The **Z-axis** runs into and out of the plane of the Stage (toward and away from the viewer), with its 0-point at the plane of the Stage.

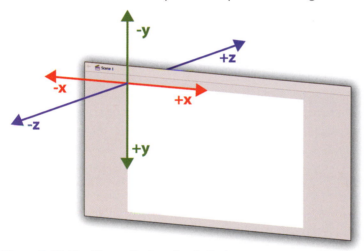

Figure 7.12: *The 3D coordinate system in Flash.*

1. Open **3DSpaceConsole.fla** in the **01_3DSpace** folder to open the file in Flash. It contains two layers: **Video** and **Background**.

2. Select the blank keyframe on Frame 1 of the **Video** layer. Select **File > Import > Import Video**. The Import Wizard dialog box appears.

3. To import the FLV file:

 - Locate the **3DSpace.flv** file you rendered out of After Effects.
 - Select the **Load external video with playback component** option.
 - Set the Skin to **None**.
 - Click **Finish** to create the FLVPlayback component on the Flash Stage.
 - Go to the Properties panel and enter an instance name of **myVideo**.

3DSpaceConsole

4. Make sure the FLVPlayback component is still highlighted on the Stage. Select **Modify > Convert to Symbol**. The **Convert to Symbol** dialog box opens:

 ▶ Enter **videoContainer** as the symbol's name.

 ▶ Select Movie Clip as the symbol type.

 ▶ Click on the center square for the registration point.

 ▶ Click **OK** (Figure 7.13).

 ▶ Go to the Properties panel and enter an instance name of **videoContainer_mc**.

Figure 7.13: *Convert the FLVPlayback component into a movie clip.*

5. Select the 3D Rotation Tool (**W**).

6. Single-click on the video movie clip. A guide for the 3D rotation appears as a multicolored circular target. Each guide line is color coded: the red line rotates the movie clip instance along the X-axis, the green line rotates the instance along the Y-axis, and the blue line rotates the instance along the Z-axis.

7. Experiment with the 3D Rotation Tool. Click on one of the guides and drag the mouse in either direction to rotate the title movie clip instance in 3D space. The orange circular guide allows you to freely rotate the instance in all three directions (Figure 7.14).

Figure 7.14: *The orange circular guide allows you to freely rotate the movie clip.*

8. Reset the rotation of the movie clip instance. Open the Transform panel and click on the **Remove Transform** button in the lower-right corner (Figure 7.15).

Figure 7.15: *Remove the 3D transformation using the Transform panel.*

9. In the Transform panel, set the 3D Rotation to: **X = 12**, **Y = –23**, **Z = 0** degrees.

10. Go to the Properties panel, and set the 3D Position's **Z** value to **23**. Click and drag the movie clip into position over the black monitor window (Figure 7.16).

Figure 7.16: *Apply 3D transformation using the Transform and Properties panel.*

11. Flash does not ignore the layer stacking order when translating objects in 3D space. Click and drag the **Video** layer underneath the **Background** layer.

12. Create a new layer and label it **actions**.

13. Select the keyframe in Frame 1 of the **actions** layer. Open the Actions panel. Enter the following code:

```
// import Flash class
import fl.video.*;

// add Event Listeners to FLVPlayback component
videoContainer_mc.myVideo.addEventListener(VideoEvent.COMPLETE, loopVideo);

// add Event Handler
function loopVideo(e:VideoEvent){
   // go back to the beginning and start playing
   e.target.seek(0);
   e.target.play()
}

// enable the cursor change for the movie clip
videoContainer_mc.buttonMode = true;
videoContainer_mc.addEventListener(MouseEvent.CLICK, startMission);

function startMission(e:MouseEvent){
   gotoAndPlay(2)
}

stop();
```

The code imports the Flash Video package. This allows Flash to access video events such as when it is done playing (COMPLETE). An Event Listener "listens" for the video to complete. When it "hears" the event, the linked Event Handler (loopVideo) instructs the FLVPlayback component to rewind the video back to the first frame (0) and starts playing it again.

Another Event Listener detects a mouse click on the movie clip. When that event occurs, the Flash movie jumps to the second frame in the Timeline and plays the animation. To provide user feedback, the buttonMode for the movie clip is set to true. This will change the appearance of the cursor when it rolls over the video indicating that the video is clickable.

14. Insert a blank keyframe on **frame 30** of the **actions** layer. Open the Actions panel and enter **stop();** to hold the playback on the last frame.

15. Select **Control > Test Movie**. Click on the video.

This completes the exercise. You experimented with 3D space in After Effects and Flash. You also added a 3D text animation preset in After Effects. 3D layers in After Effects ignore the layer stacking order in the Timeline, but not in Flash. Let's switch our focus from rotation to position. The next exercise continues your 3D trek by animating the Z-axis Position property in After Effects.

Adding a Camera in After Effects

The goal of this exercise is to animate a layer's position in three-dimensional space viewed through a 3D camera. The previous exercise defined the X-, Y-, and Z-coordinates. It is the same in After Effects. Changing the X-position of a layer moves it left or right. Changing the Y-position moves a layer up or down. The Z-axis moves a layer toward or away from the active camera.

Table 7.1: *Understanding X-Y-Z in After Effects*

Axis	Position	+ Value	- Value
X	Left and Right	Moves Right	Moves Left
Y	Up and Down	Moves Up	Moves Down
Z	Toward and Away	Moves Away	Moves Toward

To see an example of what you will build in this exercise, locate and play the **RomanMarch.mov** in the **Completed** folder inside the **02_3DAnimation** folder in **Chapter_07**. You will build a 3D animation using an imported Flash SWF file. The final composition will be prepared for NTSC video (Figure 7.17).

Figure 7.17: *The final movie contains a Flash SWF file animated along the Z-axis.*

1. In **Adobe After Effects**, select **File > Open Project**.

2. Navigate to the **02_3DAnimation** folder inside **Chapter_07**. Select **02_3DAnimation.aep** and click **Open**.

02_3DAnimation

3. The Project panel contains all of the footage you need to complete the exercise. Open the **RomanMarch** composition. It contains five layers. Each layer is a duplicate of an imported SWF footage file. Select all the layers in the Timeline. Select the 3D Layer switch for any one of the selected layers. This will turn all of the selected layers into 3D layers.

4. Type **P** on the keyboard to display each layer's Position property.

5. Now it is time to position each duplicate row of Roman soldiers in 3D space. To do this you are going to change the Z-position for each layer (Figure 7.18). First, deselect all the layers by clicking in the gray area underneath Layer 5.

 ▶ Select **Layer 2** and change the Z-position value from 0 to **300**.

 ▶ Select **Layer 3** and change the Z-position value from 0 to **600**.

 ▶ Select **Layer 4** and change the Z-position value from 0 to **900**.

 ▶ Select **Layer 5** and change the Z-position value from 0 to **1200**.

Figure 7.18: *Change the Z-position for each layer.*

6. The Comp panel currently displays a limited view of the new 3D positioning. Go to the Comp panel. From the **3D View** popup menu, select **Custom View 1**. The Comp panel now displays a better angle to see the 3D positioning. There are several views to choose from (Figure 7.19).

> ℹ *The Active Camera view is the default and the view that will be rendered when you export your final movie. Use the other views to position and align 3D layers. Before you render, return to the Active Camera view to evaluate the final composition.*

7. You can also easily change any of the custom camera views using the Orbit Camera Tool, Track XY Camera Tool, and Track Z Camera Tool in the Tools panel. Go to the Tools panel and select the **Orbit Camera Tool** (Figure 7.20).

8. Go to the Comp panel and click and drag the cursor across the image to rotate around your composition in 3D space. Experiment with the other Camera Tools. Select them from the Tools panel and click and drag in the Comp panel.

Front View

Custom View 2

Custom View 3

Figure 7.19: *3D views allow you to see 3D layers from different angles.*

- ▶ The **Orbit Camera Tool** rotates around the composition.
- ▶ The **Track XY Camera Tool** pans left, right, up, and down.
- ▶ The **Track Z Camera Tool** controls how close the layers are to the view.
- ▶ None of these tools affect the position of your layers, only the view.

Figure 7.20: *3D Camera Tools allow you to change any custom view.*

9. Return the 3D view to the **Active Camera** view. Now that you are aware of how to maneuver around the composition using the views, it is time to animate. Instead of animating each layer separately, you will use parenting to link four of the layers to one "parent" layer. All you need to do is animate the parent layer.

10. Go to the Timeline panel. Click on the menu popup arrow ▦ in the upper right corner of the panel. Select **Columns > Parent**. The Parent column appears next to the switches (Figure 7.21).

- ▶ Select Layers 2 through 5.
- ▶ From the Parent popup menu, select layer **1.RomanGROUP.swf**.
- ▶ Layers 2 through 5 are now attached to Layer 1. Any changes made to this layer, the parent, will affect all the attached layers, the children.

ℹ *Parenting allows you to attach one layer or layers to another layer. This is similar to grouping. Chapter 8 covers parenting in more detail.*

Figure 7.21: *Parenting allows you to attach one or multiple layers to another.*

11. Press the **Home** key on the keyboard to move the CTI to 00:00.

12. Select **Layer 1**. Click on the **stopwatch** icon next to the Position property. This records the layer's position at the start of the composition.

13. Move the CTI to the 11-second mark (11:00). `0;00;11;00`

14. Set the Z-position of **Layer 1** to **–2800**. A negative value on the Z-axis moves the layer toward the active camera. A new keyframe is also generated.

15. Click on the **RAM Preview** button. The Roman soldiers march into the camera. Notice that all the soldiers animate even though **Layer 1** contains the only keyframed animation. This is a result of parenting. Save your project.

16. Click and drag the **Rome.psd** file from the Project panel to the Timeline. Position it at the bottom of the layers. The background image appears in the Comp panel. For this exercise, leave this layer as a 2D layer (Figure 7.22).

Figure 7.22: *Add the background image to the composition.*

17. Let's add a camera to the composition. Select **Layer > New > Camera**. The Camera Settings dialog box appears. Enter **Camera 1** for the name. Set the preset to **50 mm** and check the checkbox to enable depth of field. Click **OK**.

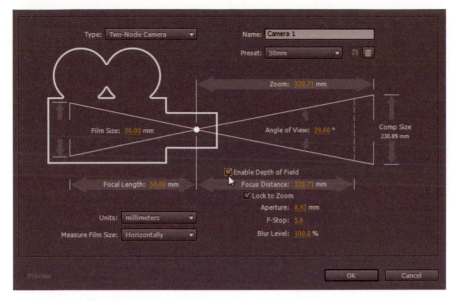

Figure 7.23: *Add a 3D camera to the composition. They appear on their own layer.*

18. By default, cameras are 3D layers. Twirl open the camera transform properties.

 ▶ Change the **Point of Interest**'s second value (Y-position) to **220**.

 ▶ Change the **Position's** second value (Y-position) to **160**.

 ▶ This camera adjustment changes the viewed perspective of the 3D layers slightly to align better with the linear perspective in the background image.

Figure 7.24: *Adjust the vertical position of the camera.*

19. Click and drag the **RomansLogo.ai** file from the Project panel to the Timeline. Position it under the **Camera 1** layer (Figure 7.25).

 ▶ Turn on the **3D Layer** switch for the layer.

 ▶ Turn on the **Continuously Rasterize** switch to maintain the smooth detail in the vector artwork as it scales larger than its original size.

Figure 7.25: *Turn on the 3D Layer and the Continuously Rasterize switch.*

20. Let's animate the logo along the Z-axis. It will animate in the opposite direction of the marching Roman soldiers. Type **P** on the keyboard to display the layer's Position property. Set the third value (Z-axis) to **–1000**. The position of the logo is now set behind the camera. This will be its starting position.

21. Move the CTI to the eight-second mark (08:00). Click on the **stopwatch** icon next to the Position property. This records the starting position of the logo.

22. Move the CTI to the 11-second mark (11:00). Set the third Position value (Z-axis) to **200**. The logo is now centered in front of the camera. This is the ending position for the logo animation. A keyframe is automatically created.

23. Click on the **RAM Preview** button. After the Roman soldiers march off the screen, the logo animates in. You have just animated several layers along the Z-axis. Changing the Z-value from positive to negative moves a layer (Roman soldiers) toward the active camera. Changing the Z-value from negative to positive moves a layer (ROMANS logo) away from the camera. This 3D effect would be extremely difficult to replicate in Flash. Save your project.

Figure 7.26: *The Roman soldiers and logo animate along the Z-axis.*

24. Let's add some finishing touches to the project before you render it. Select the **Rome.psd** layer in the Timeline. Type **T** on the keyboard to open the layer's Opacity property. You are going to fade the background image out when the logo animates in.

25. Move the CTI to the eight-second mark (08:00). Click on the **stopwatch** icon next to the Opacity property. This records a starting opacity of 100%.

26. Move the CTI to the 11-second mark (11:00). Set the Opacity value to **0**.

Figure 7.27: *Fade out the background image as the logo animates in.*

27. Select the **RomansLogo.ai** layer in the Timeline. Let's add an effect to this layer.

28. Select **Effect > Generate > CC Light Sweep**. This simulates a beam of light.

29. Move the CTI to the 11-second mark (11:00).

30. Go to the Effect Controls panel. Click on the **stopwatch** icon next to the **Center** property. Change the first value to **–100**. This positions the beam of light off the left edge of the layer.

31. Move the CTI to the 13-second mark (13:00). Set the Center property's first value to **730**. This places the beam of light off the right edge of the layer.

32. Click on the **RAM Preview** button. After the logo animates in, a beam of light moves across the letterforms adding a small highlight to the logo artwork.

Figure 7.28: *Add the CC Light Sweep effect to highlight the logo.*

33. Click and drag both audio footage files from the Project panel to the Timeline. Position them above the **Camera 1** layer. This completes the composition.

Figure 7.29: *Add the audio files to the Timeline.*

34. Select **Composition > Make Movie**. This opens the Render Queue.

35. Click on **Lossless** next to Output Module. Set the Format to **QuickTime** movie.

36. Click on **Format Options** and set the compression setting to **MPEG-4 Video**. Enable the Audio export for the music and marching sound effect.

37. Click on **Output To** and select the **Chapter_07** folder on your hard drive as the final destination for the rendered movie. Click the **Render** button.

This exercise focused on animating a layer's position along the Z-axis. As you create 3D layers, use the different 3D views in the Comp panel to see the layers from multiple angles. These views help with positioning and alignment. After Effects also lets you create your own 3D cameras to view the composition. The next exercise focuses on building an interactive 3D environment.

Creating Interactive 3D Environments

In the previous exercise you explored the 3D views available in the Comp panel. The default view is the Active Camera. The first two projects dealt with animating layers in 3D space. What if you want to animate the Active Camera? Well, you can't. Instead, After Effects allows you to add your own camera as a 3D layer in a composition and animate it in 3D space.

This exercise provides a step-by-step tutorial on adding a camera, positioning it in your 3D world, and finally setting keyframes to animate the camera through a 3D environment. You will build the environment out of 3D layers. The composition will be rendered as a Flash Video file for web delivery.

You will then use ActionScript to add interactivity to the 3D world. To see what you will build, locate and launch the **HauntedHallway.swf** file in the **Completed** folder inside the **03_3DEnvironment** folder in **Chapter_07**. Position the cursor over the arrow on the floor (Figure 7.30). As you proceed down the hallway, other animations are triggered to play based on cue points set in the FLV file.

Figure 7.30: *The final SWF file is an interactive 3D environment.*

Let's deconstruct how the artwork was created for this project. Open the layered Photoshop file in the **03_Footage** folder. The Photoshop file contains six layers. These layers will be imported and converted into 3D layers in After Effects. Each layer will be oriented in 3D space to create the final hallway scene.

HallwayScene

Figure 7.31: *The artwork was created in Photoshop on separate layers. The dimensions of the hallway are 2500 x 500 pixels at a resolution of 72 dpi.*

1. In **Adobe After Effects**, select **File > Open Project**. Open the **03_3DEnvironment** folder inside **Chapter_07**. Select **03_HauntedHallway.aep** and click **Open**. The Project panel contains footage of each layer in the Photoshop file.

03_HauntedHallway

2. Select **Composition > New Composition**. You need to make the composition the same size as the Flash Stage you will be importing the 3D animation into. Make the following settings:

 ► Composition Name: **HauntedHallway**
 ► Width: **550**
 ► Height: **400**
 ► Pixel Aspect Ratio: **Square Pixels**
 ► Frame Rate: **30**
 ► Duration: **0:00:10:00**

 Click **OK**. The new composition opens in the Comp panel.

3. Click and drag the **floor/HallwayScene.psd** footage file from the Project panel to the Timeline. Turn on the **3D Layer** switch for the layer. Type **P** on the keyboard to display the layer's Position property. Hold down the **Shift** key and type **R** to open the Rotation property as well.

4. Set the **X Rotation** and **Z Rotation** to **90**.

5. Set the **Position** property to **275.0**, **450.0**, and **0.0**.

Figure 7.32: *Rotate and position the floor layer in 3D space.*

6. Click and drag the **wall/HallwayScene.psd** footage file from the Project panel to the Timeline. Position it on top of the previous layer. Turn on the **3D Layer** switch for the layer. Open the Position and Rotation transform properties.

 ▶ Set the **Y Rotation** to **90**.

 ▶ Set the **Position** property to **525.0**, **200.0**, and **0.0**.

Figure 7.33: *Rotate and position the wall layer in 3D space.*

7. Duplicate the **wall/HallwayScene.psd** layer. Select the layer and press **Command + D** (Mac) or **Control + D** (Windows).

 ▶ Set the **Y Rotation** to **270**.

 ▶ Set the **Position** property to **25.0**, **200.0**, and **0.0**.

Figure 7.34: *Rotate and position the duplicate wall layer in 3D space.*

8. Click and drag the **ceiling/HallwayScene.psd** footage file from the Project panel to the Timeline. Position it on top of the previous layer. Turn on the **3D Layer** switch for the layer. Open the Position and Rotation transform properties.

 ▶ Set the **X Rotation** and **Z Rotation** to **90**.

 ▶ Set the **Position** property to **275.0**, **–50.0**, and **0.0**.

This sets up the basic structure of the hallway. Next you will add the doorframe, door, and chandelier to the 3D scene.

9. Click and drag the **doorframe/HallwayScene.psd** footage file to the Timeline. Position it at the top of the layers. Turn on the **3D Layer** switch.

 ▸ Set the **Position** property to **275.0**, **200.0**, and **1245.0**.

Figure 7.35: *Position the doorframe layer in 3D space.*

10. Click and drag the **door/HallwayScene.psd** footage file to the Timeline. Position it at the top of the layers. Turn on the **3D Layer** switch. Type **A** on the keyboard to display the layer's Anchor Point property. Hold down the **Shift** key and type **P** to open the Position property as well.

 ▸ Set the **Anchor Point** to **0.0**, **211.5**, and **0.0**.

 ▸ Set the **Position** property to **155.0**, **238.0**, and **1245.0**.

Figure 7.36: *Position the door layer in 3D space.*

11. Click and drag the **chandelier/HallwayScene.psd** footage file to the Timeline. Position it at the top of the layers. Turn on the **3D Layer** switch.

 ▸ Set the **Position** property to **275.0**, **20.0**, and **0.0**.

 ▸ Twirl open the **Materials Options**. Turn on the **Casts Shadows** property. This layer will now cast realistic shadows when a 3D light is added to the scene.

Figure 7.37: *Position the chandelier layer in 3D space.*

This completes the 3D environment. Next, you will add a 3D camera.

12. Select **Layer > New > Camera**. The Camera Settings dialog box appears. Enter **myCamera** for the name. Set the preset to **50 mm** and check the checkbox to enable depth of field. Click **OK**.

13. Go to the Comp panel. From the **3D View** popup menu, select **Custom View 1**. The Comp panel now displays a better angle to see the camera and the 3D hallway.

14. Use the Orbit Camera Tool, Track XY Camera Tool, and Track Z Camera Tool in the Tools panel to rotate, and zoom out to see the entire composition.

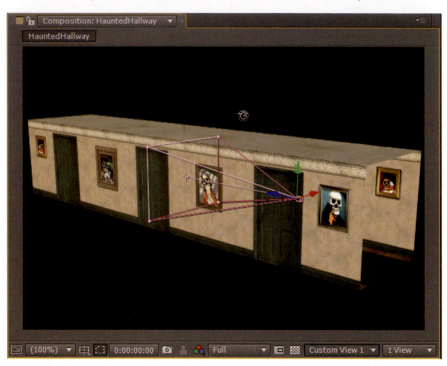

Figure 7.38: *Rotate and zoom out using the 3D Camera Tools.*

15. The camera has handles and an axis similar to other 3D layers. The triangular shape attached to it defines the field of view from the camera lens. The straight line with a cross hair target at the end is the point of interest. This indicates which way the camera is pointing. Twirl open the camera transform properties.

 ▶ Change the **Point of Interest** property to **275.0**, **200.0**, and **1250.0**.

 ▶ Change the **Position property** to **275.0**, **260.0**, and **–1939.0**.

Figure 7.39: *Change the Point of Interest and the Position properties.*

The point of interest moves to the door at the end of the hallway. This guarantees that the camera will always be facing that door as it animates down the hall. The camera position is moved to the opposite end of the hallway. This will be the starting point for the animation. The vertical position was lowered to enhance the linear perspective in the scene (Figure 7.40).

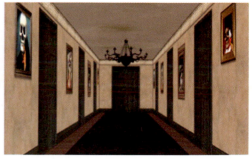

Figure 7.40: *The custom view (left) and the Active Camera view (right) show the results of changing the camera's position and point of interest.*

16. Return the 3D view to the **Active Camera** view. This view is now the same as **myCamera** view. If you add more cameras to the composition, the Active Camera view will display the view for the selected camera in the Timeline.

17. Let's add some lights to the composition. Select **Layer > New > Light**. The Light Settings dialog box appears. Set the Light Type to **Point** and click **OK**.

> ℹ️ *A point light is an omnidirectional light source. Think of it as a bare light bulb. When a light is added to a composition, the default lighting turns off. Lights only affect 3D layers.*

18. Twirl open the Light transform properties in the Timeline. Set the **Position** property to **275.0**, **150.0**, and **450.0**.

19. Twirl open the Light Options. Set the Intensity to **90%**. Turn on the **Casts Shadows** option. Click on the color swatch. The Parameter Colors dialog box appears. Change the RGB values to **180**, **208**, and **240**. This will cast an eerie blue light over the 3D scene. Notice the cast shadow projected from the chandelier. Lighting can greatly enhance your 3D layers (Figure 7.41).

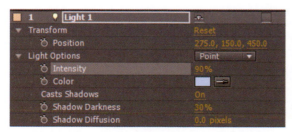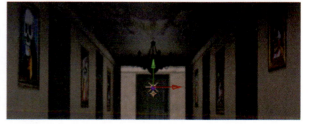

Figure 7.41: *Add a point light to the composition.*

20. Duplicate the **Light 1** layer. Set the duplicate light's **Position** property to **275.0**, **400.0**, and **−1000.0**. Set the Intensity to **95%**. This completes the lighting.

21. It is time to animate the camera. Press the **Home** key on the keyboard to move the CTI to 00:00.

22. Select the **myCamera** layer in the Timeline. Click on the **stopwatch** icon next to the Position property. This records the camera's current position.

23. Move the CTI to the nine-second mark (09:00). Change the camera's **Position property** to **275.0**, **260.0**, and **625.0**. The camera moves in close to the door at the end of the hallway. A new keyframe is created.

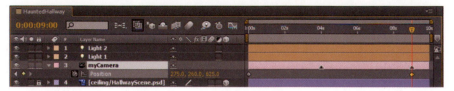

Figure 7.42: *Animate the camera along the Z-axis.*

24. Click on the **RAM Preview** button. The camera slowly moves down the hallway. Save your project.

25. The door is a separate 3D layer. Let's create an animation that opens the door. Move the CTI slightly past the nine-second mark (09:10).

26. Select the **door/HallwayScene.psd** layer in the Timeline. Click on the **stopwatch** icon next to the **Y Rotation** property. This records the starting keyframe.

27. Press the **End** key on the keyboard to move the CTI to the end of the composition. Change the **Y Rotation** property to **–102.0** degrees. This rotates the door around the Y-axis. Since you moved the layer's Anchor Point to the left edge of the door in step 10, the door rotates at that point.

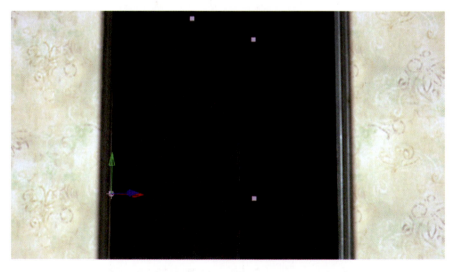

Figure 7.43: *Rotate the door layer around the Y-axis to open the door.*

28. Move the CTI in-between the two keyframes you just created (09:19).

Chapter 7: The Third Dimension

29. Select the **myCamera** layer in the Timeline. Click on the gray diamond to the left of the word Position. This adds a keyframe at the current time.

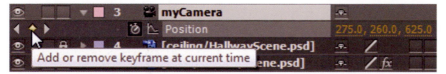

Figure 7.44: *Add a keyframe at the current time.*

30. Press the **End** key on the keyboard to move the CTI to the end of the composition. Change the camera's **Position property** to **275.0**, **260.0**, and **1025.0**. The camera now animates through the open door.

31. Just a couple more steps are needed before you render the Flash Video file. First, select the **doorframe/HallwayScene.psd** layer. Select **Effect > Color Correction > Hue/Saturation**. Go to the Effect Controls panel and adjust the **Master Lightness** to **–70**. This darkens the doorframe to match the lighting.

32. Select the **door/HallwayScene.psd** layer. Select **Effect > Color Correction > Hue/Saturation**. Go to the Effect Controls panel and adjust the **Master Lightness** to **–70**. This darkens the door to match the lighting.

33. Select the **myCamera** layer in the Timeline. Move the CTI to the four-second mark (04:00). Select **Layer > Add Marker**. Layer-time markers allow you to label specific points in time within the Timeline area. These markers are included in the rendered movie. A triangular marker appears on the selected layer duration bar. Double-click on it.

34. The Layer Marker dialog box opens. Go to the **Flash Video Point** section; enter **bat** for the name. Set the cue point to an **Event**. When you render the final composition as a Flash Video file, this marker will be included as a cue point. Click **OK**.

Figure 7.45: *Add a Flash Video cue point at the four-second mark.*

35. Move the CTI to the nine-second mark (09:00). Select **Layer > Add Marker**. Double-click on the new marker in the Timeline. In the **Flash Cue Point** section, enter **ghost** for the name. Click **OK**.

Figure 7.46: *Add a Flash Video cue point at the nine-second mark.*

36. Click on the **RAM Preview** button to view the final composition.

37. Select **Composition > Make Movie**. This opens the Render Queue.

38. Click on **Lossless** next to Output Module. Set the Format to **FLV**. Click on **Format Options** and set the Bitrate setting to **700**.

39. Click on **Output To** and select the **Chapter_07** folder on your hard drive as the final destination for the rendered movie. Click the **Render** button.

03_HauntedHallway

40. Let's move to Flash to add the interactivity. Double-click on **03_Haunted Hallway.fla** in the **03_3DAnimation** folder to open the file in Flash. It contains six layers: **actions**, **buttons**, **bat**, **ghost**, **progressBar**, and **video**.

The **bat** layer contains a movie clip of a bat flying across the Stage. It has an instance name of **bat_mc**. The **ghost** layer contains a frame-by-frame animation of a floating ghost. Its instance name is **ghost_mc**. These movie clips will play when the corresponding cue point in the FLV file is reached during playback.

Figure 7.47: *The Flash file contains two movie clips that will play based on the embedded Flash Video cue points.*

The **progressBar** layer holds a Flash ProgressBar UI component. The FLV file was encoded at high quality in After Effects. This bar will provide user feedback as the video progressively downloads from the web. Its instance name is **pBar**.

The **buttons** layer holds a button symbol. When the cursor rolls over the button the FLVPlayback component will play the video file. When the cursor rolls off, the video stops. It has an instance name of **forward_btn**. Let's add the video.

41. Select the blank keyframe on Frame 1 of the **video** layer. Select **File > Import > Import Video**. The Import Wizard dialog box appears. To import the FLV file:

▶ Locate the **HauntedHallway.flv** file you rendered out of After Effects.

▶ Select the **Load external video with playback component** option.

▶ Set the Skin to **None**.

▶ Click **Finish** to create the FLVPlayback component on the Flash Stage.

▶ Go to the Properties panel and enter an instance name of **display**.

42. Select the keyframe in Frame 1 of the **actions** layer. Open the Actions panel. Enter the following code to import the Flash packages needed for this project. Also define the variables that will be used later.

```
// import Flash packages
import fl.video.*;
import fl.controls.ProgressBarMode;

// define Variables
var flvScene = display;
var flvSource = "HauntedHallway.flv";
```

43. Next, create four new Sound objects that will play the sound effects and the background sound. The audio files are stored externally from the Flash movie in a folder labeled **Audio**.

Audio

```
// define sounds
var windSound:Sound
var batSound:Sound
var ghostSound:Sound
var laughSound:Sound
// create new Sound objects and link audio files
windSound = new Sound(new URLRequest("Audio/wind.mp3"));
batSound = new Sound(new URLRequest("Audio/bat.mp3"));
ghostSound = new Sound(new URLRequest("Audio/ghost.mp3"));
laughSound = new Sound(new URLRequest("Audio/laugh.mp3"));
```

bat

ghost

laugh

44. Set up the progress bar to manually update the number of bytes loaded using the **setProgress()** method later in the code. The code **pBar.indeterminate** tells Flash that the file you are importing has a determinate (known) file size.

wind

```
// set progress bar state
pBar.mode = ProgressBarMode.MANUAL;
pBar.indeterminate = false;
```

45. Define the Event Listeners for the FLVPlayback component and the buttons.

```
// add Event Listeners and load the video
flvScene.addEventListener(VideoProgressEvent.PROGRESS, onLoading);
flvScene.addEventListener(VideoEvent.READY, videoReady);
flvScene.addEventListener(MetadataEvent.CUE_POINT, onCue);
flvScene.source = flvSource;

// add Event Listeners for the buttons
forward_btn.addEventListener(MouseEvent.ROLL_OVER, moveForward);
forward_btn.addEventListener(MouseEvent.ROLL_OUT, stopMoving);
forward_btn.visible = false;
ghost_mc.addEventListener(MouseEvent.CLICK, enterDoor);
ghost_mc.visible = false;
```

46. Define the Event Handlers that respond to the listeners.

```
// Event Handler controls the ProgressBar
function onLoading(e:VideoProgressEvent):void {
    var bLoaded = Math.round(e.bytesLoaded/1000);
    var bTotal = Math.round(e.bytesTotal/1000);
    // Update progress...
    pBar.setProgress(bLoaded, bTotal);
}
// Event Handler removes ProgressBar when video is loaded
function videoReady(e:VideoEvent):void {
    removeChild(pBar);
    forward_btn.visible = true;
    flvScene.stop();
    windSound.play(0, int.MAX_VALUE);  // loop audio indefinitely
}
// Event Handler controls the video playback
function moveForward(e:MouseEvent):void {
    flvScene.play();
}
function stopMoving(e:MouseEvent):void {
    flvScene.stop();
}
// Event Handler for video cue points
function onCue(e:MetadataEvent):void{
    if(e.info.name == "bat"){
        bat_mc.play();
        batSound.play();
    }
    if(e.info.name == "ghost"){
        forward_btn.visible = false;
        ghost_mc.visible = true;
        ghost_mc.play();
        ghostSound.play();
        ghost_mc.buttonMode = true;
    }
}
// Event Handler for ghost button
function enterDoor(e:MouseEvent):void {
    ghost_mc.visible = false;
    flvScene.play();
    laughSound.play();
}
```

47. Select **Control > Test Movie**. This completes the exercise.

Summary

In this exercise you created a 3D environment using 3D layers, a camera and 3D lights. Cue points were also added for Flash interactivity. Through the use of ActionScript you controlled the playback of the video simulating a first-person style game. The cue points triggered other movie clips to play (Figure 7.48).

Figure 7.48: *The published SWF file allows the user to walk down the hallway. Cue points embedded within the FLV file trigger other movie clips to play.*

Before you leave this chapter, let's take a closer look at the camera settings. For this exercise and the previous one you added a camera with a 50 mm lens. Why that lens? When dealing with 35 mm film, a 50 mm focal length creates an image that most closely approximates human sight. Changes in the focal length can drastically impact the depth perceived in your 3D environment. Wide angle lenses have much shorter focal lengths and tend to exaggerate depth. Figure 7.49 shows the same 3D environment seen through a 20 mm focal length. It now looks like those never-ending hallways that occur in nightmares.

Figure 7.49: *A camera focal length of 20 mm produces exaggerated depth.*

A telephoto lens uses a longer focal length. It does not capture a wide area of the 3D scene. The perceived depth is reduced considerably. Figure 7.50 shows the same 3D environment seen through a 135 mm focal length. The hallway now looks like a very small, compressed space.

Figure 7.50: *A camera focal length of 135 mm compresses the perceived depth.*

This completes the chapter. After Effects allows you to move layers in three dimensions with the click of a button. Although you cannot model realistic shapes, you can orient the flat layers to create unique 3D environments. In addition, you can rotate the layers, and add cameras and lights that add dramatic impact to your rendered movie. You also explored using video cue points to turn linear video into interactive 3D spaces in Flash.

Some key concepts to remember from this chapter include:

▸ When a layer is converted into a 3D layer, it acquires the Z-axis.

▸ A 3D layer does not contain any thickness to it.

▸ It is best to use the XYZ Rotation properties for any type of 3D animation.

▸ Use the 3D views in the Comp panel to position and align 3D layers.

▸ The Active Camera view is the default 3D view and the view that will be rendered when you export your final movie.

▸ When a 3D light is added to a composition, the default lighting turns off. Lights only affect 3D layers.

▸ Changes in a camera's focal length can drastically impact the depth perceived in your 3D scene.

CHAPTER 8

Character Animation

Bringing characters to life in Adobe Flash and After Effects can be quite time-consuming. Both applications offer a couple of creative tools that can help reduce production time when animating 2D characters. This chapter explores character animation using Flash and After Effects.

doi: 10.1016/B978-0-240-81351-6.50008-2

Working with Bones in Flash

The art of character animation requires a lot of patience and practice. Flash provides many great tools for designing 2D characters. Using keyframes or ActionScript, these characters become virtual puppets that can walk, run, and jump. Flash CS4 introduced the Bone Tool that links each individual limb, such as a hand to an arm or a foot to a leg, and greatly enhanced the workflow.

 Download (http://booksite.focalpress.com/companion/jackson) the **Chapter_08.zip** *file to your hard drive. It contains all the files needed to complete the exercises.*

In practice, a character is divided up into several layers in the Flash Timeline. In this first exercise you will import a layered Adobe Illustrator file into Flash (Figure 8.1). You will then "rig" it together using the Bone Tool. "Rigging" is a term used by 3D modelers and animators. Like in our own bodies, our 2D characters are given bones that act as a controlling skeleton structure.

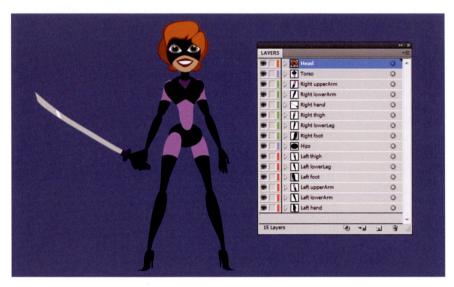

Figure 8.1: *The 2D character is made up of separate layers in Adobe Illustrator.*

1. Locate and open the file **Superhero_Bones.ai** file in the **Footage** folder in **Chapter_08**.

 ▶ The character has already been designed and assembled for you.

 ▶ Notice that each body part is on its own individual layer.

 ▶ Each layer has been labeled to correctly identify the part.

01_BonesIK

2. Open the file **01_BonesIK.fla** in the **Chapter_08** folder you copied to your hard drive. It contains one, empty layer.

3. Select **File > Import > Import to Stage** to open the Import dialog box. Locate the **Superhero_Bones.ai** file in the **Footage** folder in **Chapter_08**. Click **Open**. The Importer Wizard automatically launches. It provides a thumbnail preview

of each Illustrator layer and the ability to deactivate any layer by clicking on the checkmark to the left of the thumbnail image.

4. Make sure the **Convert layers to** option is set to **Flash Layers**. This option places all selected layers on their own layer. Each layer is labeled with the name of the layer in the Illustrator file. The layers in Illustrator are imported as vector art.

5. Make sure the check box for the **Place objects at original position** option is checked. The contents of the Illustrator file retain their exact position.

Figure 8.2: *Convert each Illustrator layer into a Flash layer.*

6. Select the **Head** layer. Individual import options specifically for that layer appear on the left of the thumbnail images.

 ▶ Check the box for **Create movie clip** for this layer.

 ▶ Click on the center square for the registration point.

Figure 8.3: *Convert each Illustrator layer into a movie clip with center registration.*

7. Repeat these steps with the remaining Illustrator layers. Create movie clips for every layer with a center registration point.

8. When you are done, click **OK**. The layered character appears assembled on the Flash Stage. The Library holds all of the movie clips that you created in the Import Wizard.

9. Now that your character is imported, let's "rig" it together. Select the Bone Tool (**X**). This tool only works with graphic or movie clip symbols. To create a bone, you simply drag from one symbol to another to link them.

10. The first bone you create is the root or sometimes called the parent bone of the armature. Click on the upper chest of the character and drag down to the hips movie clip (Figure 8.4). You have now linked these two movie clips together.

Figure 8.4: *Create the root bone that connects the torso to the hips.*

11. To add another bone, drag from the tail of the first bone to the next symbol instance you want to add to the armature.

Bone Tool (M)

 ▸ From the hips' bone, click and drag to each of the character's thighs.
 ▸ Each thigh needs to be connected to its lower leg.
 ▸ Connect the lower legs to the feet (Figure 8.5).

Figure 8.5: *Create the bones that connect the hips to each leg.*

12. To create a branched armature, click the head of the root bone and drag to create the first bone of the new branch. You will do this to create a branch for each arm and the head movie clip.

 ▸ Go back to the root bone and connect the arms, forearms, and hands similar to the technique you used for the legs.
 ▸ Connect the root bone to the head movie clip (Figure 8.6).

Figure 8.6: *Create branching bones that connect the torso to each arm and head.*

When using the Bone Tool, a new pose layer (**Armature_1**) is automatically generated in the Timeline. As you add more bones, Flash moves the symbol instance into this pose layer. Think of the armature as a skeletal structure.

13. The bones allow the chain of symbols to move together. There are two parts to a bone, the head and the tail. The head allows you to constrain the movement and rotation so that the character's parts move realistically. The hands and feet currently do not have a head joint to constrain them. To fix this:

 ▶ Go to the Library and click and drag four **Handle** movie clips to the Stage.

 ▶ Put all four movie clips on an empty layer in the Timeline.

 ▶ Position each handle in front of a hand or foot.

 ▶ Using the Bone Tool, connect each body part to its handle. Now you have a bone head on the hands and feet (Figure 8.7).

Figure 8.7: *Create branching bones from the hands and feet.*

14. As a result of how you add your bones, you may need to adjust the stacking order of each layer. To do this, select the object on the Stage and right-click. Select **Arrange** and the stacking order you desire (Figure 8.8).

Figure 8.8: *Adjust the stacking order for each bone.*

15. To adjust the position for the bone's head points, select the Free Transform Tool. Click and drag the registration point to a new position. This will also change the position of the bone that is attached to it (Figure 8.9).

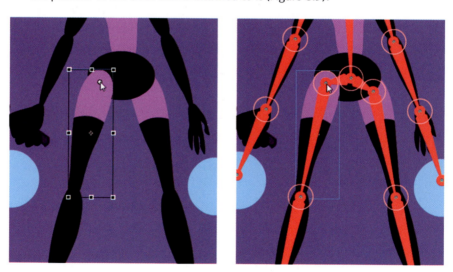

Figure 8.9: *Adjust the bone's end points by changing the registration point.*

16. Each bone's head joint is set up by default to rotate. The shoulder and hip bones should not do this as it will cause the upper arms and legs to move unrealistically and possibly separate from the torso and hips. Select the shoulder bone. Go to the Properties panel and uncheck the **Enable** checkbox. Repeat this for the hip bones (Figure 8.10).

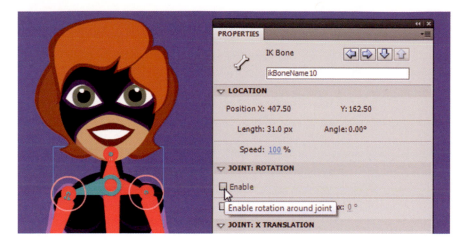

Figure 8.10: *Disable the joint rotation property for the shoulder and hip bones.*

17. You can constrain the rotation for each bone by clicking on it and then checking the Constrain boxes in the Properties panel. The constrained angle is visually displayed at the bone's head points (Figure 8.11).

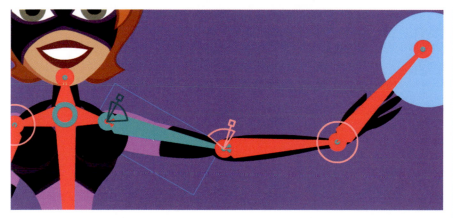

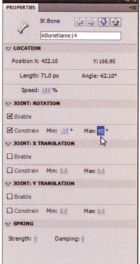

Figure 8.11: *Constrain the joint rotation in the Properties panel.*

18. With the armature in place, click and drag any of the bones to manipulate your character. The **Armature** layer is automatically set up with a motion tween. Move the playhead to a different frame and pose your character to create a new keyframe. Continue to reposition the playhead on different frames and adjust the character's pose (Figure 8.12).

Figure 8.12: *The Armature layer is automatically set up with a motion tween.*

Each keyframe holds a specific pose that you create. To reposition a keyframe, hold down the **Control** key to select it. Once the keyframe is selected, click and drag it to a new frame. To delete a keyframe, right-click on it and select **Clear Pose** (Figure 8.13).

Figure 8.13: *To remove a keyframe, right-click on it and select Clear Pose.*

Using the Spring Tool in Flash Professional CS5

Flash Professional CS5 introduces a new tool called Spring that can be applied to the armature. It automates the effect of a spring-like motion and can be applied to the entire armature or to an individual bone within the armature. The Spring Tool has two properties that control the amount of spring each bone has, as well as damping to control the amount of decay over time.

> The Spring Tool is only available in Flash Professional CS5. For CS4 users, you will need to animate the same effect manually using keyframes.

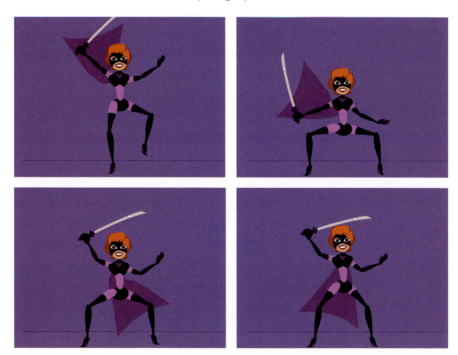

Figure 8.14: *The superhero's cape uses the Spring Tool to reinforce the main action.*

Chapter 8: Character Animation

19. To see an animated version of this exercise, open **01_BonesIK_Complete.fla** in the **Completed** folder in **Chapter_08**. Once you have created an armature and animated it, select the armature span in the Timeline and convert it to a symbol. For this example, the character animation is nested inside a graphic symbol on the main Timeline. A Classic Tween was applied to the symbol instance to animate the superhero dropping into the frame (Figure 8.14).

01_BonesIK_Complete

The Bone Tool supports armatures within vector shapes. This allows you to easily bend and morph the shapes in Flash. In this Flash document the superhero's cape was created as a vector shape. Moving from bottom to top, an IK armature was applied using the Bone Tool (Figure 8.15).

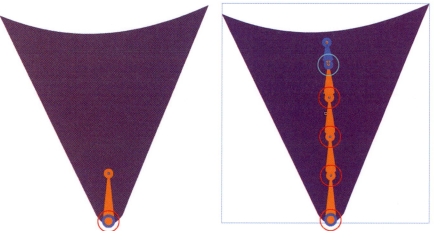

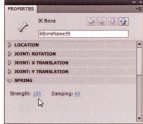

Figure 8.15: *The Bone Tool supports IK armatures in vector shapes. The Root bone (bottom) has the least amount of flexibility and the last child bone (top) has the most flexibility (higher Strength setting in the Properties panel).*

In the Properties panel, there is a Spring section that allows you to adjust the strength and damping controls. The last bone that was added to the cape has its **Spring Strength** set to **100**. The **Damping** is set to **60**. This determines how much flexibility is present in the bone when it is animated (Figure 8.15).

Each bone below that varies in spring strength. For this example, a strength of 100 was applied to the first bone, 80 to the second, 60 to the third, 20 to the fourth, and 0 to the root bone (the first bone in the armature). To create the cape animation, the last child bone (top) was selected and dragged down until the armature was vertical in the opposite direction on frame 30 (Figure 8.16).

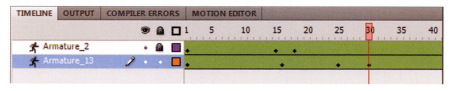

Figure 8.16: *The last child bone was animated on frame 30 in the Timeline.*

As you learned in Chapter 2, when publishing an SWF file for After Effects, use graphic symbols and vector shapes. Movie clips within the SWF will not display properly in After Effects. Before publishing your animation, make sure to open the **Handle** movie clip and turn the **handle guide** layer into a Guide layer. Guide layers do not export in the SWF file (Figure 8.17).

Figure 8.17: *Turn the Handle artwork into a Guide layer so that it doesn't export.*

20. Open **01_Superhero_Complete.aep** in the **Completed** folder in **Chapter_08**. The published SWF file was imported as footage into After Effects and layered with a bitmap background image. A **Glow** effect was applied to create a rim-light effect on the character.

An adjustment layer has a **Lens Flare** effect added to highlight the superhero's blade (Figure 8.18). To see the final rendering, locate and play **Superhero.mov** in the **Completed** folder. Let's focus on character animation using After Effects.

Figure 8.18: *The final Flash animation is imported into After Effects.*

Parenting Layers in After Effects

Let's compare animation techniques between Flash and After Effects. After Effects offers a technique called **parenting**. This method attaches one or more layers to a parent layer. If a parent layer moves across the Comp panel, the child layers follow. With the exception of opacity, any changes made to the parent layer's transform properties are inherited by the child layers. Child layers can have their own animation, but these do not affect the parent.

In this exercise, you will learn how to assign parenting to several layers. Once the layers are linked together, you will then animate the character and export the final composition as a Flash SWF file. To see an example of what you will build, locate and launch the **SuperHero.swf** file in the **Completed** folder inside the **02_Parenting** folder in **Chapter_08** (Figure 8.19). Welcome to parenthood!

Figure 8.19: *The completed character animation uses parenting in After Effects.*

1. Create a new project in **Adobe After Effects**. Import the footage file. Double-click inside the Project panel. This opens the Import File dialog box. Locate the **Superhero.ai** file inside the **02_Footage** folder in **02_Parenting/Chapter_08**. Select the file.

2. Choose **Composition – Retain Layer Sizes** (CS5) as the Import type. For CS4 users, import as **Composition – Cropped Layers**. Click **OK**.

3. Double-click on the Superhero composition in the Project panel to open it in the Timeline and Comp panels. Why import an Illustrator file instead of a Flash file? Each Illustrator layer imports with their original dimensions. Flash SWF files are imported as flattened rasterized files.

4. Before you "parent" the layers, you need to move each layer's anchor point. This allows the character's limbs to rotate correctly at the joints rather than at the center which is an anchor point's default location. To do this:

 ▸ Select the **Head** layer. Notice in the Comp panel the small cross hair target that appears between the superhero's eyes. That is the anchor point.

 ▸ Go to the **Tools** panel and select the **Pan Behind Tool** .

 ▸ Go back to the Comp panel and click and drag the anchor point down to the superhero's chin. This is similar to using the Free Transform Tool in Flash to reposition a symbol's registration point (8.20).

Figure 8.20: *Change the anchor point's position using the Pan Behind Tool.*

5. With the Pan Behind Tool still selected, click on the **torso** layer. Reposition the anchor point at the bottom of the torso (Figure 8.21).

6. Move the remaining anchor points. With the Pan Behind Tool still selected:

 ▸ Click on a layer in the Comp panel.

 ▸ Click and drag the anchor point to the proper location for the wrist, elbow, knee, and ankle joints.

 ▸ The anchor point position for the upper arms should be close to the shoulder.

 ▸ The anchor point position for the thighs should be at the hips.

 ▸ The only layer that you will keep the anchor point at its default location in the center is the **hips** layer.

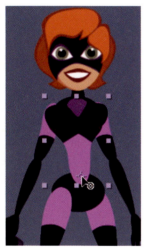

Figure 8.21: *Change the anchor point's position using the Pan Behind Tool.*

7. To set up the parenting structure, you need to open the Parent column in the Timeline panel. If it is not already visible, you can right-click on the **Layer Name** column header and select **Columns > Parent**. Now it is time to figure out which layers are going to be the parents and which are the children.

8. Let's start by connecting the **Head** layer (child) to the **neck** layer (parent). There are a couple of ways to attach a child to a parent. You can use the Parent popup menu to select the appropriate parent. You can also use the Pick Whip Tool located to the left of the popup menu. Click on the **spiral icon** (pick whip) for the **Head** layer and drag it to the name column of the **neck** layer (Figure 8.22). Release the mouse. You just linked the head and neck layers.

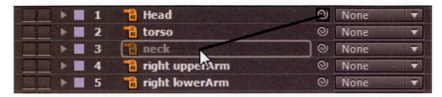

Figure 8.22: *Use the Parent pick whip to link layers in After Effects.*

9. Link the other layers using the same technique. Click on the Parent pick whip for each child layer and use it to point to its parent layer. Figure 8.23 shows you how to set up the parenting structure. If you study the parenting scheme, you will notice that the **hips** layer is the main parent layer for all the other layers. When it moves or rotates, all the layers will follow. Save your project.

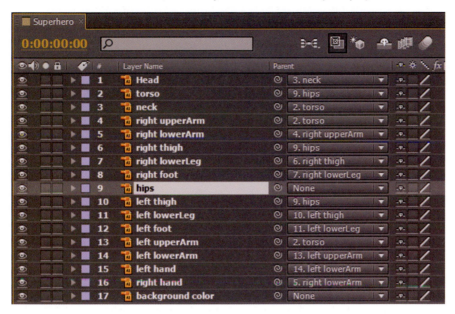

Figure 8.23: *Parent the remaining layers as shown.*

10. Now the fun begins. Select the **right UpperArm** layer in the Timeline. Type **R** on the keyboard to display the layer's Rotation property. Scrub through the Rotation value. In the Comp panel the right upper and lower arm rotates along with the right hand. The child layers inherit the transform properties of the parent layer. The upper arm's parent layer (torso) does not rotate.

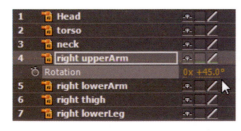

Figure 8.24: *Rotate the upper arm. Its child layers rotate but the parent layer does not.*

11. Select the **right lowerArm** layer in the Timeline. Open the layer's Rotation property. Scrub through the Rotation value. In the Comp panel the right lower arm and right hand rotate. The upper arm does not (Figure 8.25).

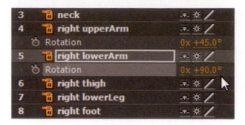

Figure 8.25: *Rotate the lower arm. Its child layers rotate but the parent layer does not.*

Let's do a quick review. A child layer inherits transform properties from its parent layer. These include position, rotation, and scale. Opacity is not passed from parent to child. Also, any effect that is applied to the parent layer does not affect its children. A child layer can also animate on its own without affecting its parent. A child layer can only have one parent. So now that you have "parented" the layers, it is time to create the character animation.

12. For this exercise, rather than stifle your creativity with step-by-step instructions, just play and have fun animating the superhero character. To animate, set keyframes for the layers you want to move or rotate, drag the Current Time Indicator (CTI) to a new time in the Timeline and change the transform properties. Remember to save often.

01_Parenting_DONE

13. If you would like to see one possible solution, open the **01_Parenting_DONE** project in the **Completed** folder. The superhero composition is set to 30 frames per second and has a duration of two seconds. You can set the duration of your character animation to whatever you want.

Select all the layers in the Timeline and type **U** on the keyboard. This opens all transform properties that contain keyframes (Figure 8.26). Let's deconstruct how the character animation was done.

- ▶ First, the vertical position of the **hips** layer was animated moving down in the Comp panel. All child layers moved with it.
- ▶ Next, the left and right thighs were rotated to spread the legs apart.
- ▶ The lower legs and feet were then rotated to maintain an invisible ground plane that the superhero was standing on.
- ▶ Finally, the left and right arms were animated in the Comp panel.

When creating character animation using the parenting technique, focus on one particular region at a time. Then go back and animate another section. By making multiple passes through the composition, you will create a much more effective animation and not become overwhelmed by all the layers and keyframes.

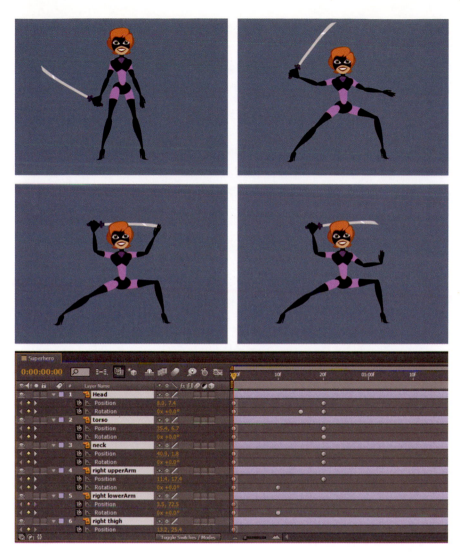

Figure 8.26: *Create a character animation using keyframed properties in the Timeline.*

14. Once you have finished the character animation, it is time to export it. Before you do that, delete the **background color** layer. You want to export the SWF file with an alpha channel.

15. Select **File > Export > Adobe Flash Player (SWF)**. This opens the Save File As dialog box. Save the SWF file to the **02_Parenting** folder in **Chapter_08**.

16. The SWF Settings dialog box appears. In the Images area, set After Effects to **Ignore Unsupported Features**. Since the footage is an Adobe Illustrator file and does not contain any gradients, all the layers will export as vectors.

17. Click **OK**. Save your After Effects project. Locate the exported Flash SWF file. Double-click on it to play the animation in the Flash Player.

SuperHero

18. Let's move to Flash. Double-click on **SuperHero.fla** in the **02_Parenting** folder to open the file in Flash. It contains two layers: foreground and background.

19. Select **Insert > New Symbol**. Enter **mcSuperhero** for the name and make sure that the type is set to Movie Clip. Click **OK**.

20. The Timeline for the new movie clip appears. Highlight the first blank keyframe and select **File > Import > Import to Stage** to open the Import dialog box. Choose the SWF file you created in After Effects. Click **Open**.

21. When the SWF file is imported into the movie clip, it appears as a series of keyframes. Scrub through the Timeline to see the animation.

Figure 8.27: *The imported SWF file appears as a series of keyframes in the Timeline.*

22. The character animation was rather complex and there are a lot of symbols now in the Library. For each keyframe in After Effects, a new graphic symbol was created for the layer. Organize the Library better. Create a new folder labeled **SWF Import** to hold the imported SWF sequence.

23. Click on the **New Layer** icon at the bottom of the Timeline panel. Rename the layer **superhero**. Position the new layer in between the foreground and background layers.

24. Click and drag the **mcSuperhero** symbol from the Library to the Stage. Rotate and scale the movie clip into position. Save and test your movie. This completes the exercise. Parenting is similar to the Bone Tool in Flash in that it links layers together. The next section focuses on the Puppet Tools in After Effects.

Figure 8.28: *Position the imported character animation on the Flash Stage.*

The Puppet Tools

An amazing set of tools in After Effects are the Puppet Tools. Similar to the Bone Tool in Flash, they allow you to quickly add joints (Deform Pins) to raster images and vector graphics, including still images, shapes, and text characters. These joints can then be animated over time, bringing the static image to life.

The Puppet Tool adds Deform Pins to a layer in a composition. The tool works by deforming parts of a layer according to the positions of pins that you place and move. These pins define what parts of the image should move, what parts should remain rigid, and what parts should overlap. In addition, the Puppet Tools allow you to record real-time animation using the Motion Sketch Tool.

Let's create a puppet. This exercise provides a step-by-step tutorial on using the three Puppet Tools to animate characters. You will use the Puppet Tools in the Tools panel to directly apply and work with the effect in the Comp panel.

1. In **Adobe After Effects**, select **File > Open Project**. Open the **03_Puppet** folder inside **Chapter_08**. Select **03_PuppetTool.aep** and click **Open**. The Project panel contains a composition and the footage needed to complete this exercise.

03_PuppetTool

Figure 8.29: *The project contains a composition with a raster image of a court jester.*

2. Select the **Puppet Pin Tool** from the Tools panel. It is the last tool on the right. This tool places and moves **Deform Pins**.

3. Go to the Comp panel and click in the center of the jester's belt buckle to add a new Deform Pin. Click on his left shoulder and left hand to create two additional pins (Figure 8.30). As soon as you create the first Deform Pin, the Puppet effect is added to the Timeline and Effect Controls panel.

4. Drag the pin on the left hand of the court jester up and down. Notice the realistic movement. This is a result of a mesh applied to the layer's outline.

Figure 8.30: *Add Deform Pins to the waist, left shoulder, and left hand (left image). Click and drag the left hand Deform Pin to see the Puppet Tool in action (right image).*

5. Select the **Show Mesh** box in the Tools panel. When you place the first Deform Pin, the layer's outline is automatically divided into a mesh of triangles (Figure 8.31). Each triangle in the mesh is associated with the pixels of the image, so the image's pixels move with the mesh, creating natural movement.

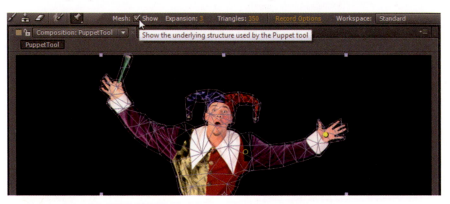

Figure 8.31: *A mesh is created and applied to the layer's outline. Each triangle controls how the image's pixels move.*

The Expansion field in the Tools panel lets you increase the mesh size to catch any stray pixels not included in the mesh. You can also increase the number of triangles within the mesh. The higher the number, the more processing time required, as well as an increase in the rendering time.

6. Turn off the mesh. As you moved the Deform Pin you may have noticed that the court jester's feet did a little dance as well. To keep the jester's feet firmly planted on the ground, add two more pins to the character's ankles. Also pin the jester's right shoulder and hand.

7. Drag the Deform Pin on the left hand up and down again. Notice that the jester's feet stayed pinned in their position. When you move a Deform Pin, the mesh changes shape to match the movement. It also tries to keep the other parts of the mesh as rigid as possible. The result is a more natural, lifelike movement in your character. The movement of the arm is greater than the motion in the waist and feet, just as a body moves in the real world.

8. Let's animate the Deform Pins. Make sure the **Jester.psd** layer is still selected in the Timeline and type the **U** key on the keyboard. This opens the Mesh property along with the seven created Deform Pins and their position values.

> *Keyframes are automatically enabled for Deform Pins. After Effects assumes that you will use these pins to create an animation. This is different from other transform properties where you have to manually click the stopwatch to enable keyframes.*

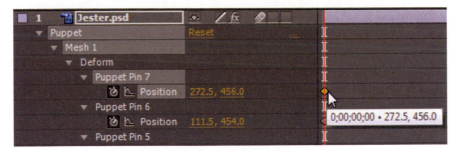

Figure 8.32: *Puppet Pins automatically enable position keyframes.*

9. Drag the Current Time Indicator (CTI) to the one-second mark (01:00). Click and drag the Deform Pin on the right hand of the character down. A motion path appears and a keyframe is automatically added to the Timeline.

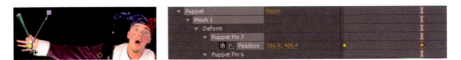

Figure 8.33: *Change the position of a Deform Pin to record the keyframe.*

10. Have some fun animating the character's arms and legs. Move the CTI to a new point in time and change the positions of the Deform Pins. If you want to move multiple pins at once, select a pin and then hold down the Shift key and click on another. Click the **RAM Preview** button to preview the character animation.

11. Move the CTI to the beginning of the Timeline. The Puppet Tool can also record pin movements using Motion Sketch. To record a pin movement, move the cursor over the Deform Pin in the center belt buckle and hold down the **Command** (Mac) or **Control** (Windows) key. The stopwatch cursor appears over the Deform Pin indicating the Motion Sketch Tool.

12. Click and drag the pin back and forth. When you are done, release the mouse. After Effects records the animation and the court jester is now belly dancing. After you release the mouse, the motion path appears in the Comp panel along with the accompanying keyframes in the Timeline.

13. Move the CTI to the beginning of the Timeline. Select the Deform Pin over the right hand and move it to the right. Notice that the character's right hand moves behind his head. You can control whether the image moves in front of or behind another using the **Puppet Overlap Tool**.

14. Select the **Puppet Overlap Tool** from the Puppet Pin Tool popup menu. This tool places Overlap Pins, which control which parts of an image should appear in front of others when the animation creates overlapping images.

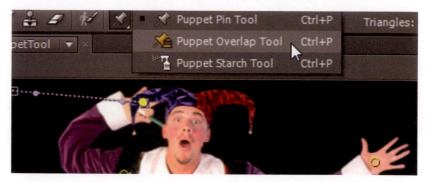

Figure 8.34: *Select the Puppet Overlap Tool from the Puppet Pin Tool popup menu.*

15. Click to add an Overlap Pin on the right hand, directly over the Deform Pin. Change the **In Front** value to **50%** in the Tools panel. Change the **Extent** value to 100 to extend the Overlap mesh up the right arm. Now you can control how the arm overlaps the head by increasing (moves in front) or decreasing (moves behind) the In Front property (Figure 8.35).

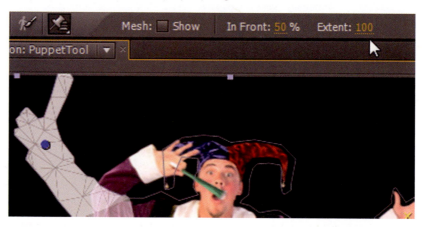

Figure 8.35: *Add an Overlap Pin and change its In Front value to move the image in front of or behind another image.*

16. The Overlap Pin also appears in the Timeline below all of the Deform Pins. Its properties can be keyframed over time (Figure 8.36).

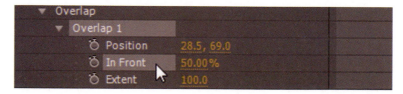

Figure 8.36: *The Overlap Pin also appears in the Timeline under the Deform Pins.*

What happens when you stretch a Deform Pin too far and start seeing unwanted artifacts or tearing in the mesh? Use the **Puppet Starch Tool** which stiffens parts of the image so that they are distorted less.

17. In Figure 8.37 the court jester is doing an extreme split. That must explain his facial expression. His left leg has been stretched too far, causing a distortion in his right thigh. Select the **Puppet Starch Tool** from the Puppet Pin Tool popup menu. An outline view of the character appears in the Comp panel.

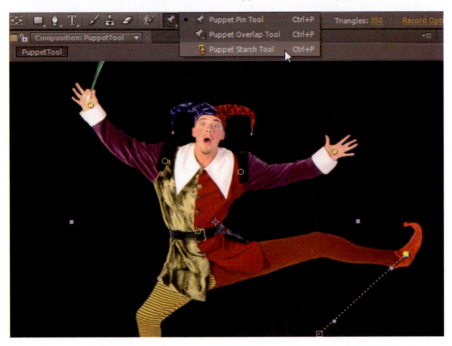

Figure 8.37: *Select the Puppet Starch Tool from the Puppet Pin Tool popup menu.*

18. Click and add a Starch Pin on the right hip in the outline. Increase the **Extent** value to **80** and the **Amount** value to **30%** in the Tools panel. Notice that the right thigh of the character moves back closer to its original shape (Figure 8.38).

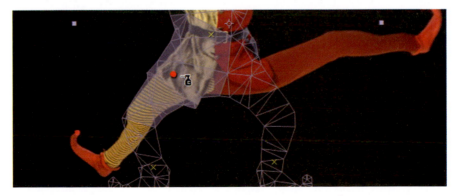

Figure 8.38: *Add a Starch Pin to decrease the amount of distortion in the mesh.*

19. Before you render the final composition, turn on the **Motion Blur** switch for the **Jester.psd** layer (Figure 8.39). Enable the **Motion Blur** button above the Timeline to activate Motion Blur for the composition.

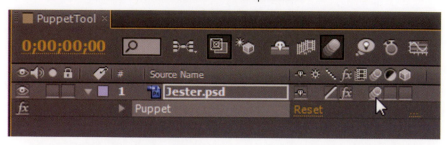

Figure 8.39: *Turn on Motion Blur for the layer to improve your character animation.*

20. You may want to increase the triangles of the mesh to make the deformation more smooth and accurate. Select the **Show Mesh** box in the Tools panel and scrub the Triangles value. Increasing the triangles increases the render time.

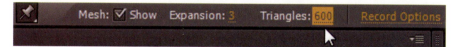

Figure 8.40: *Increase the triangles in the mesh for smoother deformations.*

This completes this exercise. Keep playing with the Puppet Tools to create your own unique character animation using the court jester. Add your own image or 2D character to the project. Remember to save often.

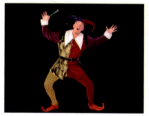 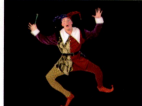

This exercise introduced you to the Puppet Tools in After Effects. The Puppet deformation effect produces natural, lifelike movement in a static image. There are three Puppet Tools. The Puppet Pin Tool creates and moves the Deform Pins. The Puppet Overlap Tool allows you to control which image moves in front of or behind another image. The Puppet Starch Tool stiffens parts of the image so that they are distorted less.

These Puppet Tools are a lot of fun to play around with. There are many creative possibilities open to you using these tools. The last exercise in this chapter integrates the Puppet Tools in After Effects with ActionScript in Flash. You will create an interactive dancing puppet for the web.

Building Interactive Puppets

In this exercise you will create an interactive Flash project that incorporates character animation created using the Puppet Tools. It is a simple version of those funny internet toys that entertain us for hours online. These time killer websites are a waste of time, but they are a good waste of time.

To see what you will build, locate and play the **04_VideoCreator.swf** file located in the **Completed** folder in **04_Interactive/Chapter_08**. Click and drag the different thumbnail images of dance moves to the disco track. When you are done, click on the dance button that appears. The character dances in the order of your placed disco moves. Click on the clear track button to reset the dancer and start again (Figure 8.41).

Figure 8.41: *The final interactive Flash project incorporates character animation created with the Puppet Tools in After Effects.*

The mechanics behind this project are fairly basic in Flash. It involves a drag and drop interaction, an array that stores the different dance moves and plays them back in the correct sequence, and the NetConnection and NetStream class objects that connect and stream the videos. Think of it as a starting point for your own creative designs. The exercise is meant to get you thinking about how you can control linear animation created in After Effects using the power of ActionScript in Flash.

The character was designed in a 3D application and rendered out as a still image. That image was imported into After Effects as a footage file. It was added to a composition and animated using the Puppet Tools. The only trick that you need to be aware of is how to make all the dance moves work seamlessly together.

Figure 8.42 shows an image sequence for each character animation used in the completed project. It should become quite obvious that the first and last frames for all three dance moves are the same starting image. This creates the seamless playback in Flash as one video is replaced by another.

Figure 8.42: *The first and last frame for each animation are identical.*

04_DiscoMan

1. In **Adobe After Effects**, select **File > Open Project**. Open the **04_Interactive** folder inside **Chapter_08**. Select **04_DiscoMan.aep** and click **Open**. The Project panel contains three folders. The **Footage** folder holds the rendered 3D character image. The **Completed** folder holds the three final compositions used. The **Create Your Own** folder has a composition ready for you.

2. Double-click on the **CreateYourOwn** composition to open its Timeline and Comp panels. The composition has a duration of two seconds.

3. Before you start using the Puppet Pin Tool, double-click on the layer-time marker 🔲 at the end of the Timeline. It contains a Flash Video cue point labeled "end." The cue point has been set to an event. This event tells Flash that the current video is done and to load in the next video in the sequence. Click **OK** to close the dialog box.

4. Select the **Puppet Pin Tool** 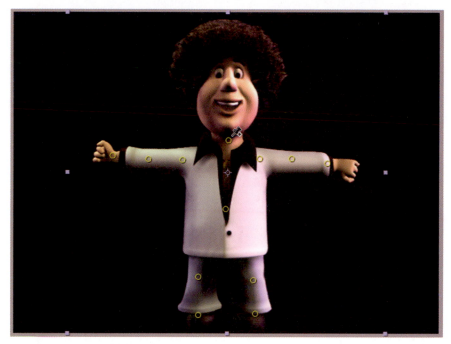 from the Tools panel.

5. Go to the Comp panel and click in the center of the disco character to add a new Deform Pin. Add additional pins at all the joints (Figure 8.43).

Figure 8.43: *Add the Deform Pins to the character.*

6. Select the **DiscoMan.png** layer in the Timeline. Type the **U** key on the keyboard. Get into the habit of renaming your Deform Pins so that you know what they are deforming. To do this, select the name and press the Return/Enter key on the keyboard. This highlights the name and allows you to rename it.

7. Now it is time to animate the Puppet pins. Move the Current Time Indicator (CTI) to new points in the Timeline. Click and drag the Deform Pins to create your own unique disco moves. If needed, use the Puppet Overlap Tool and Puppet Starch Tool to achieve the desired results you want. Have fun!

8. Once you have created your character animation, press the **End** key to move the CTI to the end of the Timeline. Click on the **Reset** button to the right of the word Puppet. This restores the Puppet Pins to their original location. Now the first and last frames are identical, which is what you want. Save your project.

Figure 8.44: *Click Reset to reposition the Deform Pins back to their original placed location.*

9. Click on the **RAM Preview** button to view the final composition.

10. Select **Composition > Make Movie**. This opens the Render Queue.

11. Click on **Best Settings** to open the Render Settings dialog box. Change the Resolution from Full to **Half** (Figure 8.45). The dimensions of the rendered Flash Video (FLV) file will now be 320 x 240.

Figure 8.45: *Render the Flash Video file at half resolution (320 x 240).*

12. Click on **Lossless** next to Output Module. Set the Format to **FLV**. Click on **Format Options** and set the Bitrate setting to **400**. Under **Channels**, encode the alpha channel. Select **RGB + Alpha** (Figure 8.46).

Figure 8.46: *Render the Flash Video file with an alpha channel.*

13. Click on **Output To** and select the **videos** folder inside the **04_Interactive** folder in the **Chapter_08** folder on your hard drive. Click the **Render** button.

04_VideoCreator

14. Let's move to Flash. Double-click on **04_VideoCreator.fla** in the **04_Interactive** folder to open the file in Flash. It contains all the files you need to complete this exercise. Let's deconstruct the file.

 ▶ The three thumbnail images are movie clips with instance names of **clip1**, **clip2**, and **clip3**. The registration point has been set to the left center.

 ▶ The disco track is a movie clip with an instance name of **holder**. Its registration point has been set to the left center as well.

 ▶ The two button symbols have instance names of **reset_btn** and **play_btn**.

15. Select the keyframe in Frame 1 of the **actions** layer. Open the Actions panel. The ActionScript is already set up. Let's deconstruct sections of the code and show you where you can add your character animation.

The code defines some variables to store information. The variable **numClips** stores the number of clips used. The variable **openSlot** refers to the open slot available in the disco track. It holds three slots, one for each thumbnail image. The thumbnail images are 80 x 80 pixels. The variable **clipOffset** stores that information. This is used to properly place each image when dragged to the disco track movie clip.

```
// define the number of clips, open slots, space between each clip
var numClips:uint = 3;
var openSlot:uint = 0;
var clipOffset:uint = 80;
```

Next, the starting horizontal and vertical positions for each thumbnail image need to be stored into a variable. These six variables hold that information.

```
// variables to store original clip location
var startX1:Number
var startY1:Number
var startX2:Number
var startY2:Number
var startX3:Number
var startY3:Number
```

A new Array object is created to hold the playback sequence for the video clips. Another variable named **videoIndex** is defined to store the array index number of the current video clip.

```
// array to store the video playback sequence
var videoSequence:Array = new Array();
var videoIndex:uint = 0;
```

A new Sound object is created to play the disco music. The audio file is stored externally from the Flash file in a folder labeled **audio**. A SoundChannel object is created to stop the audio from playing when the Reset button is clicked.

audio

```
// create a new Sound object and SoundChannel
var disco:Sound
disco = new Sound(new URLRequest("audio/disco.mp3"));
var discoControl:SoundChannel = new SoundChannel();
```

disco

Each video clip is loaded into a Video object created in ActionScript. The code creates the NetConnection and NetStream objects. The embedded cue point is listened for using the code **vStream.client**. This metadata listener (**client.onCuePoint**) calls a function named **onCuePoint** that will be added later. The last part of the code creates the Video Display object and positions it on the Flash Stage. The NetStream object is attached to the Video object.

Flash Video

Net Connection

links to FLV

Net Stream

transfers data

Video Object

```
// create video NetConnection and NetStream
var vConnection:NetConnection = new NetConnection();
vConnection.connect(null);
var vStream:NetStream = new NetStream(vConnection);

// create a cuePoint listner
var client:Object = new Object();
client.onCuePoint = onCuePoint;
vStream.client = client;

// create a video display object
var myVideo:Video = new Video(320, 240);
myVideo.x = 344;
myVideo.y = 120;
addChild(myVideo);
setChildIndex(myVideo, 0);
myVideo.attachNetStream(vStream);
```

Next, the Event Listeners are defined. A "for loop" generates an Event Listener for each thumbnail image. It also records each movie clip's position on the Flash Stage and stores that information into the **startX** and **startY** variables.

```
// loop through the movie clips to assign Event Listeners
for(var i:uint = 1; i <= numClips; i++){
    // create temp variable
    var currentClip:MovieClip = this["clip" + i];
    // record original Stage location
    this["startX" + i] = currentClip.x
    this["startY" + i] = currentClip.y
    // add button mode and event listeners
    currentClip.buttonMode = true;
    currentClip.addEventListener(MouseEvent.MOUSE_DOWN, dragIt);
    currentClip.addEventListener(MouseEvent.MOUSE_UP, stopdragIt);
}

// create Event Listeners for play and reset buttons
play_btn.addEventListener(MouseEvent.CLICK, onPlay);
play_btn.visible = false;
reset_btn.addEventListener(MouseEvent.CLICK, onReset);
```

With the Event Listeners, objects, and variables defined, the next part of the code creates the Event Handlers and methods.

The first two Event Handlers set up the drag and drop interaction. The draggable area is confined to a **new Rectangle** over the thumbnail images and disco track.

```
// define the Event Handlers
function dragIt(e:MouseEvent):void{
   // set the depth to be on top
   setChildIndex(MovieClip(e.currentTarget), numChildren - 1);
   e.target.startDrag(false, new Rectangle(10, 100, 210, 200));
   stage.addEventListener(MouseEvent.MOUSE_UP, stopdragIt);
}

function stopdragIt(e:MouseEvent):void{
   e.target.stopDrag();
   stage.removeEventListener(MouseEvent.MOUSE_UP, stopdragIt);
   placeClip(e.target);
}
```

When a clip is released, the function **placeClip** is called. This function contains a conditional that places the clip either in the disco track or back to its starting position based on where the clip is on the Stage when you let go of the mouse.

```
function placeClip(draggedClip){
   if(draggedClip.hitTestObject(holder)){
      draggedClip.x = holder.x + openSlot;
      draggedClip.y = holder.y;
      openSlot += clipOffset;
      // remove button properties
      draggedClip.buttonMode = false;
      draggedClip.removeEventListener(MouseEvent.MOUSE_DOWN, dragIt);
      draggedClip.removeEventListener(MouseEvent.MOUSE_UP, stopdragIt);
      // call function to add the corresponding video clip to the array
      addVideo(draggedClip.name);
      // show the PLAY button when all three slots are filled
      if(openSlot == 240){ play_btn.visible = true; }
   }else{
      // reset the clip back to its original Stage location
      var clipNumber:uint =  draggedClip.name.substr(4);
      draggedClip.x = this["startX" + clipNumber];
      draggedClip.y = this["startY" + clipNumber];
   }
}
```

videos

DiscoDance01

DiscoDance02

DiscoDance03

The video sequence array is populated if the movie clip is successfully dragged to the disco track. The function **addVideo** checks to see which clip was dragged to the disco track and loads the corresponding external video file. If you would like to swap the existing videos with your own, this is the part of the code you would change. Select the file name and change it to the name of your Flash Video (FLV) file (see code on next page).

```
function addVideo(whichClip){
    // add the correspoding video to the array
    if(whichClip == "clip1"){ videoSequence.push("videos/DiscoDance01.flv") };
    if(whichClip == "clip2"){ videoSequence.push("videos/DiscoDance02.flv") };
    if(whichClip == "clip3"){ videoSequence.push("videos/DiscoDance03.flv") };
}
```

The function **onCuePoint** listens for the embedded cue point at the end of each video clip. When that frame is played, the next video in the array sequence is streamed into the Video object. Since the first and last frames are identical for all video clips, the video swap is unnoticeable.

```
// add Event Handler to respond to the metadata loading
function onCuePoint(cuePoint:Object):void {
    if(cuePoint.name == "end"){
        videoIndex++;
        if(videoIndex == videoSequence.length){
            videoIndex = 0;
        }
        vStream.play(videoSequence[videoIndex]);
    }
}
```

16. Select **Control > Test Movie**. This completes the exercise.

Summary

This completes the chapter on character animation using the Bone Tool in Flash and parenting and Puppet Tools in After Effects. Both applications offer tools that can save a lot of time and headaches when trying to animate a character. The next chapter focuses on creating visual effects in After Effects and then integrating them into your Flash projects.

CHAPTER 9

Visual Effects

Stunning visual effects can add dramatic punch to any Flash project. This chapter focuses on creating different kinds of visual effects, from very subtle to explosive, using the tools in After Effects.

doi: 10.1016/B978-0-240-81351-6.50009-4

Controlling the Weather

Visual effects are an art form all to themselves. After Effects provides myriad effects that you can apply to your moving and still images. With a plethora of plug-ins available, this chapter focuses on some of the more popular ones that can enhance your Flash projects. Let's start by creating your own dramatic weather. After Effects offers you hundreds of effects to make it all happen.

 Download (http://booksite.focalpress.com/companion/jackson) the **Chapter_09.zip** *file to your hard drive. It contains all the files needed to complete the exercises.*

In this first exercise, you will learn how to create snow in After Effects and apply that effect to a Flash animation. You were exposed to the CC Snow effect briefly in Chapter 2, but that project was intended for broadcast. Figure 9.1 shows the final effect composited in Flash.

Figure 9.1: *The completed animation integrates the CC Snow effect in After Effects.*

1. Launch **Adobe After Effects**. Select **Composition > New Composition**. The Composition Settings dialog box appears. You will set up the composition to match the Flash file you are integrating the effect into.

2. Make the following settings and then click **OK** to create the new composition.
 ▶ Composition Name: **Snow**
 ▶ Width: **550**
 ▶ Height: **400**
 ▶ Pixel Aspect Ratio: **Square Pixels**
 ▶ Frame Rate: **30**
 ▶ Duration: **0:00:01:00**

3. Make sure the Timeline panel is highlighted. Select **Layer > New > Solid**. The Solid Settings dialog box appears. Make the following settings:

 ▶ Enter **Snow** for the solid name.

 ▶ Click on the **Make Comp Size** button.

 ▶ Set the color of the solid layer to **Black**. It needs to be black in order for the effect to composite correctly in Flash.

 ▶ Click **OK**.

4. A solid layer of color appears in the Timeline and in the Comp panel. Select **Effect > Simulation > CC Snow**. This is a third-party plug-in from Cycore that ships with After Effects. If you do not see this effect in your Effects menu, you may need to install this plug-in from the After Effects installation CD.

5. The CC Snow effect gives you just that, falling snowflakes (Figure 9.2). It is a fairly simple effect. Go to the Effect Controls panel. Increase the **Amount** to **400** and the **Speed** to **1.5**. Since you are going to composite this effect in Flash, increase the **Opacity** to **70%**.

Figure 9.2: *Apply the CC Snow effect to a black solid layer. Use the Effect Controls panel to adjust the effect's properties.*

6. Click on the **RAM Preview** button. The duration of the composition is set to one second. Although the snow effect does not create a continuous loop, you will not notice with all those snowflakes falling. Save your project.

7. Select **Composition > Make Movie**. This opens the Render Queue.

8. Click on **Lossless** next to Output Module. Set the Format to **FLV**. Click on **Format Options** and set the Bitrate setting to **400**. Click on **Output To** and select the **Chapter_09** folder on your hard drive as the final destination for the rendered movie. Click the **Render** button.

9. Let's move to Flash. Double-click on **01_WinterScene.fla** in the **01_Weather** folder to open the file in Flash. It contains three layers: a background image, a movie clip instance of a skater, and a snow layer.

01_WinterScene

10. Select the blank keyframe on Frame 1 of the **snow** layer.

11. Select **File > Import > Import Video**. The Import Video Wizard dialog box appears. To import the FLV file:

 ► Locate the **Snow.flv** file you rendered out of After Effects.
 ► Set the deployment to **Embedded FLV in SWF and Play in Timeline**.
 ► Click **Next**.
 ► Set the Embedding type to **Movie Clip**. Click **Next**.
 ► Click **Finish** to embed the video. The first frame of the video appears on the Stage and a video symbol is added to the Library.

12. Now that the video is imported, it is time to composite it with the other layers. Select the snow movie clip instance. Go to the Properties panel and change **Blend** mode to **Add** (Figure 9.3). This blend mode causes the black background to disappear and you are left with only the white snowflakes.

Figure 9.3: *Change the Blend mode from Normal to Add.*

13. Save and test your movie. This completes the exercise. Snow is quite simple to create in After Effects and integrate in Flash. With a minimal amount of time and effort, you can create realistic snow. Imagine the time it would take to animate or program the snow falling using ActionScript.

 Why embed an FLV file? Out of all the possible outputs for this exercise, this file format produces the smallest size file that doesn't drastically increase the Flash movie. The final published SWF file with the embedded video is 64 KB. If you rendered out a PNG sequence and imported the files into Flash, its final published size would have been around 375 KB.

Flash Professional CS5 displays an SWF size history in the Properties panel. This shows how your SWF has grown over time based on data gathered every time you compile your file (Figure 9.4). The next part of the chapter also deals with particles—the shattering kind.

Figure 9.4: *Flash Professional CS5 displays an SWF size history.*

Shattering Layers

In this section of the chapter, you can take out your frustrations by blowing stuff up. Let's use a popular particle generator, **Shatter**. The name says it all. The Shatter effect explodes graphic images. The effect's controls allow you to set explosion points and adjust the strength and radius of the blast. In this exercise you will create a title sequence for a Flash project.

1. Open **01_ShatterZone.aep** inside the **02_Shatter** folder in **Chapter_09**.

2. The Project panel contains all the footage you need to complete this exercise. A composition is already set up for you in a **Comps** folder. Double-click on the **ShatterZone** composition to open its Timeline and Comp panels.

01_ShatterZone

 It contains two layers: a nested window composition and a vector logo created in Adobe Illustrator. Both layers have been converted into 3D layers and animate over time. The first thing you need to create is the starfield background. To do this you need a new solid layer.

3. Make sure the Timeline panel is highlighted. Select **Layer > New > Solid**.
 - Enter **Starfield** for the solid name.
 - Click on the **Make Comp Size** button.
 - Set the color of the solid layer to **White**.
 - Click **OK**.

4. A solid layer of color appears in the Timeline and in the Comp panel. Click and drag the solid layer to the bottom of the stack underneath the window and logo layers (Figure 9.5).

Figure 9.5: *Create a new white solid layer and position it at the bottom of the layer stack in the Timeline.*

5. Select **Effect > Simulation > CC Star Burst**. The white solid layer is replaced with white stars that zoom toward the active camera. Go to the Effect Controls panel and change the **Size** value to **30.0**. This creates a more realistic starfield.

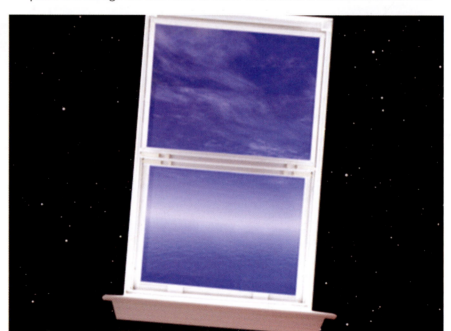

Figure 9.6: *Apply the CC Star Burst effect to create the animated starfield background.*

6. Select the **WindowComp** layer in the Timeline. Select **Effect > Simulation > Shatter**. The image of the window turns into a wireframe view of the Shatter effect. Scrub through the Timeline and you will see that the effect starts immediately by exploding wireframe bricks across the Comp panel.

Figure 9.7: *Apply the Shatter effect to the window. The layer turns into a wireframe view of the effect.*

7. Move the Current Time Indicator (CTI) to the five-second mark (05:00). This is the point in time where the window has completed its animation.

8. In the Effect Controls panel, select **Rendered** in the **View** popup menu. The grid will disappear and you will see the layer's content, or what's left of it.

9. Twirl open the **Shape** properties and make the following changes:

 ▶ Set the Pattern from **Bricks** to **Glass**.

 ▶ Change the **Repetitions** value to **15.0**. This value specifies the scale of the shards of glass. Increasing this value increases the number of pieces by scaling down the size of the shatter map. Consequently, the layer breaks into more and smaller pieces of glass.

 ▶ Change the **Extrusion** value to **0.10**. This will reduce the thickness for each shattered particle.

10. Force 1 and Force 2 controls define the blast areas. Twirl open the **Force 1** properties and change the **Radius** value to **0.0**. The window reassembles itself in the Comp panel. Click on the **stopwatch** icon 🕘 for **Radius** to record its value at the current time.

11. Move the CTI to the seven-second mark (07:00). Change the **Radius** value to **2**.

12. Physics control how the pieces move and fall through space. Twirl open the **Physics** properties and change the **Gravity** value to **0.0**.

13. Click on the **RAM Preview** button. The window now shatters into several shards of glass particles after it finishes animating in. Save your project.

Figure 9.8: *The final effect shatters the window layer.*

14. Select **Composition > Make Movie**. This opens the Render Queue.

15. Click on **Lossless** next to Output Module. Set the Format to **FLV**. Click on **Format Options** and set the Bitrate setting to **400**.

16. Click on **Output To** and select the **Chapter_09** folder on your hard drive as the final destination for the rendered movie. Click the **Render** button.

17. The final size for the FLV file is around 510 KB. Create a new Flash file at 30 frames per second. Import the video as an externally linked file.

18. Save and test your Flash movie. This completes this exercise. Experiment with the other properties within the Shatter effect. The effect even contains a 3D camera built into it. You can set the camera to fly around the exploded particles. It is truly an amazing and powerful effect.

So far in this chapter you have been building visual effects using only the tools available in After Effects. Some visual effects are extremely hard to replicate and require actual footage. Realistic fire and explosions are a couple of these types of effects that do not have a plug-in readily available in After Effects.

There are several good companies that provide royalty free stock footage that can help you out. One such company is Artbeats (*www.artbeats.com*). In the next exercise you will use one of their stock footage files to enhance a logotype for a restaurant.

Playing with Fire

Visual effects do not have to take up the entire Flash Stage. They can be more subtle in design, used for accenting smaller elements such as a company logo or button. In this section of the chapter, you will scale down the visual effects and bring static imagery to life using track mattes. This exercise uses an alpha track matte to enhance a logo for a fictitious restaurant called "Brimstones."

1. Open **01_Brimstones.aep** inside the **03_Fire** folder in **Chapter_09**.

2. The Project panel contains all the footage you need to complete this exercise. A composition is already set up for you in a **Comps** folder. Double-click on the **Brimstones** composition to open its Timeline and Comp panels. It contains a logotype created in Adobe Illustrator (Figure 9.9).

01_Brimstones

Figure 9.9: *The composition contains two layers imported from Adobe Illustrator.*

3. Click and drag the **RF107.mov** footage file from the Project panel to the Timeline. Position the movie in-between the two Illustrator layers (Figure 9.10).

Figure 9.10: *Add the stock footage to the Timeline.*

4. Click and drag the Artbeats footage of flames in the Comp panel. Align the bottom edge of the movie with the horizontal line in the logo (Figure 9.11).

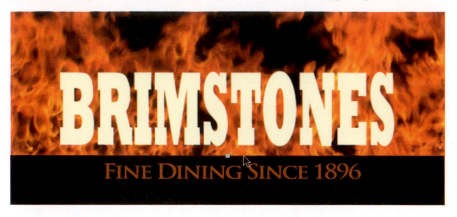

Figure 9.11: *Reposition the stock footage layer in the Comp panel.*

5. Make sure the **RF107.mov** layer is still selected. Click on the popup menu under **TrkMat** and select **Alpha Matte "Brimstones/Brimstones.ai"** to apply the track matte (Figure 9.12).

Figure 9.12: *Apply a track matte to the stock footage layer.*

6. Go to the Comp panel. The track matte uses the alpha channel information in the logo layer to mask the video. Now the flames play inside the letters, creating a unique look for the restaurant (Figure 9.13).

Figure 9.13: *The track matte uses the alpha channel information to mask the video.*

Chapter 9: Visual Effects

7. Click on the popup menu under **TrkMat** and select **Alpha Inverted Matte "Brimstones/Brimstones.ai"** to reverse the track matte. Now the letters punch a hole into the flames footage (Figure 9.14).

Figure 9.14: *The alpha inverted matte punches holes into the stock footage.*

8. Set the track matte back to **Alpha Matte "Brimstones/Brimstones.ai."**

9. Before you render the composition, crop the Comp panel to help reduce the file size for the Flash Video file. Click on the **Region of Interest** button at the bottom of the Comp panel.

10. Click and drag in the Comp panel to create a smaller region of interest. Select **Composition > Crop Comp to Region of Interest**. The size of the Comp panel is reduced to the dimensions of the region of interest bounding box.

Figure 9.15: *Reduce the region of interest.*

11. You now have an animated logotype that you can render out to multiple formats. Save your project. If you want to export the file to Flash, render the composition as a Flash Video (FLV) file with an encoded alpha channel. Import the video into Flash. At half resolution, the FLV file size will be around 350 KB.

Distorting Typography

In Chapter 6, you experimented with motion graphics. In addition to the powerful text engine and animation presets in After Effects, you can also add visual effects to text layers. The next two exercises focus on distorting typography to create effects that are next to impossible to achieve in Flash.

01_LiquifyText

Exercise 1: Liquifying Text

1. Open **01_LiquifyText.aep** inside the **04_DistortText** folder in **Chapter_09**.

2. The Project panel contains all the footage you need to complete this exercise. A composition is already set up for you in a **Comps** folder. Double-click on the **Horror In Wax** composition to open its Timeline and Comp panels.

3. Click on the **RAM Preview** button. The title layers scale up from the center of the Comp panel. Move the Current Time Indicator (CTI) to two seconds (2:00) in the Timeline (Figure 9.16). You are going to add an effect that will simulate the title melting off the screen. Select the **WAX** layer.

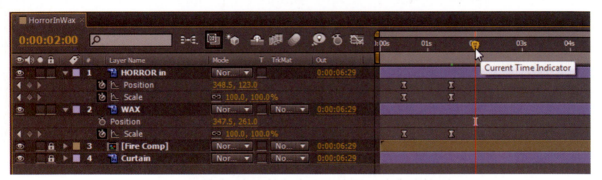

Figure 9.16: *Move the CTI to the two-second mark in the Timeline.*

4. Select **Effect > Distort > Liquify**. The Liquify effect provides tools that let you push, pull, rotate, enlarge, and shrink areas in a layer (Figure 9.17). Think of working with clay. The effect allows you to sculpt a layer into any shape you want.

Figure 9.17: *The tools in the Liquify effect allow you to distort a layer.*

5. The Liquify effect creates an invisible mesh on the layer. Click on the **stopwatch** icon for **Distortion Mesh** to record its value at the current time (2:00 seconds). This will allow you to animate your changes to the mesh over a span of time.

Figure 9.18: Turn on keyframes for the Distortion Mesh at the two-second mark.

6. Move the CTI to three seconds (3:00) in the Timeline.

7. Select the **Warp** brush . This allows you to push pixels forward as you drag.

8. Go to the Comp panel and click and drag on the type. The distortion is concentrated at the center of the brush area, and the effect intensifies as you hold down the mouse button or repeatedly drag over an area. (Figure 9.19).

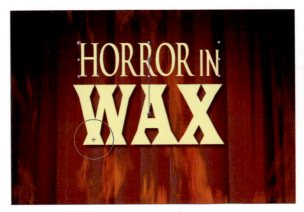

Figure 9.19: Use the Warp brush to push the pixels around to simulate melting.

9. To change the brush settings, twirl open the **Warp Tool Options**. Adjust the brush size and pressure to whatever value you want.

10. Repeat the previous steps to add more keyframes to the distortion mesh. Move the CTI forward in time. Click and drag the Warp brush over the title to push the pixels off the bottom of the Comp panel (Figure 9.20).

Figure 9.20: Push the pixels off the bottom of the Comp Window.

11. With the **WAX** layer still highlighted in the Timeline, select **Effect > Perspective > Drop Shadow**. Go to the Effect Controls panel to adjust its parameters as needed.

12. Repeat the same process with the **HORROR IN** layer (Figure 9.21):

- ▶ Select **Effect > Distort > Liquify**.
- ▶ Click on the **stopwatch** icon for **Distortion Mesh** at two seconds (2:00).
- ▶ Move the CTI forward in time.
- ▶ Click and drag the Warp brush over the title to push the pixels off the bottom of the Comp panel.
- ▶ Select **Effect > Perspective > Drop Shadow**.

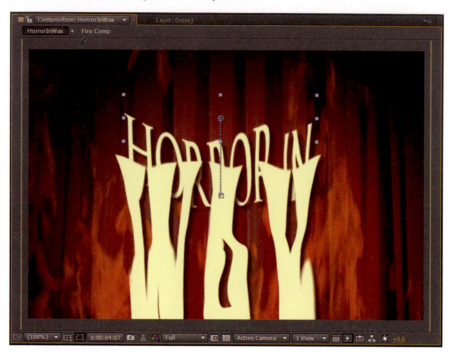

Figure 9.21: *Apply the Liquify effect to the other title layer.*

13. Click on the **RAM Preview** button. Save your project. To see a completed example of this exercise, locate and open **01_LiquifyText_Complete.aep** inside the **Completed** folder in the **04_DistortText** folder. Several keyframes are used to create the final effect of the title melting off the screen (Figure 9.22).

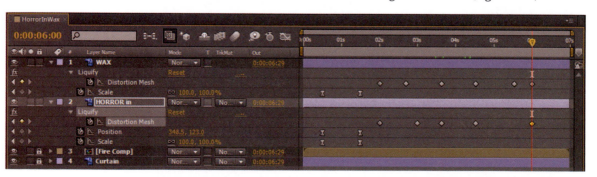

Figure 9.22: *Several keyframes were used to created the desired effect of melting text.*

14. The final composition can be used as an opening title sequence for a Flash movie. If you want to export the file to Flash, render the composition as a F4V file. Import the video as an externally linked file. The rendered Flash Video file size is around 1.25 MB.

HorrorInWax

Type: MPEG-4 Video
Size: 1.25 MB

Exercise 2: Adding Turbulence to Typography

The previous exercise was an homage to the classic horror/sci-fi films of the 1950s. Let's continue with that theme and create another title sequence using the Turbulent Displace effect. This effect uses fractal noise to create distortions in an image. For this exercise you will use it to simulate flowing water.

1. Open **02_TurbulenceText.aep** inside the **04_DistortText** folder in **Chapter_09**.

2. The Project panel contains all the footage you need to complete this exercise. A composition is already set up for you in a **Comps** folder. Double-click on the **Turbulence Displacement** composition to open it.

02_TurbulenceText

3. Click on the **RAM Preview** button. The title was created in Adobe Illustrator. It has a Gaussian Blur effect added to the layer that fades the text on and off the screen. The underwater image scales up in size and changes position to give the illusion of swimming through water (Figure 9.23).

Figure 9.23: *A Gaussian Blur fades the text on and off the screen.*

4. Select the **It_Title.ai** layer. Type **U** on the keyboard to open all of the layer's keyframed properties (Figure 9.24).

Figure 9.24: *Open the keyframed properties for the title layer.*

5. Press the **Home** key on the keyboard to move the Current Time Indicator to the beginning of the composition (00:00).

6. Select **Effect > Distort > Turbulent Displace** to add the effect to the **It_Title.ai** layer. Go to the Effect Controls panel to adjust the effect's parameters.

7. Click on the **stopwatch** icon for **Evolution** to record its value at the beginning of the composition (00:00). The Evolution value is set in units called **revolutions**. Animating this setting results in changes of the turbulence over time.

8. Press the **End** key to move the CTI to the end of the Timeline.

9. Change the **Evolution** value to **3x + 0.0**. This property now completes three revolutions based on the duration of the composition (Figure 9.25).

Figure 9.25: *The Evolution value is set in units called revolutions .*

10. Click on the **RAM Preview** button. The title now distorts as if it were underwater (Figure 9.26). In addition to simulating water effects, the Turbulent Displace effect can be used to create waving flags. Using the **Pinning** parameter, you can specify which edges to pin so that the pixels along those edges aren't displaced. For this exercise, keep the setting to **Pin All**.

Figure 9.26: *The distortion gives the illusion that the text is underwater.*

11. Change the **Antialiasing for Best Quality** setting from **Low** to **High** (Figure 9.27).

Figure 9.27: *Adjust the antialiasing for the effect.*

12. Repeat the same process with the **Underwater.psd** layer:

 ▶ Select **Effect > Distort > Turbulent Displace**.

 ▶ Set the **Amount** value to **10**.

 ▶ Set the **Size** value to **30**.

 ▶ Click on the **stopwatch** icon for **Evolution** to record its value at the beginning of the composition (00:00).

 ▶ Press the **End** key to move the CTI to the end of the Timeline.

 ▶ Change the **Evolution** value to **4x + 0.0**.

 ▶ Change the **Antialiasing for Best Quality** setting from **Low** to **High**.

13. Click on the **RAM Preview** button. Save your project. To see a completed example of this exercise, locate and open **002_TurbulenceText_Complete.aep** inside the **Completed** folder in the **04_DistortText** folder.

14. If you want to export the file to Flash, render the composition as an F4V file. Import the video as an externally linked file. The rendered Flash Video file size is around 915 KB. Let's explore more distortion effects.

Turbulence Displacement

Type: MPEG-4 Video
Size: 913 KB

Designing Interactive Page Turns

After Effects ships with at third-party plug in called CC Page Turn. It is fairly easy to use. The tricky part is in designing the artwork for the effect. CC Page Turn simulates a page flip and gives you several options that allow you to control the fold and define what imagery goes on the front and back of the page. Let's start by deconstructing the footage used in this exercise.

Book

1. Open **Book.psd** inside the **Footage** folder inside the **05_PageTurn** folder in **Chapter_09**. Study how the file is put together. It contains five layers. Notice that the **Page2** and **Page4** layers are flipped horizontally. These layers will appear on the back side of the CC Page Turn effect and will automatically flip back to the correct orientation (Figure 9.28).

Figure 9.28: *The layered Photoshop document holds each page on a separate layer.*

01_PageTurn

2. Open **01_PageTurn.aep** inside the **05_PageTurn** folder in **Chapter_09**. The layered Photoshop document has been imported as a composition into After Effects. Each layer in the Photoshop file is retained as a separate layer in the Timeline. More importantly, each layer is set to the same dimensions of 800 x 600 pixels. Why is this important?

 CC Page Turn only displays the effect within the dimensions of the layer it is applied to. Even though the artwork does not fill the entire frame, you need the empty space to see the page flip correctly (Figure 9.29). Click on the **RAM Preview** button to see the effect in action.

3. Let's practice on one page so that you can see how to use the CC Page Turn effect. In the Project panel, click and drag **Page1/Book.psd** down to the Composition icon 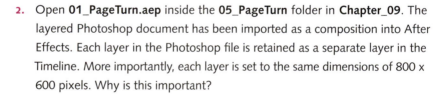 at the bottom of the Project panel. This automatically creates a comp using the selected footage.

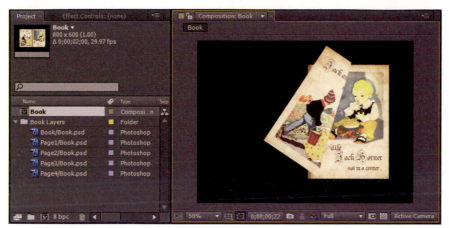

Figure 9.29: *Each layer is 800 x 600 pixels. This size will properly display the CC Page Turn effect as it animates over time.*

4. A new Timeline and Comp panel open. While the **Page1/Book.psd** layer is highlighted, select **Effect > Distort > CC Page Turn**. The effect is immediately noticeable in the Comp panel in the lower right corner of the page.

5. Go to the Comp panel and click and drag the **Fold Position** handle. Drag it to the right to flatten out the page. Drag the handle to the left to flip the page over. Notice that the same image is on the backside of the layer (Figure 9.30).

Figure 9.30: *Click and drag the Fold Position handle to control the page turn.*

6. Go to the Effect Controls panel to adjust the effect's parameters. Experiment with the **Fold Direction** and **Fold Radius** values to constrain the amount of page turn in the Comp panel. Notice each parameter has a stopwatch icon.

7. Open the **Book** composition to study how the Fold Position, Fold Direction, and Fold Radius parameters were keyframed over time (Figure 9.31).

Figure 9.31: *The CC Page Turn fold parameters are keyframed over time.*

8. Select the **Page1** layer in the Timeline. Go to the Effect Controls panel to see how its parameters were adjusted. Notice that the **Back Page** is set to the **Page2** layer. Select the **Page3 Copy** layer. Its **Back Page** is set to the **Page4** layer.

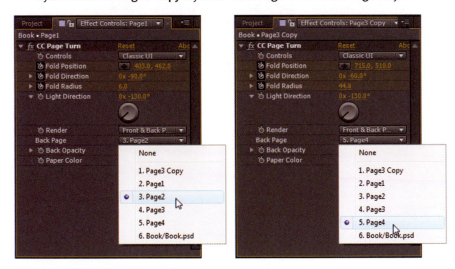

Figure 9.32: *The Back Page artwork is set in the Effect Controls panel. Remember the artwork will be flipped horizontally on the back side of the page.*

9. Before you render the composition, crop the Comp panel to help reduce the file size of the FLV file. Click on the **Region of Interest** button at the bottom of the Comp panel.

10. Click and drag in the Comp panel to create a smaller region of interest. Scrub through the Timeline to make sure the pages remains inside the area. Use the corner handles to resize the region if necessary (Figure 9.33).

11. Select **Composition > Crop Comp to Region of Interest**. The size of the Comp panel is reduced to the dimensions of the region of interest bounding box.

Figure 9.33: *Reduce the region of interest. Creating a smaller region requires less processing power and helps improve the RAM preview.*

12. Select **Composition > Make Movie**. This opens the Render Queue.

13. Click on **Lossless** next to Output Module. Set the Format to **FLV**. Click on **Format Options** and set the Bitrate setting to **900**. Click **OK**.

14. Under **Channels**, encode the alpha channel. Select **RGB + Alpha**. Click **OK**. Click on **Output To** and select the **Chapter_09** folder on your hard drive as the final destination for the rendered movie. Click the **Render** button.

15. Let's move to Flash. Double-click on **01_PageTurn.fla** in the **05_PageTurn** folder to open the file in Flash. It contains four layers: a background image, a video layer, a button layer, and a layer to hold the ActionScript.

01_PageTurn

16. Select the blank keyframe on Frame 1 of the **video** layer.

17. Select **File > Import > Import Video**. The Import Video Wizard dialog box appears. To import the FLV file:

 ▶ Locate the **Book.flv** file you rendered out of After Effects.
 ▶ Set the deployment to **Embedded FLV in SWF and Play in Timeline**.
 ▶ Click **Next**.
 ▶ Set the Embedding type to a **Movie Clip**. Click **Next**.
 ▶ Click **Finish** to embed the video. The first frame of the video appears on the Stage and a video symbol is added to the Library.

18. Reposition the movie clip on the Stage and give it an instance name **pages**.

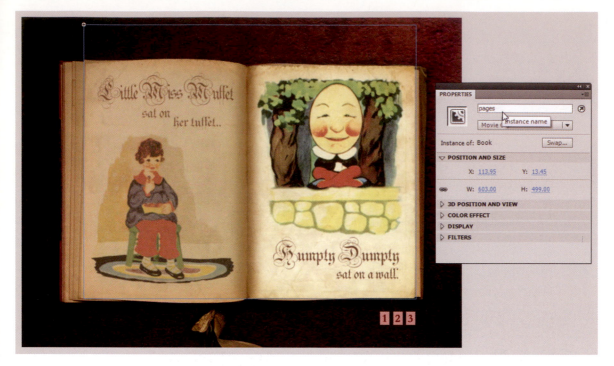

Figure 9.34: *Import the FLV file and give it an instance name in the Properties panel.*

19. Double-click on the movie clip to open its Timeline. Add a new layer labeled **actions**. Select the blank keyframe in Frame 1 and open the Actions panel. Enter the **stop();** action to hold the playback head on the first frame (Figure 9.35).

Figure 9.35: *Add an **actions** layer inside the movie clip to hold ActionScript.*

20. Click on **Scene 1** to return to the main Timeline. The three buttons have already been set up for this exercise. They each have unique instance names of **page1_btn**, **page2_btn** and **page3_btn**. The buttons will control the video's playback.

Before you add the ActionScript you need to download **Tweener**. Tweener is an open source Class used to create tweenings and other transitions via ActionScript code for projects built in Flash. It can also be used to tween the playback head forward and backward in a movie clip. It can be downloaded at the following URL: *http://code.google.com/p/tweener/*.

caurina

21. Once you have downloaded Tweener and uncompressed the files, copy the **caurina** folder into the **05_PageTurn** folder in **Chapter_09**.

22. Select the blank keyframe in Frame 1 of the **actions** layer. Open the Actions panel. The first step is to import the Tweener class. Enter the following code:

```
import caurina.transitions.Tweener;
import caurina.transitions.properties.DisplayShortcuts;
DisplayShortcuts.init();
```

23. Add the Event Listeners to the buttons on the Stage. Enter the following code:

```
page1_btn.addEventListener(MouseEvent.CLICK, goSpread1);
page2_btn.addEventListener(MouseEvent.CLICK, goSpread2);
page3_btn.addEventListener(MouseEvent.CLICK, goSpread3);
```

24. Add the Event Handlers. Each function adds a new Tween that is attached to the **pages** movie clip. The property that is being tweened is the frame number (**_frame**) the playback head needs to tween to in one second (**time:1**).

```
function goSpread1(e:MouseEvent):void {
    Tweener.addTween(pages, {_frame:0, time:1, transition:"linear"});
}
function goSpread2(e:MouseEvent):void {
    Tweener.addTween(pages, {_frame:31, time:1, transition:"linear"});
}
function goSpread3(e:MouseEvent):void {
    Tweener.addTween(pages, {_frame:60, time:1, transition:"linear"});
}
```

25. Save and test your movie. Click on the buttons to turn the pages in the book (Figure 9.36). This completes the exercise.

Figure 9.36: *Save and test the final interactive page turn.*

Fun with Fractals

Fractal Noise is a very cool effect to play around with in After Effects. It generates grayscale noise that you can use for organic-looking backgrounds, textures, or to simulate clouds or even a fireball. It has a ton of properties associated with it. The best way to learn about fractal noise is to experiment with it. The last exercises explore some creative applications using fractal noise.

Exercise 1: Dark City

01_DarkCity

1. Open **01_DarkCity.aep** inside the **06_Fractals** folder in **Chapter_09**. In this exercise, you will create a smog effect using the Fractal Noise effect and add it to a 3D animation of a cityscape (Figure 9.37).

Figure 9.37: *The final composition incorporates Fractal Noise to create smog.*

2. The Project panel contains all the footage you need to complete this exercise. A composition is already set up for you in a **Comps** folder. Double-click on the **Smog** composition to open its Timeline and Comp panels. It contains a black solid layer. Select the layer.

3. Select **Effect > Noise & Grain > Fractal Noise**. The black solid layer changes to grayscale noise, similar to Abobe Photoshop's Clouds filter (Figure 9.38). Fractal Noise only deals with grayscale to create the noise, not color.

Figure 9.38: *Apply the Fractal Noise effect to the black solid layer.*

4. Go to the Effect Controls panel. Fractal Noise is rather complex. There are a variety of options to choose from. First, lower the **Contrast** value to **60.0**.

5. Twirl open the **Transform** properties. Make the following changes:

 ▸ Uncheck the checkbox for **Uniform Scaling**.

 ▸ Change the **Scale Height** value to **250.0**.

 ▸ Enable the **Perspective Offset** option by clicking on its checkbox. The layers of noise now will animate moving at different depths to create a 3D look.

6. To animate the noise, use the **Offset Turbulence** property. First, click on its **stopwatch** icon 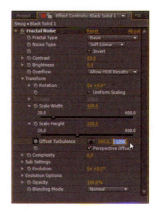 to set a keyframe at the beginning of the composition.

7. Press the **End** key on the keyboard to move the CTI to the end of the composition. Change the **Offset Turbulence** value to **360.0, –1200.0**. This animates the noise vertically over the duration of the composition.

8. There is too much detail in the Fractal Noise. Lower the **Complexity** value to **3.0**. This controls the number of noise layers that are combined to create the Fractal Noise. Lowering the number softens the amount of detail.

9. Click on the **RAM Preview** button. The Fractal Noise slowly animates up at different depths. This completes the first part of this exercise. Save your project.

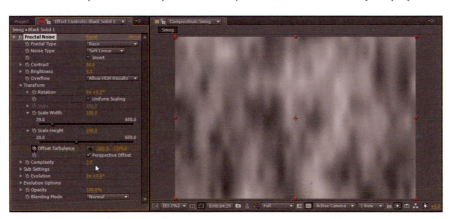

Figure 9.39: *Adjust the Fractal Noise properties to create the animated smog.*

10. With the smog ready, it is time to add it to a city. Double-click on the **CityZoom** composition to open its Timeline and Comp panels. It contains three footage layers: a foreground, middleground, and background art that create a cityscape (artwork courtesy of *www.istockphoto.com*).

 The layers have been converted into 3D layers and positioned in 3D space. A camera layer animates through the space and into the cityscape (Figure 9.40). You will nest the smog composition you just created into this composition.

Figure 9.40: *The CityZoom composition contains a 3D animation using a camera layer.*

11. Click and drag the **Smog** composition from the Project panel to the Timeline. Position the nested comp in between the foreground and **Dark City** logo layers (Figure 9.41). Enable the 3D Layer switch.

Figure 9.41: *Add the Smog composition to the Timeline and convert it into a 3D layer.*

12. Type **P** on the keyboard to display the layer's **Position** properties. Set the layer's position to **160.0, 120.0, 400.0**.

13. Type **T** on the keyboard to display the layer's **Opacity** properties. Set the layer's opacity to **30%**.

Figure 9.42: *The final animation with the Fractal Noise.*

14. Click on the **RAM Preview** button. Save your project. If you want to export the file to Flash, render the composition as an F4V file. Import the video as an externally linked file.

Exercise 2: Firestorm

In this exercise you will create a seamless looping background using Fractal Noise for a web banner ad. To see an example of what you will build, locate and launch the **02_FractalFire.swf** file in the **Completed** folder inside the **06_Fractals** folder in **Chapter_09** (Figure 9.43).

Figure 9.43: *The final Flash file integrates a seamless looping Fractal Noise background.*

1. Create a new project in **After Effects**. Select **Composition > New Composition**. Enter **Firestorm** as the Composition Name. Select **Web Banner, 468 x 60** from the Preset popup menu. Set the duration to **0:00:05:00**. Click **OK**.

2. Make sure the Timeline panel is highlighted. Select **Layer > New > Solid**. The Solid Settings dialog box appears. Make the following settings.

 ▶ Enter **FirestormFractal** for the solid name.
 ▶ Click on the **Make Comp Size** button.
 ▶ Set the color of the solid layer to **Black**.
 ▶ Click **OK**.

3. With the solid layer highlighted, select **Effect > Noise & Grain > Fractal Noise**.

4. Go to the Effect Controls panel. Change the **Fractal Type** to **Dynamic Progressive**. The Fractal Noise is created by generating a grid of random numbers for each noise layer. The Fractal Type setting determines how the grid renders the random numbers. The Dynamic Progressive setting produces cloudlike noise, perfect for a fireball. Experiment with the other settings.

5. Raise the **Contrast** value to **133.0**.

6. Twirl open the **Transform** properties and lower the **Complexity** value to **5.0**. You will use the **Evolution** property to animate the noise in this exercise. This adds progressive revolutions that continue to change the noise with each added revolution.

7. Twirl open the **Evolution** property. First, click on its **stopwatch** icon to set a keyframe at the beginning of the composition.

8. Press the **End** key on the keyboard to move the CTI to the end of the composition. Change the **Evolution** value to **2x + 0.0**. This property now completes two revolutions based on the duration of the composition.

9. To create a looping background, twirl open the **Evolution Options** properties. Enable the **Cycle Evolution** by clicking on its checkbox. Set the **Cycle** value to **1**.

Figure 9.44: *Use the Cycle Evolution property to create a looping background.*

10. Click on the **RAM Preview** button. The evolution completes the number of revolutions you specified for Cycle for the length of the composition. Save your project. What about color? Fractal Noise doesn't have any color settings.

Figure 9.45: *Evolution creates an organic-looking background.*

11. With the solid layer highlighted, select **Effect > Color Correction > Colorama**. Go to the Effect Controls panel and twirl open the **Output Cycle** properties. Select the **Fire** preset from the popup menu next to **Use Preset Palette**. Now you have a firestorm (Figure 9.46).

Figure 9.46: *Apply Colorama to create the fiery look.*

12. Before you render the composition, you have to address one small problem. The last frame of a cycle is identical to the first frame. To create a seamless loop:

 ▶ Press the **End** key to move the CTI to the end of the composition.

 ▶ Press the **Page Up** key to jump to the frame before the last frame (04:13).

 ▶ Click and drag the **Work Area End** blue tab to align with the CTI.

Figure 9.47: *Reduce the workspace by one frame to create a seamless loop.*

13. Select **Composition > Make Movie**. This opens the Render Queue.

14. Click on **Lossless** next to Output Module. Set the Format to **FLV**. Click on **Format Options** and set the Bitrate setting to **400** (Figure 9.48).

Figure 9.48: *Render the Flash Video using the Web Banner preset.*

15. Click on **Output To** and select the **Chapter_09** folder on your hard drive as the final destination for the rendered movie. Click the **Render** button.

16. Let's move to Flash. Double-click on **02_FractalFire.fla** in the **06_Fractals** folder to open the file in Flash. It contains two layers: a **type animation** layer and a **video** layer. The type animation is contained in a movie clip.

02_FractalFire

17. Double-click on **mc_TitleAnimation** in the Library. It contains two layers that hold graphic symbols. Each graphic symbol tweens in over time (Figure 9.49).

Figure 9.49: *The type animation is contained within a movie clip symbol.*

18. Return to the main Timeline. Select the blank keyframe in the **Video** layer.

19. Select **File > Import > Import Video**. The Import Video Wizard dialog box appears. To import the FLV file:

 ▶ Locate the **Firestorm.flv** file you rendered out of After Effects.

 ▶ Set the deployment to **Embedded FLV in SWF and Play in Timeline**.

 ▶ Set the Embedding type to **Movie Clip**. Click **Next**.

 ▶ Click **Finish** to embed the video. The first frame of the video appears on the Stage and a video symbol is added to the Library.

20. Save and test your movie. The final published SWF file with the embedded video is 60 KB. If file size is a concern, you can always reduce the duration of the composition in After Effects. This completes the exercise.

Figure 9.50: *The final published SWF file is around 60 KB.*

Summary

This chapter exposed you to some of the more popular effects within After Effects and showed you how to integrate them into Flash. There are so many possible creative solutions you can come up with that it is mind-boggling. As mentioned previously, the best way to learn about the effects is to experiment.

After Effects does provide documentation that you can access directly from the application. Select **Help > Effect Reference** to open the Adobe Help Viewer. Select an effect category to find the effect you want to know more about.

This completes the chapter. The next, and final, chapter concludes your journey with Flash and After Effects. It focuses on optimizing your rendered compositions for web and DVD.

CHAPTER 10

Optimization and Encoding

Your journey towards integrating Flash and After Effects comes to an end. This chapter discusses how to optimize your video renderings for web and DVD deployment.

doi: 10.1016/B978-0-240-81351-6.50010-0

Understanding Compression

When you are finished with a composition in After Effects, you need to render it to a file that can be played using the QuickTime or Flash Player, imported into another software like Adobe Premiere, or transferred to another medium such as film. After Effects renders compositions for the web, television, film, and even playback on mobile devices. The trick is knowing how to optimize the video for the final destination and still achieve great-looking video.

When integrating Flash and After Effects, obviously you want to avoid rendering uncompressed video. The resulting video files would be too large and the data rates too high to download and play back effectively on the web. You need to compress your movies in After Effects or use the Adobe Media Encoder. This chapter focuses on preparing high-quality compressed videos.

The best place to begin is in understanding why and how compression is done. Human perception is limited and compression tools take advantage of this by "losing" data that we will never miss. Compression tools and formats employ complex mathematical calculations that are way beyond the scope of this book. The concepts, however, are much easier to understand.

What Is a Codec?

On a fundamental level, compression reduces the amount of transferable data, referred to as the data rate, needed to display an acceptable video image. It analyzes a sequence of images and sounds. From that, it encodes a file that removes as much data as possible while still providing a reproduction that, to our senses (sight and sound), closely retains the quality of the original source.

Figure 10.1: *Temporal compression looks for redundancy in data over a series of frames.*

There is a **co**mpressor and a **dec**ompressor, known as a **codec**, that performs the actual compression. A compressor reduces the amount of digital information required to store the video. A decompressor decodes the compressed data during playback. It's important to use the same codec for the compressor and decompressor. If the decoder can't understand the encoder's compressed data you will not be able to view the digital video.

There are two types of compression used: temporal and spatial. **Temporal compression**, also called **interframe compression**, looks for redundancy in data over a series of frames (Figure 10.1). If there is no change in the data from frame to frame, it copies that part of the previous frame into the next one. Temporal compression encodes only the changes from one frame to another and is used when creating a Flash Video file.

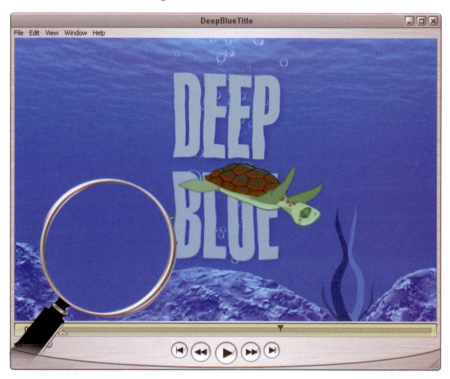

Figure 10.2: *Spatial compression looks for redundancy in only the current frame.*

Spatial compression, also referred to as **intraframe compression**, looks for redundancy within the data structure of one single frame. Since the human eye is unable to distinguish small differences in color, areas of similar color are averaged and combined using spatial compression. This works fine for static images, such as a JPEG image, but not the best choice for lots of movement.

There is a wide variety of file formats available for video and audio. Common source file formats include Apple QuickTime (MOV files), Microsoft Video for

Windows (AVI files), and MPEG files used for High Definition Video (HDV) and Standard DVD. A QuickTime movie is the most common source file used in converting video into the Flash Video (F4V and FLV) format.

The Flash Player or QuickTime Player needs to have the proper codec installed in order to play back the video. Fortunately, the latest Flash Player has three specific video codecs built in: **H.264** for F4V files, and **On2 VP6** and **Sorenson Spark** for FLV files. What is the difference between the video codecs?

Table 10.1: *Differences between the Flash Video Codecs*

Sorenson Spark (for FLV)	On2 VP6 (for FLV)	H.264 (for F4V)
Supported in Flash Player 6 or higher	Supported in Flash Player 8 or higher	Flash Player 9 Release 3 or higher
Requires less processing power than On2 VP6—it also compresses faster	Requires up to twice as much processing power over Sorenson Spark	Requires the highest decoding processing power over On2 VP6
Acceptable image quality	Superior image quality	Best image and compression quality
Does not support alpha channels	Supports alpha channels for video compositing in Flash	Does not support alpha channels
Performs well on slower computer processors	Only choice for compositing video with alpha channels in to Flash	Offers a broad support for devices

Compression can also be **lossy** or **lossless**. Lossy compression loses information for good. It's gone! It can dramatically reduce a video file size up to 100:1 which is optimal for web delivery. Similar to JPEG compression, the more you compress, the lower the quality and the more artifacts that are introduced into the image.

When it is critical that the original source and the decompressed data need to be identical, use Lossless compression. This is commonly used in the popular ZIP file format, or PNG and GIF image files. Lossless compression reduces a file anywhere from 10 to 50%. The file size still remains relatively large.

Streaming the Data

On the web, data is transferred from a web server to your browser or Flash Player on your computer. Digital video holds a lot of data and with the limitations of storage and the internet bandwidth, compression becomes a much needed ally. The fewer the items you have, the less you have to move. The act of transferring the video data is called streaming.

Streaming acts like a river's current, in that it moves data from a server to your Flash Player. If the current of the river remains constant and steady, you have no problem transferring the data from point A to point B. Too much water causes flooding and then you have problems. The Flash Player becomes

overwhelmed by all the data being pushed its way so it creates a dam to buffer the data and then release it (Figure 10.3). If your video is constantly starting and stopping online, you may want to reconsider the data rate.

Figure 10.3: *The bandwidth decides how much information can stream.*

Streaming data is not the only issue you need to contend with. The **bandwidth** is the deciding factor on how much information can stream to the Flash Player. It controls the playback and the overall user experience. Suppose we have a school of fish, our data, moving downstream. The data rate would relate to how fast the current is moving the fish. The bandwidth would relate to the width of the river. If the river narrows, not as many fish can get through, causing a backup, or delay (Figure 10.3). What is the best data rate to use?

Determining the Video Data Rate

Let's clarify what data rate is. Data rate refers to the amount of data transferred per a unit of time. Time is usually expressed in kilobits per second (Kbps). The data rate and the bandwidth work hand-in-hand. Whereas the bandwidth determines the video playback, the data rate defines the visual quality of the video.

The data rate also helps determine the bandwidth needed to play back the video smoothly. It is important to understand that the data rate contains two tracks: a video track and an audio track. The total data rate for an F4V and FLV file is the sum of the video and the audio data rates.

Table 10.2: *Suggested Total Data Rates for Different Connection Speeds*

Bandwidth Connections	Suggested Total Data Rates
Dial-up	40–60 Kbps
ISDN	80–200 Kbps
Satellite, slow high-speed	200–350 Kbps
High-speed	400–600 Kbps

What do those numbers mean? Data rate is a quantity that defines the amount of information sent within a unit of time. For example, if you were using a dial-up connection (56K modem), you could effectively receive 56.6 Kbps of data every second. This occurs in a perfect world, which rarely happens. By lowering the data rate, it allows the connection to process not only the video data but other online activities that are occurring at the same time.

Data Rate Formula for Video

How can you determine the data rate for your Flash Video? There are three components that can help you. These include the frame size, frame rate, and the codec used. You can determine a good starting point for a data rate using the following formula:

(Width x Height x Frame Rate)/Compression = Data Rate (Kbps)

Let's take the first project you built in Chapter 1 as an example. The project in After Effects was rendered at 360 x 240 at 29.97 fps. The FLV codec used was On2 VP6, which compresses video at about 70:1, or a compression divider of 7000. Here is what the formula would look like:

(360 x 240 x 29.97)/7000 = 370 Kbps

The data rate is expressed in kilo**bits** per second (Kbps). If you took that same file and rendered it using the Sorenson Spark codec, the compression divider would need to change to 6000. As you probably guessed, the On2 VP6 codec provides better compression.

(360 x 240 x 29.97)/6000 = 432 Kbps

What about F4V files? If you took that same file and rendered it using the H.264 codec, a good compression divider would be 8000. The codec used for F4V files achieves better compression than the previous two codecs, but requires more processor power.

(360 x 240 x 29.97)/8000 = 324 Kbps

In fact, Flash Player 9.0.115 and higher have three profiles for the H.264 codec. They are **Baseline**, **Main**, and **High**. The Baseline profile uses a compression divider of about 6500. The Main profile's compression divider is 8000, and the High profile is slightly higher at 8250 (Figure 10.4).

Why do all that math when you can use the default settings in After Effects and Adobe Media Encoder? These are suggested preset data rates. It doesn't guarantee acceptable playback for everyone. Also keep in mind that the numeric value returned is only for the video track.

Figure 10.4: *The H.264 codec has three profiles to choose from.*

If your project contains audio, the default data rate for the FLV audio encoder is 96 Kbps. When added to a default video codec of 400, you get a grand total of 496 Kbps, which is appropriate in a high-bandwidth situation. Let's take a detour for a moment and enter the world of digital audio.

Digital Audio Basics

Sound greatly enhances the user experience whether you are watching a video or interacting with elements in a Flash movie. It is important to understand a few key principles about audio to achieve great results when integrating it into Flash or After Effects.

Figure 10.5: *Vibrating objects generate waves of compressed air that we hear as sound.*

What is sound? Vibrating objects, such as guitar strings or vocal cords, generate waves of rapidly varying air pressure. Sound waves occur as repeating cycles of pressure move out and away from the vibrating object. When these vibrations reach our ears, we hear sound. The **frequency**, or pitch, refers to the number of cycles (waves) per second. The **amplitude**, or intensity, of sound is the size (height of the wave) of the variations. When you see audio waveforms in software applications, they illustrate these pressure waves.

Figure 10.6: *Audio waveforms are visually represented in Flash and After Effects.*

Electronic representations of sound waves can be recorded in either **digital** or **analog** formats. Analog recordings use audio tape, which is a very thin strip of plastic, coated with magnetic particles. A microphone converts the sound pressures into electric impulses. The electric impulses align with the magnetic particles to create a pattern on the tape that represents the sound.

Computers record audio as a series of zeros and ones. Digital audio breaks the original waveform up into individual samples. This is referred to as digitizing or audio sampling. The **sampling rate** defines how often a sample is taken during the recording process.

When audio is recorded at a higher sampling rate, the digital waveform perfectly mimics the original analog waveform. Low sampling rates often distort the original sound because they do not capture enough of the sound frequency. The frequency of a sound is measured in Hertz (Hz), which means cycles per second. A kilohertz (kHz) is a thousand cycles per second. Table 10.3 lists some common sampling rates used in digital audio.

Table 10.3: *Common Digital Audio Sampling Rates*

Sampling Rate	Usage
8000 Hz	Low quality with low file size used for the web
11,025 Hz	Good for narration only—do not use for music
22,050 Hz	Adequate quality and file size used in older multimedia
44,100 Hz	Audio CD quality, used for video and music
48,000 Hz	DVD quality, used for video and music

The bit depth of each audio sample is equally as important as the sampling rate. In digital audio, bit depth describes the amount of data contained in each sample, measured in bits. You can compare audio bit depth to image bit depth. The lower the number, the less detail captured, resulting in poorer quality sound. Common examples of bit depth include CD audio, which is recorded at 16 bits, and DVD-Audio that records up to 24-bit audio.

Once the audio has been sampled, it can be saved out into a number of file formats. It should come as no surprise that After Effects can import a variety of these audio file formats. The imported audio works like all the other footage

in the Project panel. An audio footage file is added to the Timeline as a layer. You can have multiple layers of audio to mix the sounds together. Here are some common audio file formats that can be imported into After Effects:

▸ **AIFF** (Audio Interchange File Format) is a standard audio format for the Mac.

▸ **WAV** (Waveform Audio Format) is a standard audio format on a Windows-based computer.

▸ **MP3** (Motion Picture Expert Group) is the file format of choice for Flash movies. It uses a compression algorithm to remove certain parts of sound that are outside the hearing range of most people. As a result, the audio still sounds great, but with a small file size.

When it comes to audio codecs, F4V files use the AAC (Advanced Audio Coding) codec. This works as a companion to the video H.264 codec in offering superior performance and compression. Flash Video (FLV) files use the popular MP3 codec. MP3 compresses audio at about 11:1, or a compression divider of 11. You can determine a good starting point for an audio bit rate using the following formula:

(Sampling Rate x Channels x Bit Depth)/Compression = Data Rate (Kbps)

If we take the first project you built in Chapter 1 as an example, the formula would result in a data rate of 128 Kbps. If you did not want to use the math, a good starting point is the default setting of 96 Kbps. This is the setting you used for every exercise in this book that contained audio.

(44,100 x 2 (stereo) x 16)/11 = 128 Kbps

If you want to reduce the overall file size, choose mono (1 channel) instead of stereo. You will not notice too much of an audio difference from the built-in speakers on your computer. To achieve the best audio compression, you must begin with an audio file that is recorded at the highest quality available. Try and use a direct digital transfer if possible. Recording analog to digital can add distortion and audible artifacts. The same considerations apply to video.

Optimizing Your Video before Encoding

Determining an appropriate data rate is not an exact science because not all video is the same. Video that contains a lot of movement with large frame sizes is going to require a higher data rate. Figure 10.7 shows what happens if you choose a lower data rate for a video that requires much more.

Video of a talking head doesn't require the same data rate due to the lack of movement. It all boils down to balancing the quality of the imagery and sound to the playback limitations based on user bandwidth. In addition to the video

content, there are ways to optimize your video prior to encoding. If you look at the data rate formula again you will see three components that you have control over: frame size, frame rate, and codec compression.

Figure 10.7: *The left image has a video data rate of 400 Kbps. The right image has a video data rate of 40 Kbps. Both have the same frame size and frame rate.*

The frame size and frame rate play important roles in determining the final data rate. You can't expect a 720 x 480 video to play back smoothly using a dial-up connection. One way to optimize your video for the web is to reduce the frame size. Table 10.4 offers some frame size suggestions:

Table 10.4: *Suggested Frame Sizes for Different Playbacks*

Playback	4:3 Frame Size	16:9 Frame Size
Dial-up	160 x 120	192 x 108
High-speed	320 x 240 or 512 x 384	448 x 252
Hard drive or CD-ROM	640 x 480	704 x 396

As discussed in Chapter 2, frame rate is the speed at which video plays back its frames. The NTSC format uses a frame rate of 29.97 frames per second. PAL has a frame rate of 25 frames per second. If we use our river metaphor again, both of these frame rates could flood the streaming process and overwhelm the Flash Player. One method of optimizing your frame rate is to cut it in half. If your project in After Effects is set to 29.97 or 30 frames per second, use a frame rate of 15 frames per second when creating the FLV file. For PAL, use a frame rate of 12 frames per second. You can also use equal divisions of the source frame rate such as 7.5 fps for NTSC or 6 fps for PAL.

Cutting the frame rate can produce a choppy playback. Watch your video content again. If it contains a lot of movement, it may need the higher frame rate for a smoother playback. If that is the case, you will have to reduce the frame size to compensate for the higher frame rate.

Try and match the FLV frame rate to the Flash movie's frame rate. The audio track will always remain at its original frame rate. If you create a Flash Video file at 30 fps and import it into a Flash movie set to 15 fps, the video portion will

Chapter 10: Optimization and Encoding

play at 15 fps, but the audio will remain at 30 fps. Proper planning done ahead of time can avoid unnecessary headaches later on.

Figure 10.8: *Try and match the FLV frame rate to the Flash movie's frame rate.*

Finally, let's focus on a video's codec. The most popular video codecs, such as MPEG-4, are lossy codecs. Remember, lossy compression removes information when the video is compressed in order to make the file size smaller. When you use these compressed files to create an FLV file, you are compressing a compressed file. Think of it as making a copy of a copy. The more generations you make, the lower the quality.

To create better looking FLV files, use a lossless codec on the source file before you encode it in the Adobe Media Encoder. A popular lossless compression codec is **Animation**. This is the default compression codec for QuickTime movies in After Effects. If you are exporting a Flash Video file directly from After Effects, you will not need to create a lossless source file since you are exporting using the original source.

Figure 10.9: *The Animation codec is a lossless compression.*

Keep in mind that these are all just suggestions for you to follow. Nothing is cast in stone. To achieve the best results with Flash Video, you are going to have to experiment. You now have some starting points to work from.

Streaming Video on the Web

In Chapter 4, you used the Adobe Media Encoder to create Flash Video files that you would upload to your website. What about streaming video content? This deployment option lets you host video files using a Flash Media Server. This is a server solution optimized to deliver streaming, real-time media. You can host

your own Flash Media Server, or use a hosted Flash Video Streaming Service (FVSS). Adobe has partnered with several content delivery network (CDN) providers that offer hosted services.

What is the benefit over using a local web server? Flash Media Server uses bandwidth detection to deliver video or audio content based on the user's available bandwidth. You can provide different content for users based on their connection speed. For example, if your target audience tries to watch your FLV file using a dial-up modem, you can deliver an appropriately encoded file that doesn't require too much bandwidth.

When deploying streaming video the playback starts sooner than it does using other methods of incorporating video. Streaming uses less of the user's memory and disk space. For security concerns, streaming video is the way to go because the video is not saved to the user's cache when streamed. For more information, go to: *www.adobe.com/products/flashmediaserver/*.

Publishing to a DVD Using iDVD

You are going to use a rendered movie from After Effects to publish it onto a DVD. You cannot do this directly through After Effects. You need to use software that creates DVDs such as Adobe Encore or iDVD on the Mac.

 Download (http://booksite.focalpress.com/companion/jackson) the **Chapter_10.zip** *file to your hard drive. It contains all the files needed to complete the exercises.*

iDVD

1. On a Mac, launch **iDVD**. When the application loads, click on **Magic iDVD**. This is similar to the Import Video Wizard in Flash in that it walks you through the steps in creating a DVD.

2. Next, add your movie to iDVD. To do this, the easiest way is to select the rendered movie file in **Chapter_10** and drag it to the **Drop Movies Here** area.

Figure 10.10: *Add your movie to iDVD.*

3. Enter a DVD title and choose a theme for your DVD menus. For this exercise the **Marquee** theme was used from **Old Themes** or **4.0 Themes** (Figure 10.11).

Figure 10.11: *Choose a theme.*

4. You can edit the screen text by simply clicking on it. By default, iDVD uses the file name. Click on it and change it to whatever you want (Figure 10.12).

Figure 10.12: *Change the screen text to whatever you want.*

5. Click on the **Play** button to preview your DVD playback (Figure 10.13).

Figure 10.13: *Preview the DVD playback.*

6. Insert a blank DVD into your DVD burner.

7. Click the **Burn** button ⊙ . When the process is complete, iDVD ejects your DVD and you can play it on a DVD player. It is that easy! Enjoy.

Figure 10.14: *Burn the DVD.*

Summary

This completes the chapter on optimizing and rendering. You learned about compression and the popular codecs used. The next section focused on data rates and how they affect your final rendered video. Finally, you exported the same After Effects composition for the web and DVD delivery.

Some key concepts to remember include:

▶ Compression reduces the amount of transferable data needed to display an acceptable video image.

▶ A compressor and a decompressor, known as a codec, performs the actual compression.

▶ Data rate refers to the amount of data transferred per a unit of time. Time is usually expressed in kilobits per second (Kbps).

Your journey has come full-circle. You started your quest by learning about the workspace and workflow in After Effects. In this final chapter you dug deeper into the last stage of the workflow—rendering. Along the way you created visual effects and animation using both Flash and After Effects. These two applications were made for each other. Hopefully you have been inspired to explore more uncharted territories using these two powerhouse applications.

Thank you for taking the journey.

Index